PAUL STRAND

PAUL STRAND

AN AMERICAN VISION
SARAH GREENOUGH

APERTURE FOUNDATION
IN ASSOCIATION WITH THE
NATIONAL GALLERY OF ART
WASHINGTON

Negatives made by Richard Benson, Newport, Rhode Island.
Composition by David E. Seham Associates Inc., Metuchen, New Jersey.
Printed by Franklin Graphics, Providence, Rhode Island.
The staff at Aperture for *Paul Strand* are:
Michael E. Hoffman, Executive Director;
Stevan A. Baron, Vice President, Production;
Linda Tarack, Production Assistant.
Book design by Wendy Byrne and Peter Bradford.
Jacket design by Peter Bradford.
The staff at the National Gallery of Art are:
Frances Smyth, Editor-in-Chief;
Mary Yakush, Senior Editor.

Aperture Foundation publishes a periodical, books, and portfolios of
fine photography to communicate with creative people everywhere.
A complete catalogue is available upon request from
Aperture, 20 East 23rd Street, New York, NY 10010

Paul Strand: The Formative Years 1914–1917, a portfolio of
ten hand-pulled photogravure prints, is published by Aperture. The prints are produced
from enlarged inter-glass negatives made by Paul Strand
in 1916 and 1917 from his original negatives. The edition is limited to
300 examples, boxed and numbered, and thirty artist's proofs.
Further information is available from Aperture.

Exhibition Schedule
National Gallery of Art, Washington 2 December 1990 – 3 February 1991
The Art Institute of Chicago 26 May – 21 July 1991
The Saint Louis Art Museum 11 August – 6 October 1991
The Museum of Fine Arts, Houston 10 November 1991 – 12 January 1992
Whitney Museum of American Art, New York 12 March – 15 May 1992
The Fine Arts Museums of San Francisco, M.H. de Young Memorial Museum
14 June – 16 August 1992
Victoria and Albert Museum, London 16 September – 22 November 1992

CONTENTS

LIST OF LENDERS

Mr. Charles Allem
Paul Strand Archive, Aperture Foundation
The Art Institute of Chicago
Mr. David Bakalar
Center For Creative Photography, Tucson
The Cleveland Museum of Art
Peter C. Daub
The J. Paul Getty Museum
Gilman Paper Company Collection
Matthew Perkins Hoffman
Michael E. Hoffman
Sarah Warren Hoffman
Jederman Collection, N.A.
Kunsthaus, Zürich
The Metropolitan Museum of Art
The Minneapolis Institute of Arts
Museum of Fine Arts, Boston
The Museum of Fine Arts, Houston
Museum of Fine Arts, Museum of New Mexico
The Museum of Modern Art, New York
National Gallery of Art
Page Imageworks, Merrily and Tony Page
The Philadelphia Museum of Art
Private Collection
Mr. and Mrs. C. David Robinson
The Saint Louis Art Museum
San Francisco Museum of Modern Art
Federico Sassoli de Bianchi
The Southland Corporation
Southwestern Bell Corporation
Galerie Zür Stockeregg
University Art Museum, University of New Mexico
Margaret Weston
Weston Gallery

This exhibition and publication are made possible
by a grant from the Southwestern Bell Foundation.
In addition, Southwestern Bell Corporation is giving sixty-one
Paul Strand photographs to the National Gallery of Art.
These works are marked with
an asterisk beside each title in this publication.
With this gift, Southwestern Bell becomes the first corporation
to fund an exhibition at the Gallery and at the same time
to donate a major collection of works of art.
In making this essential contribution to
the National Gallery's collection, the corporation has joined
the ranks of those foundations and individuals whom
we recognize as Benefactors of the National Gallery of Art,
and will become a Founding Benefactor of the collection
of prints, drawings, and photographs.

Southwestern Bell's support at the National Gallery
extends beyond the traditional boundaries of corporate
commitment to a special exhibition, into the realm of
education and acquisitions, providing a new model for
corporate support of museums across the country.
On behalf of the trustees of the National Gallery,
I would like to express our profound gratitude to
Southwestern Bell for this gift to the nation,
which will preserve in perpetuity some of
the outstanding works of this great artist.

John R. Stevenson, President
National Gallery of Art

ACKNOWLEDGMENTS

This book attempts to describe the community of ideas that fostered Strand's art. Here, we would like to thank the large community that made this production possible. Some exhibitions and publications are truly the inspiration and work of a single person, but others, perhaps because of the dedication that the work engenders or the complexity of the project, are the result of the ideas and efforts of a confluence of people. *Paul Strand* is an example of the latter. In chronological order of their appearance into this project we must thank Michael E. Hoffman and Robert Anthoine of the Aperture Foundation for reminding us that 1990 was the centennial celebration of the birth of this important American artist, and for placing at our disposal every resource needed to create the finest tribute to Strand. We were fortunate to have the guidance of Robert Macfarlane, managing director of The Durfee Foundation, who recognized that the potential of this project perfectly suited the far-reaching vision of the Southwestern Bell Corporation. Their support has been crucial not only in the success of this exhibition and catalogue, but also in enabling the Gallery to preserve the finest examples of Strand's art. Their corporate gift to the Gallery of sixty-one Strand photographs, the first of its kind, represents an extraordinary commitment to the arts, and we are extremely grateful to Edward Whitacre, chairman and chief executive officer, Gerald Blatherwick, vice-chairman, human resources, corporate communications, and government relations, and Martin R. Berg, director, corporate communications.

From the beginning we were clear that we wanted to celebrate both the development and range of Strand's art and also his remarkable craftsmanship. Richard Benson, who has come closer than anyone to achieving the perfection of a Strand image, assumed the monumental task of creating the reproductions included in this volume. Working with Wayne Turner and the skilled technicians on the staff at Franklin Graphics, Mr. Benson perfected the process of using four ink colors on a six-color press to create the remarkable plates seen in this book.

We are grateful to all our lenders for sharing with us their prized photographs and their knowledge of Strand's art: Charles Allem; David Travis of The Art Institute of Chicago; David Bakalar; Terence Pitts of the Center for Creative Photography; Peter C. Daub; Pierre Apraxine and Lee Marks of the Gilman Paper Company Collection; Weston J. Naef and Judith Keller of the J. Paul Getty Museum; Kaspar Fleischmann and Lorraine Davis of the Galerie für Kunstphotographie zür Stockeregg; Frank and Patti Kolodny; Matthew and Sarah Hoffman; Dr. Guido Magnaguagno of the Kunsthaus, Zurich; Maria Morris Hambourg of The Metropolitan Museum of Art; Carroll T. Hartwell of the Minneapolis Institute of Art; Clifford Ackley and Sue Reed of the Museum of Fine Arts, Boston; Anne Tucker of the Museum of Fine Arts, Houston; Steve Yates of the Museum of Fine Arts, Santa Fe; John Szarkowski of The Museum of Modern Art; Merrily and Tony Page; Martha Chahroudi of the Philadelphia Museum of Art; David and Mary Robinson; Judy Levy and Barbara Butts of The Saint Louis Art Museum; Sandra Phillips of the San Francisco Museum of Modern Art; Federico Sassoli de Bianchi; John Thompson and Richard Fitzgerald of The Southland Corporation; Peter Walch of the University of New Mexico Art Museum; and Russ Anderson and Margaret Weston of the Weston Gallery. Beaumont Newhall, with a characteristically generous spirit, greatly enriched our publication and exhibition, as have several other individuals who shared their time and knowledge, including Naomi Rosenblum, Virginia Zabriskie, Marjorie and Leonard Vernon, and Amy Rule of the Center for Creative Photography.

At Aperture Foundation we thank Peter Bradford, Wendy Byrne, and Stevan Baron; and we are especially grateful to Anthony Montoya, director of the Paul Strand Archive, for his help in facilitating our research.

At the National Gallery we were fortunate to have the support of our director, J. Carter Brown, our deputy director, Roger Mandle, and D. Dodge Thompson, chief of exhibition programs. Elizabeth A. C. Weil, corporate relations officer, has been involved in every stage of the project and her efforts have been instrumental to its success. With precision and grace, Frances Smyth, editor-in-chief, and Mary Yakush, senior editor, offered astute critical advice on all aspects of this publication, while at the same time efficiently and expertly coordinating the copublication with Aperture. In addition, we are indebted to many other individuals, including Gaillard Ravenel, Mark Leithauser, Gordon Anson, and the staff in the department of design and installation for their thoughtful presentation of this exhibition; Mary Suzor and the staff of the registrar's office, especially Judy Cline, for making the complicated shipping arrangements; Hugh Phibbs and Virginia Ritchie for their matting and framing; Susan Arensberg for coordinating educational programs; Willow Johnson for assistance with Italian translations; Peggy Parsons and Vicki Toye for enabling us to present Strand's films during the course of the exhibition; Thomas McGill in the library; Elizabeth Pochter and Naomi Remes of the department of exhibition programs; Deborah Shepherd of the department of corporate relations; and Abigail Walker and Meg Alexander in the editors office. In the division of prints, drawings, and photographs we are particularly grateful to Andrew Robison for his support and guidance and to Jane Savoca and Amelia Henderson for their assistance. Megan Fox, exhibition assistant at the Gallery, deserves special recognition for her contributions to all aspects of the exhibition and publication.

FOREWORD

Paul Strand honors the centennial anniversary of the artist's birth, and also highlights the National Gallery's increased commitment to the art of photography as we approach the fiftieth anniversary of our founding. The National Gallery of Art has had a long history of support for twentieth-century American art, reflected in numerous acquisitions and major exhibitions. Among the latter, the Gallery in the past few years has organized a series of retrospectives celebrating the numerous accomplishments of Alfred Stieglitz and his circle, beginning with Stieglitz himself (1983), followed by Ansel Adams (1985), Georgia O'Keeffe (1987), and John Marin (1990). We are extremely pleased to add *Paul Strand* to this impressive roster.

Born in 1890, Strand was witness to some of the most exciting and turbulent decades of the modern age. In 1916, in his mid-twenties, he burst upon the New York art world with a series of prescient images that demonstrated a remarkably thorough understanding of the issues posed by modern art, and throughout his long career continued to make works that addressed the most compelling intellectual and social issues of his time. He was concerned not with the fleeting or ephemeral aspects of life, but with its more permanent, enduring qualities. Combining the vision of a modernist with the goals of a classicist, his art revealed those physical, psychological, and historical ties that bind a people to their native land.

Strand was not only an artist, but, as he undoubtedly would want clearly stated, a photographer. It is for that reason that we are all the more pleased to welcome him into the Gallery. Modeled after our key set of photographs by Stieglitz, the Gallery's photographic collection is based on dense complexes of work by major photographers. The Southwestern Bell Foundation is enabling us to achieve this goal with Strand. They have generously supported the exhibition and this catalogue, and in addition are giving sixty-one carefully chosen Strand photographs to the Gallery, allowing us to preserve in perpetuity for the nation some of the finest examples, which show the full range of his art from 1915 to 1974. Many corporations support exhibitions, but Southwestern Bell, like Strand himself, is clearly interested in something more permanent. Southwestern Bell has thus become the first corporation to fund not only activities connected with the exhibition proper, but also a truly major acquisition. We thank them for their vision and commitment.

Many other individuals were crucial to the success of this undertaking and are cited in the acknowledgments. Here I would like to thank in particular Michael E. Hoffman and Robert Anthoine of the Aperture Foundation and Paul Strand Archive for their devotion to this project. For many years the Foundation has sought to promote not only Strand's creative achievement but also that of other individuals who evidenced a similar commitment to and experimentation with the medium of photography. The contribution to this project made by Richard Benson, who worked with Strand in the last years of his life, is also of inestimable value. The exhibition is the work of Sarah Greenough, curator of photographs at the National Gallery. For the insights and understanding that she has brought to this project, we are grateful.

Finally, we would like to applaud the many museums and private collectors throughout the world who generously shared their superb photographs with us for this exhibition and gave freely of their time and knowledge. To them we extend our deepest thanks.

J. Carter Brown, Director
National Gallery of Art

EARLY WORK

Photography, which is the first and only important contribution thus far, of science to the arts, finds its raison d'être, like all media, in a complete uniqueness of means. This is an absolute unqualified objectivity. Unlike the other arts which are really anti-photographic, this objectivity is of the very essence of photography, its contribution and at the same time its limitation. And just as the majority of workers in other media have completely misunderstood the inherent qualities of their respective means, so photographers, with the possible exception of two or three, have had no conception of the photographic means. The full potential power of every medium is dependent upon the purity of its use, and all attempts at mixture end in such dead things as the color-etching, the photographic painting and in photography, the gum-print, oil-print, etc., in which the introduction of hand work and manipulation is merely the expression of an impotent desire to paint. It is this very lack of understanding and respect for their material, on the part of the photographers themselves which directly accounts for the consequent lack of respect on the part of the intelligent public and the notion that photography is but a poor excuse for an inability to do anything else.

 The photographer's problem therefore, is to see clearly the limitations and at the same time the potential qualities of his medium, for it is precisely here that honesty no less than intensity of vision, is the prerequisite of a living expression. This means a real respect for the thing in front of him, expressed in terms of chiaroscuro (color and photography having nothing in common) through a range of almost infinite tonal values which lie beyond the skill of human hands. The fullest realization of this is accomplished without tricks of process or manipulation, through the use of straight photographic methods. It is in the organization of this objectivity that the photographer's point of view toward Life enters in, and where a formal conception born of the emotions, the intellect, or of both, is as inevitably necessary for him, before an exposure is made, as for the painter, before he puts brush to canvas. The objects may be organized to express the causes of which they are the effects, or they may be used as abstract forms, to create an emotion unrelated to the objectivity as such. This organization is evolved either by movement of the camera in relation to the objects themselves or through their actual arrangement, but here, as in everything, the expression is simply the measure of a vision, shallow or profound as the case may be. Photography is only a new road from a different direction but moving toward the common goal, which is Life. . . .

"Photography," *Camera Work,* June 1917

*Blind Woman, New York, 1916

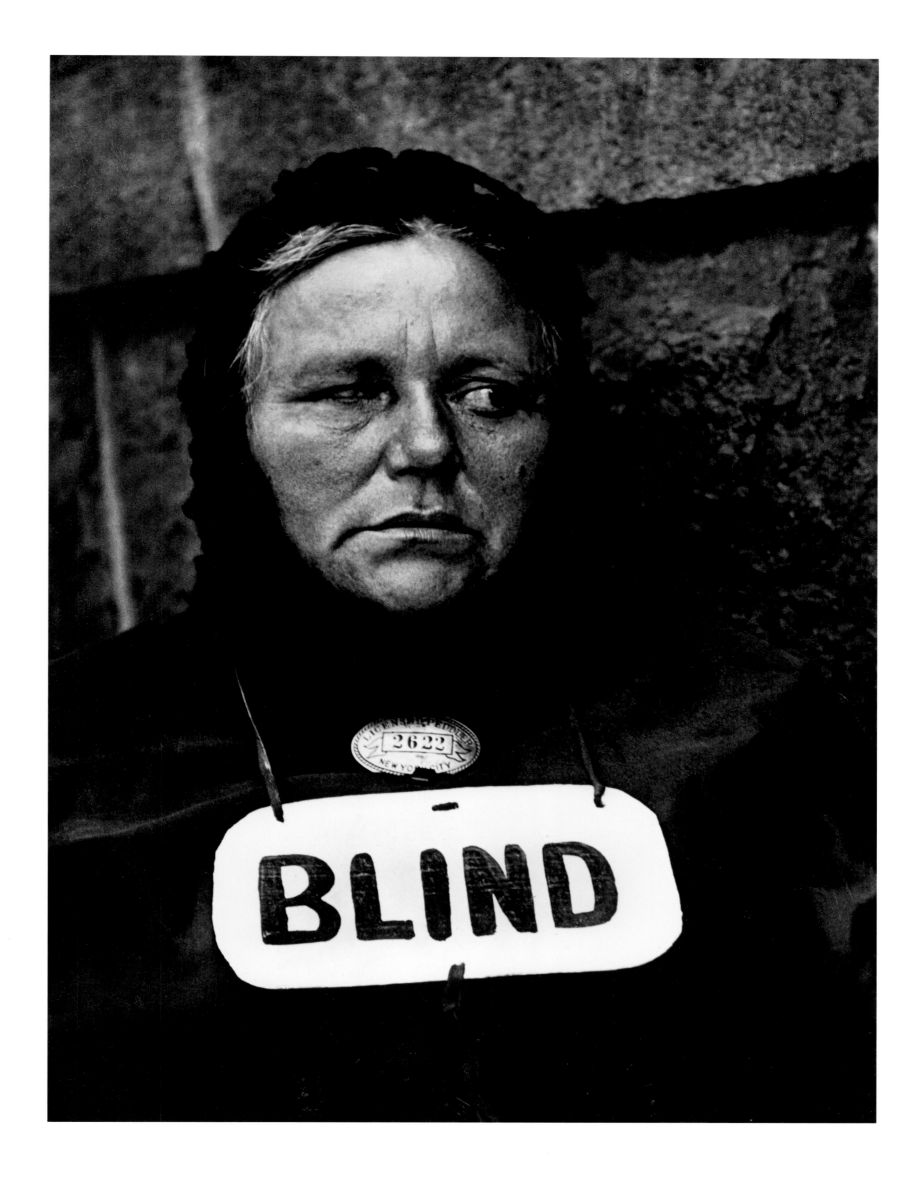

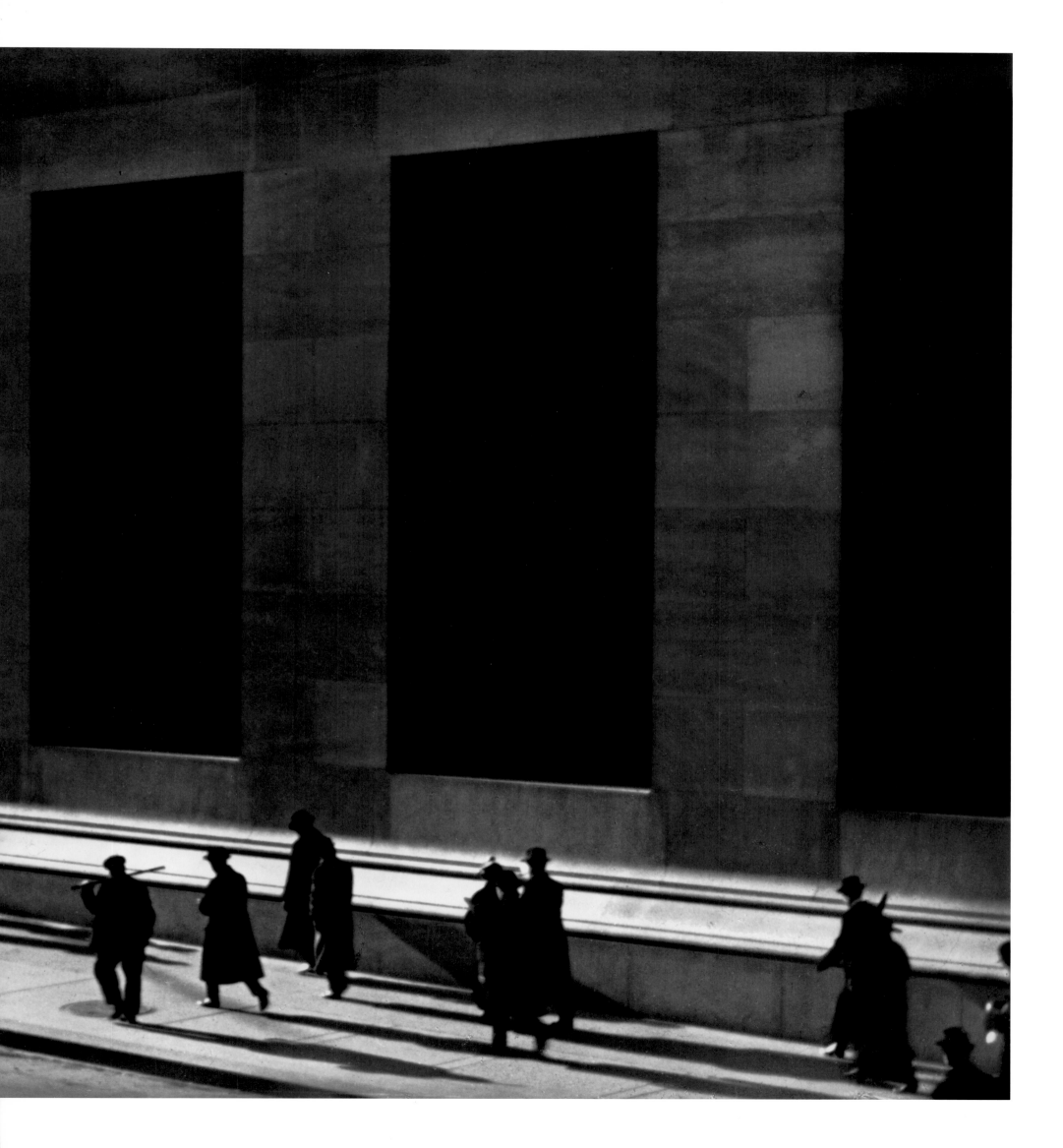

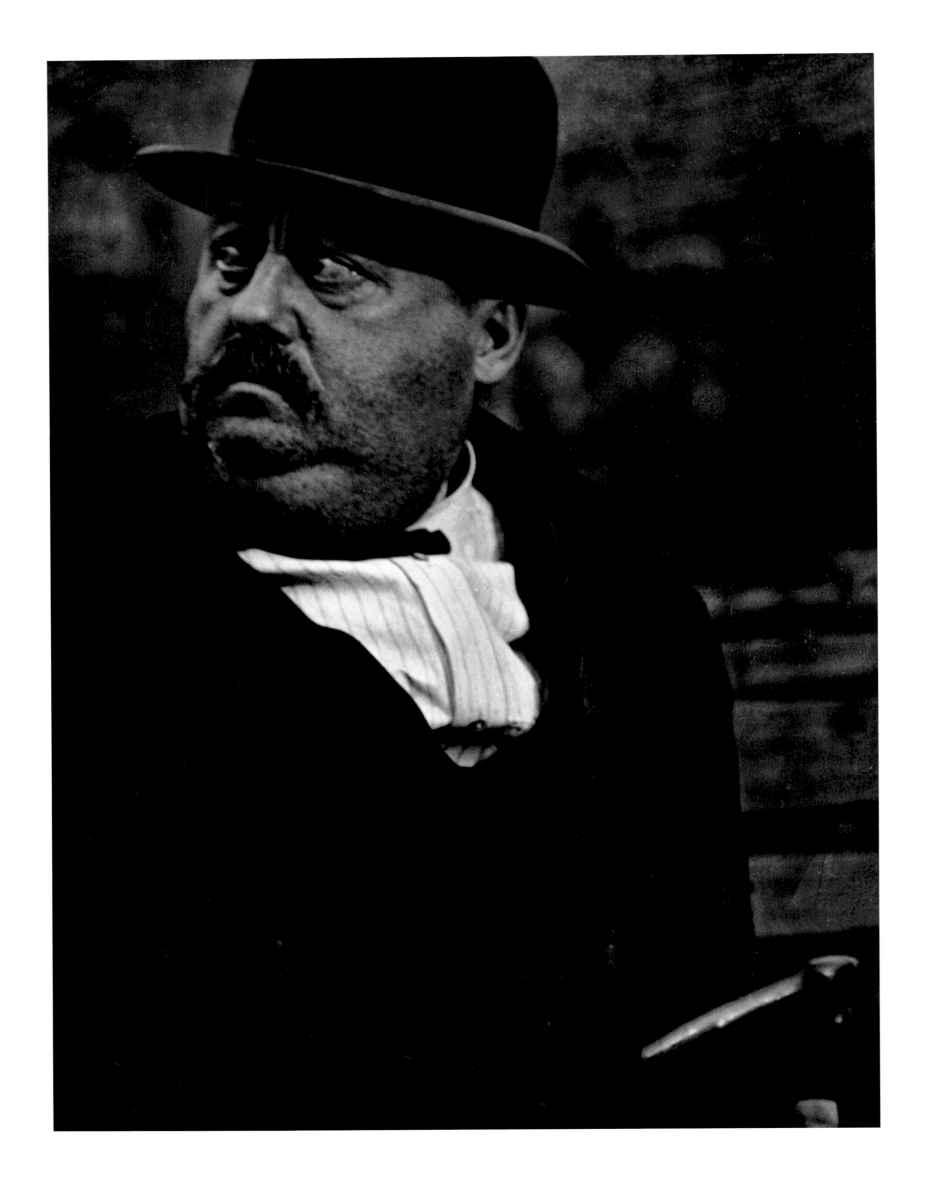

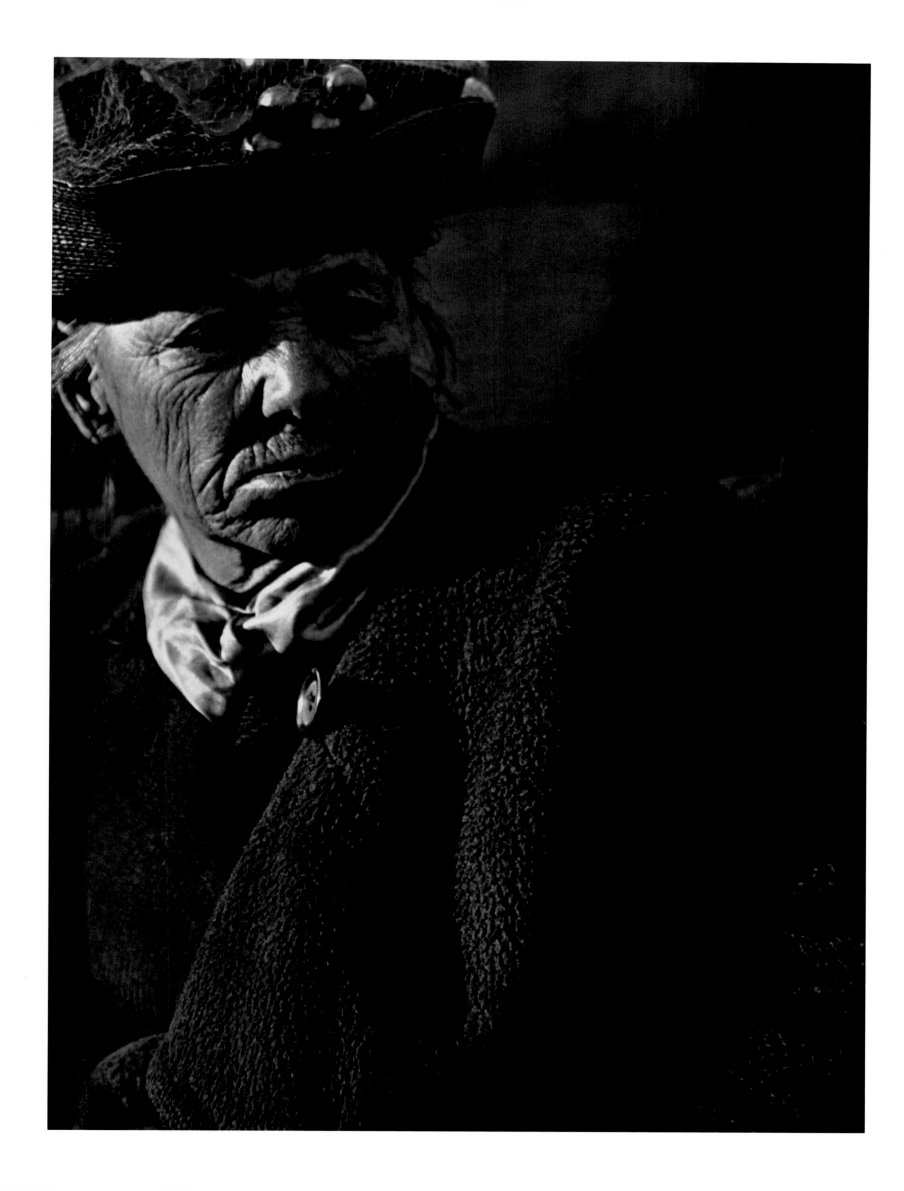

. . . . Notwithstanding the fact that the whole development of photography has been given to the world through *Camera Work* in a form uniquely beautiful as well as perfect in conception and presentation, there is no real consciousness, even among photographers, of what has actually happened: namely, that America has really been expressed in terms of America without the outside influence of Paris art-schools or their dilute offspring here. This development extends over the comparatively short period of sixty years, and there was no real movement until the years between 1895 and 1910, at which time an intense rebirth of enthusiasm and energy manifested itself all over the world. Moreover, this renaissance found its highest aesthetic achievement in America, where a small group of men and women worked with honest and sincere purpose, some instinctively and few consciously, but without any background of photographic or graphic formulae much less any cut and dried ideas of what is Art and what isn't; this innocence was their real strength. Everything they wanted to say, had to be worked out by their own experiments: it was born of actual living. In the same way the creators of our skyscrapers had to face the similar circumstance of no precedent, and it was through that very necessity of evolving a new form, both in architecture and photography that the resulting expression was vitalized. Where in any medium has the tremendous energy and potential power of New York been more fully realized than in the purely direct photographs of Stieglitz? Where a more subtle feeling which is the reverse of all this, the quiet simplicity of life in the American small town, so sensitively suggested in the early work of Clarence White? Where in painting, more originality and penetration of vision than in the portraits of Steichen, Käsebier and Frank Eugene? Others, too, have given beauty to the world but these workers, together with the great Scotchman, David Octavius Hill, whose portraits made in 1860 have never been surpassed, are the important creators of a living photographic tradition. They will be the masters no less for Euorpe than for America because by an intense interest in the life of which they were really a part, they reached through a national, to a universal expression. In spite of indifference, contempt and the assurance of little or no remuneration they went on, as others will do, even though their work seems doomed to a temporary obscurity. The things they do remain the same; it is a witness to the motive force that drives.

The existence of a medium, after all, is its absolute justification, if as so many seem to think, it needs one and all, comparison of potentialities is useless and irrelevant. Whether a water-color is inferior to an oil, or whether a drawing, an etching, or a photograph is not as important as either, is inconsequent. To have to despise something in order to respect something else is a sign of impotence. Let us rather accept joyously and with gratitude everything through which the spirit of man seeks to an ever fuller and more intense self-realization.

"Photography," *Camera Work*, June 1917

Fifth Avenue, New York, 1915

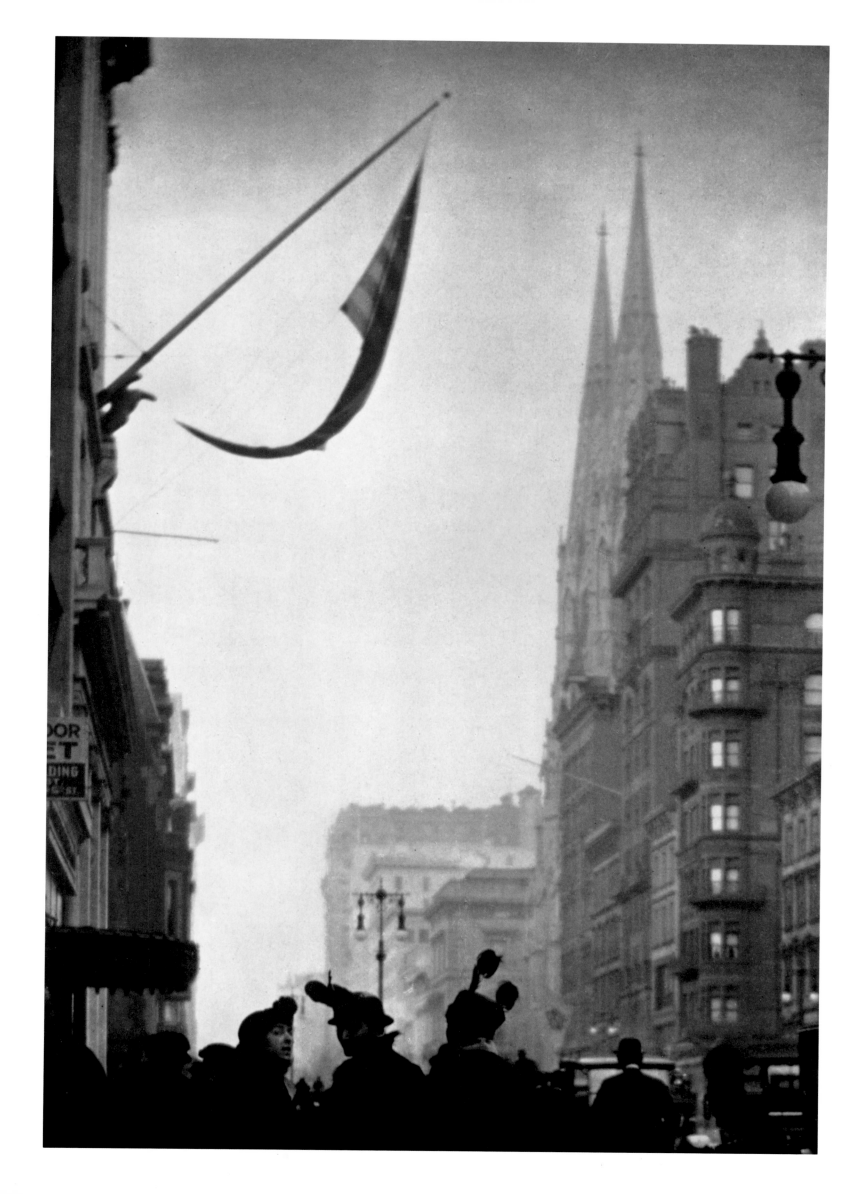

17

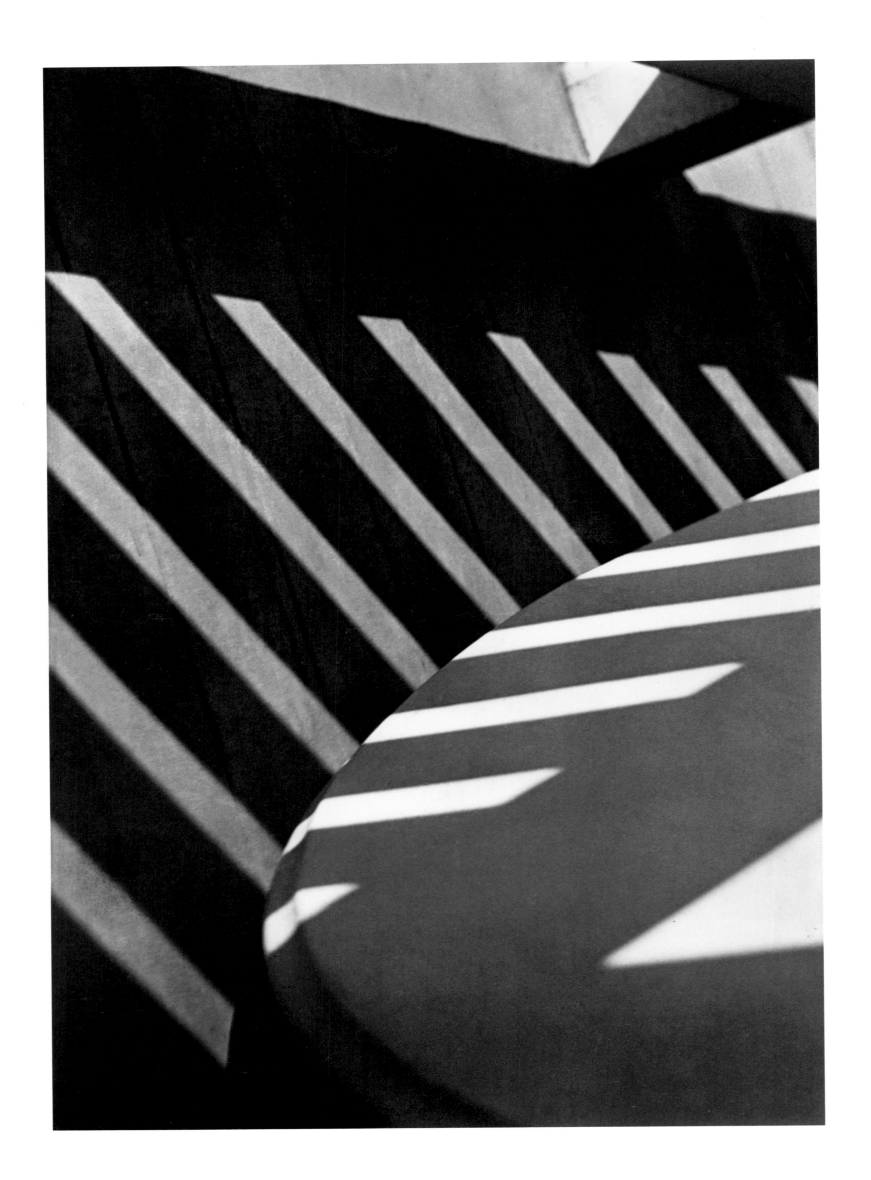

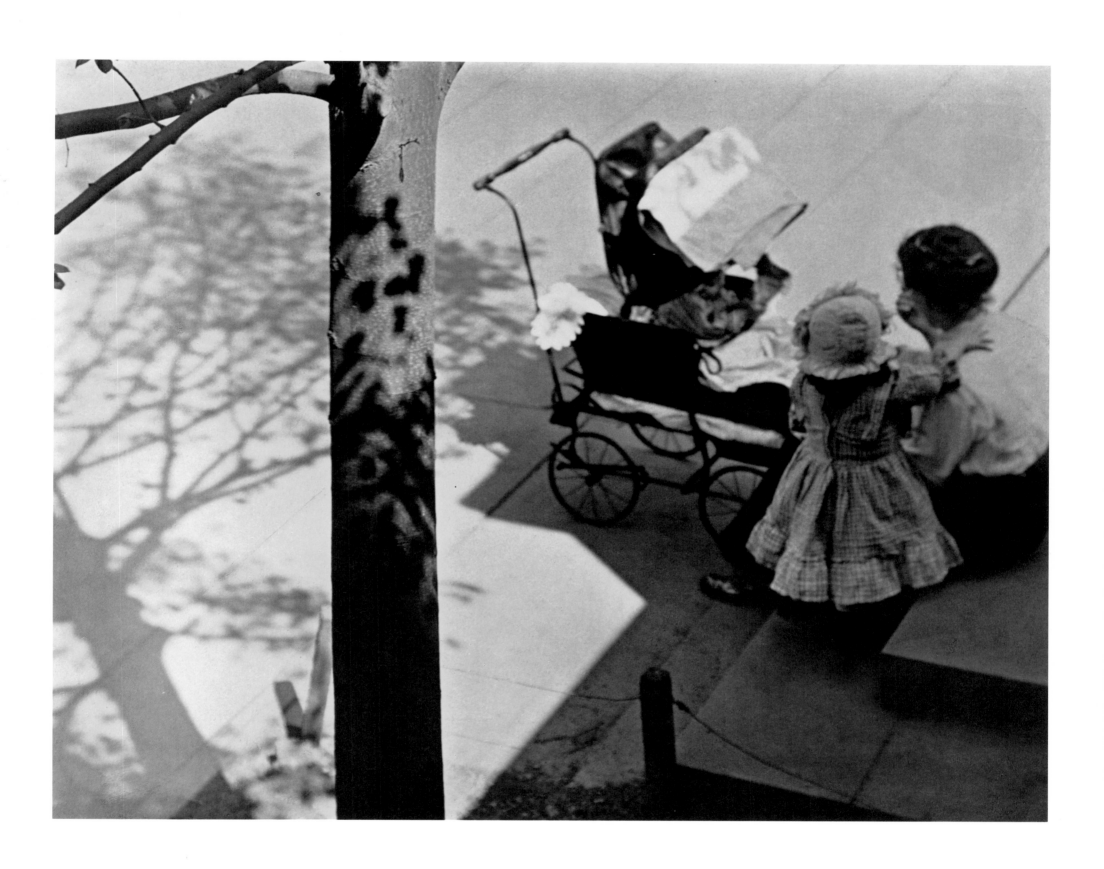

18 *Porch Shadows, 1916*
19 *New York, 1916*

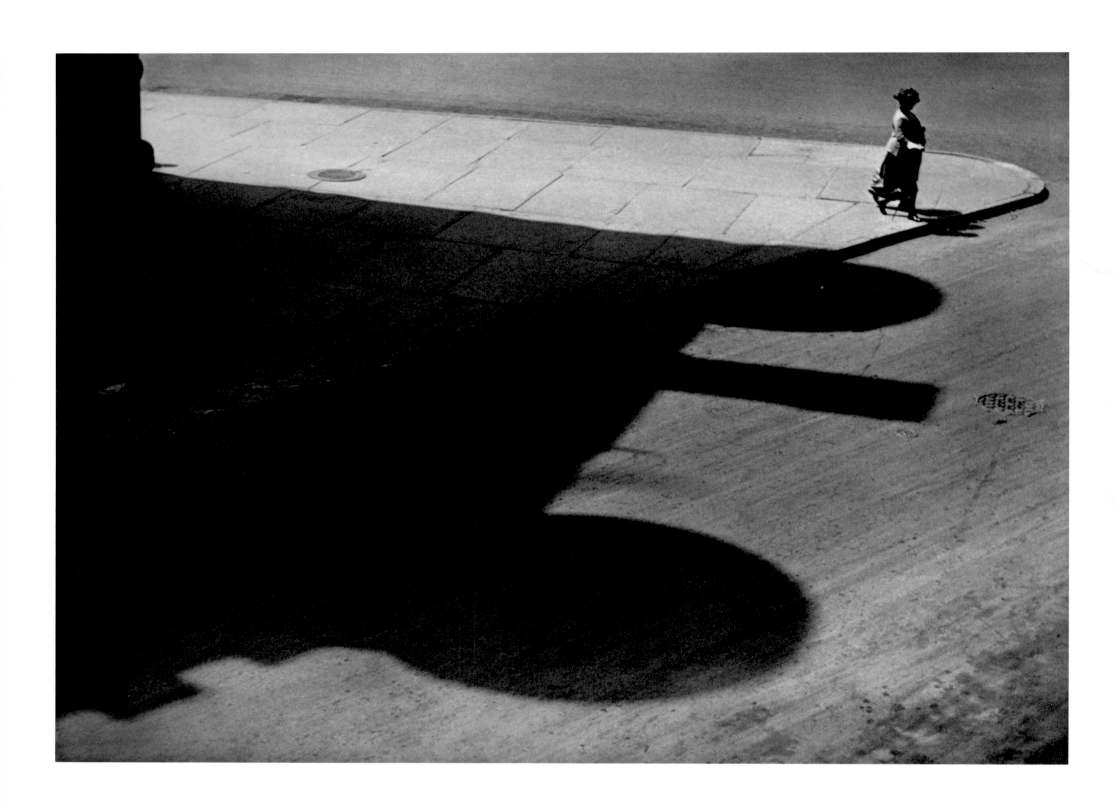

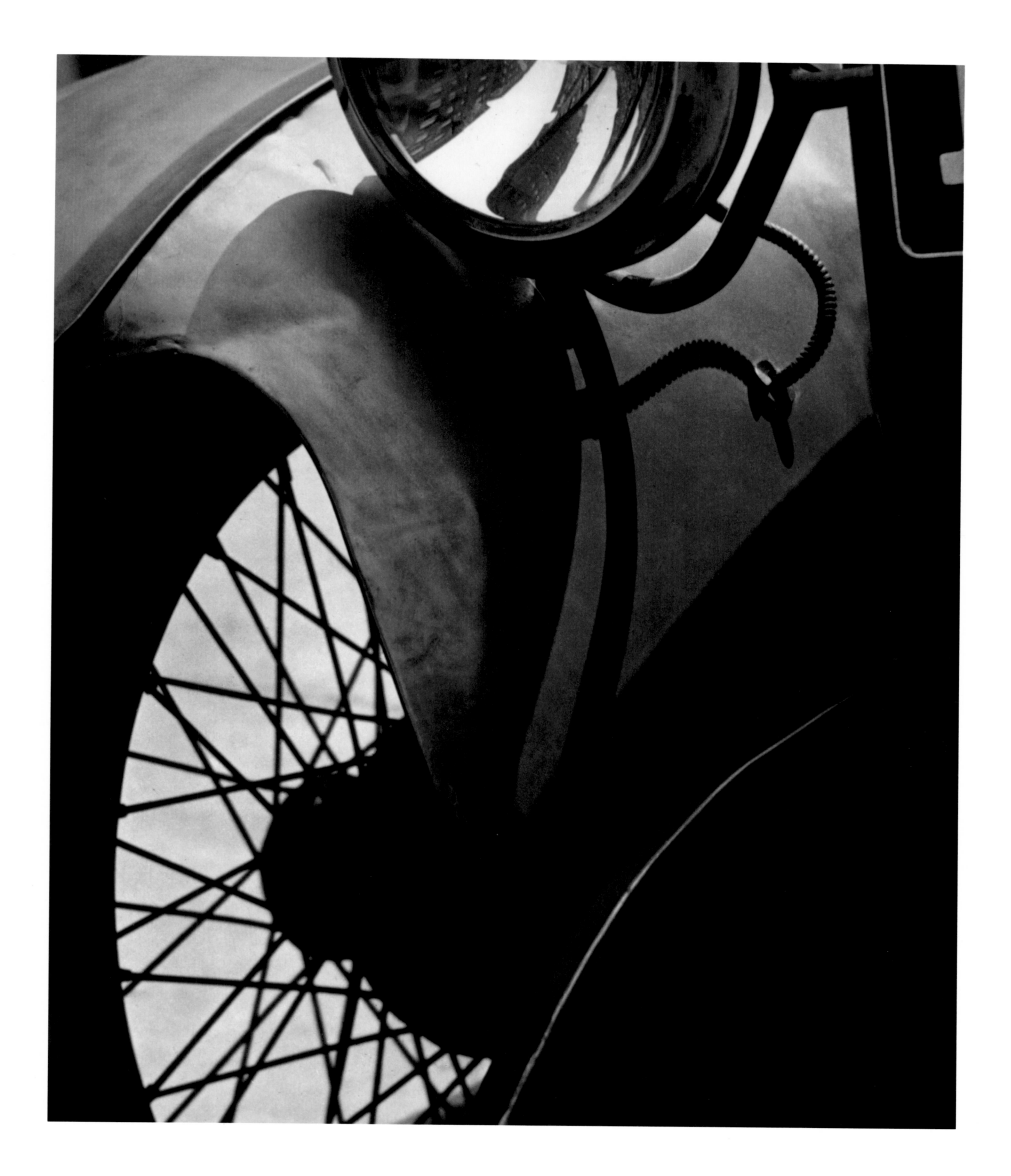

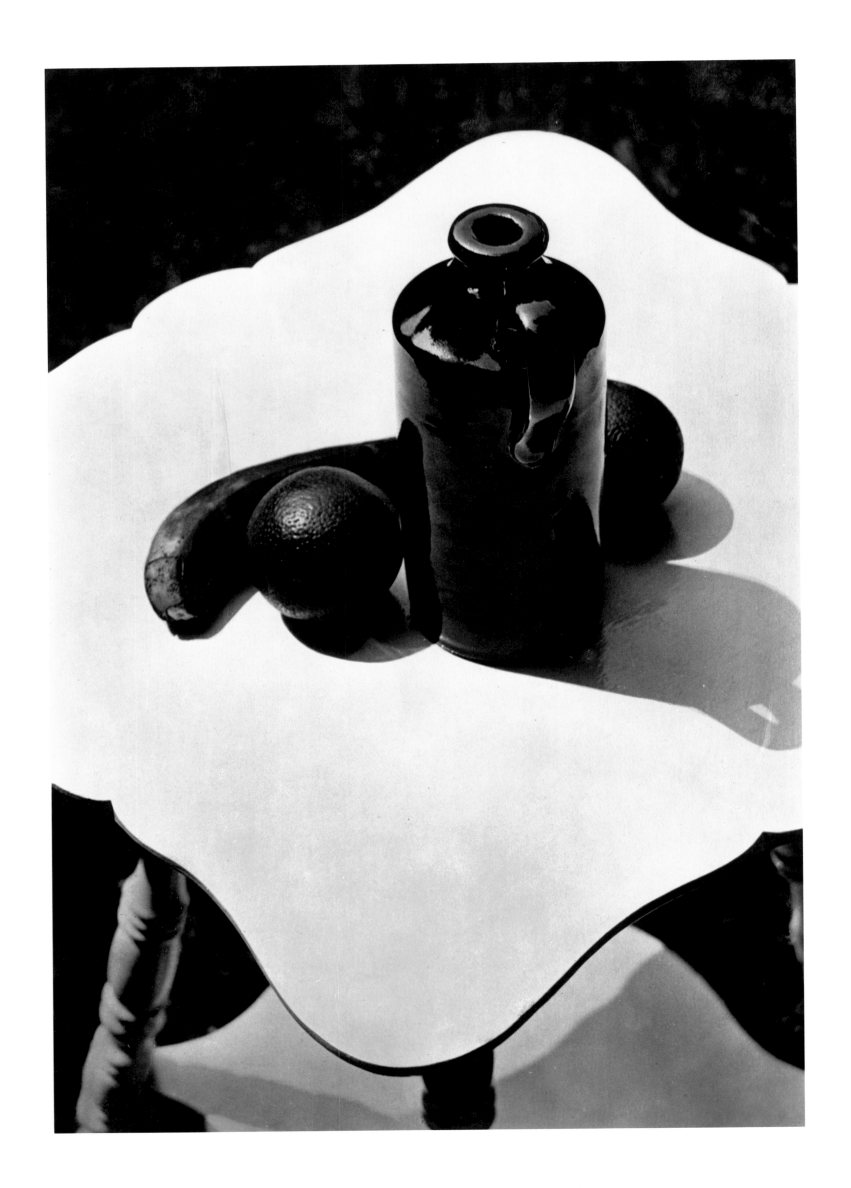

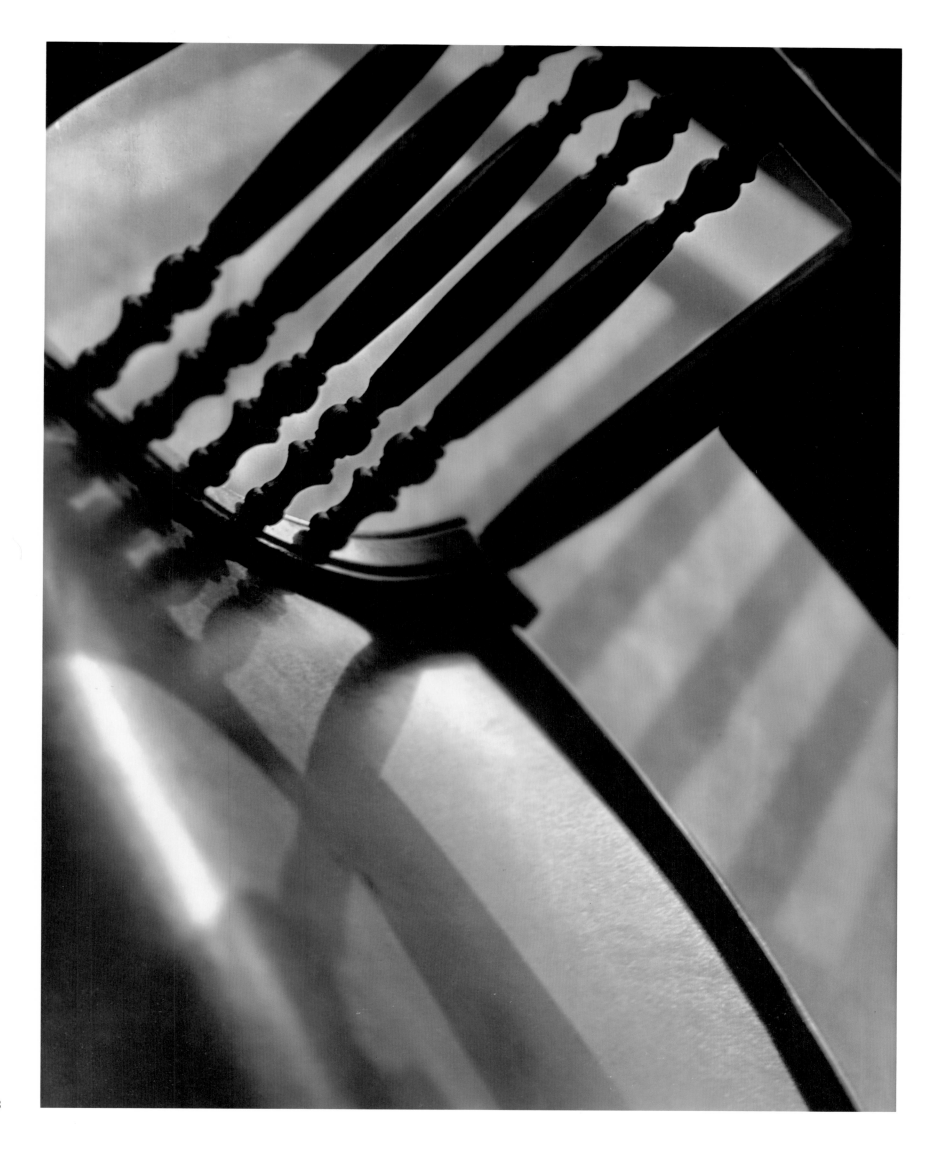

Ceramic and Fruit, 1916 or 1919 24
Bowls, 1916 25

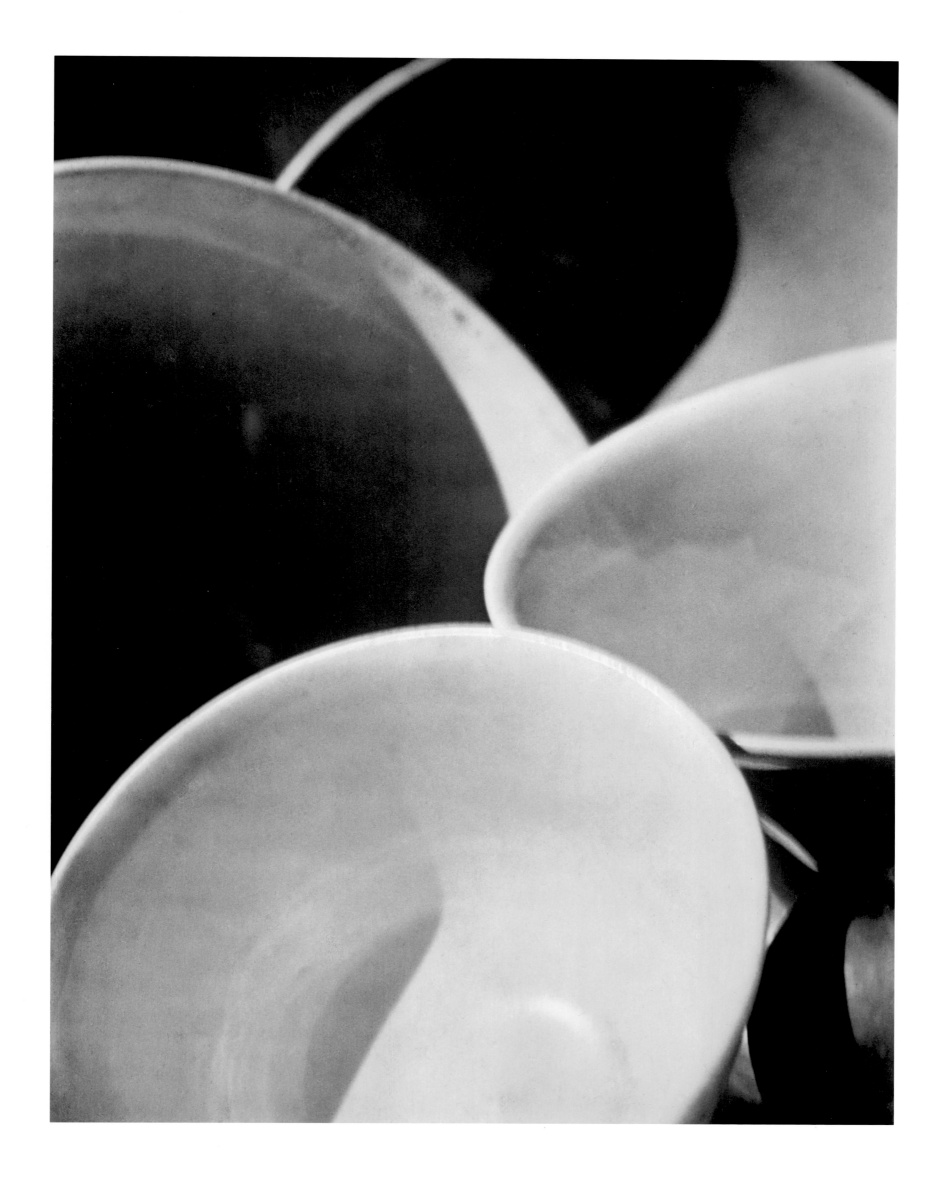

26 *The White Fence, 1916

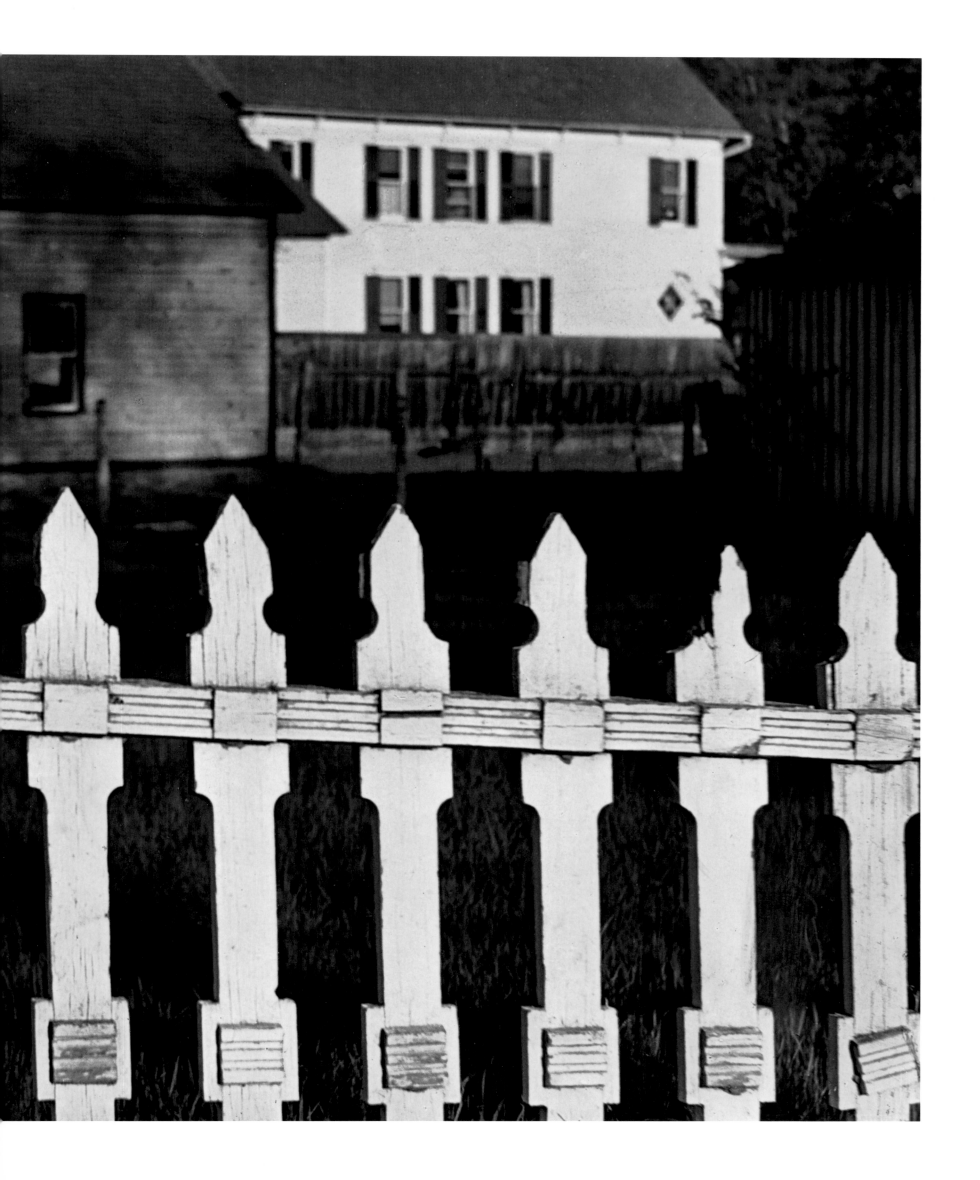

28 *Geometric Backyards, New York, 1917*

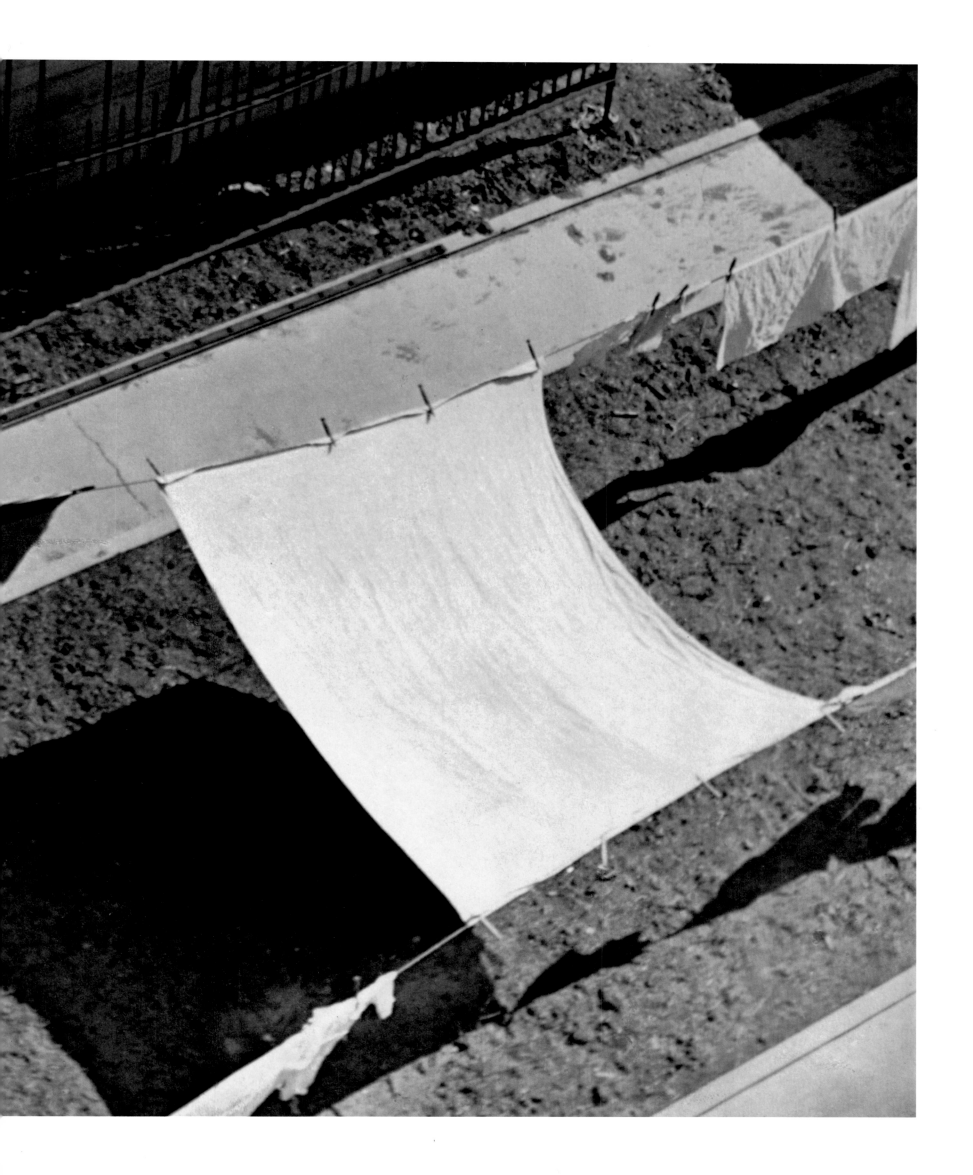

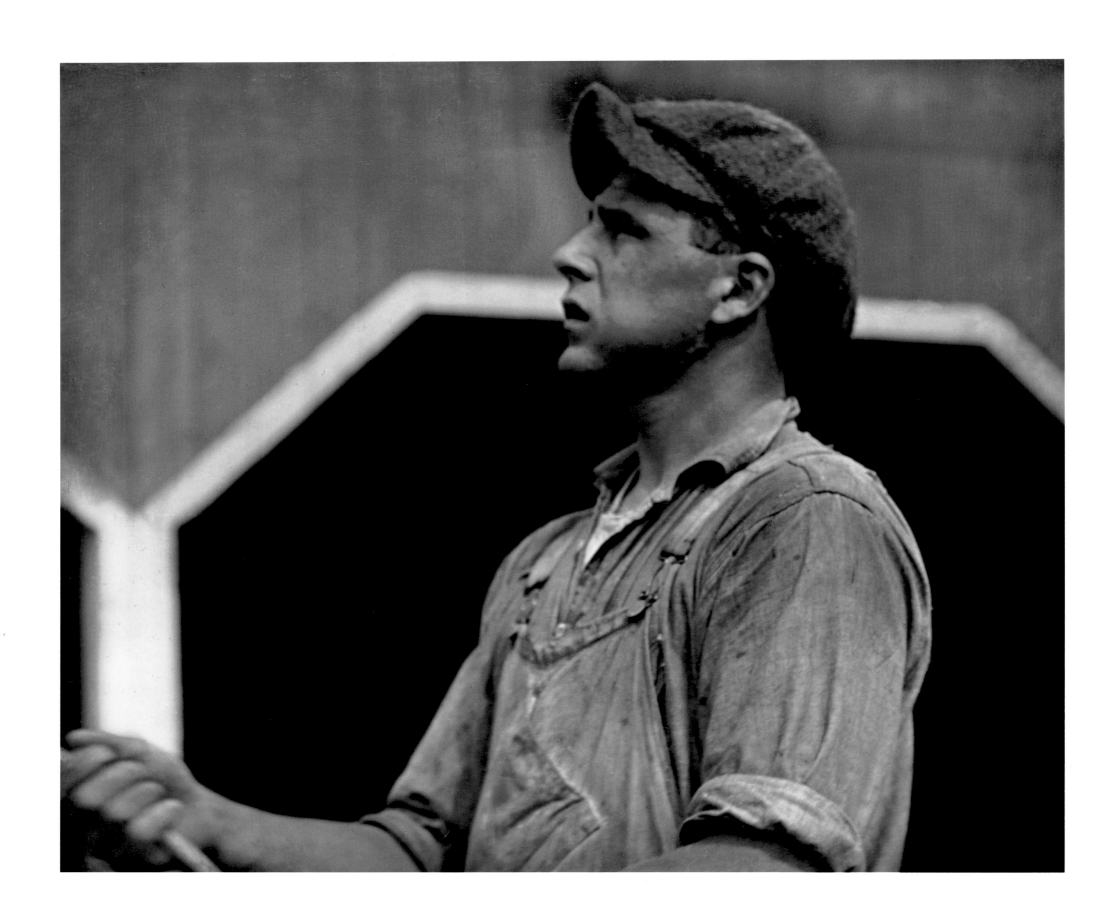

*Workman, 1916 30

AN AMERICAN VISION
SARAH GREENOUGH

The history of modern art is littered with manifestos, treatises, and other publications proclaiming the birth of new movements, and the history of photography is no different. While some of these works are filled more with rhetoric than substance, more with noise and righteous posturing than with carefully formulated thought, others, because of their clarity or forcefulness, are truly signposts indicating a new direction for future work. Paul Strand's article "Photography," published in the last issue of *Camera Work* in June 1917, is one of those seminal publications. In it he carefully delineated the new aesthetic of "pure" photography. Believing that the power of any medium was dependent on the purity of its application, Strand stated that the "absolute unqualified objectivity" of photography was its "very essence . . . its contribution and at the same time its limitation." It was the photographer's mission, he continued, "to see clearly the limitations and at the same time the potential qualities of his medium, for it is precisely here that honesty, no less than intensity of vision, is the prerequisite of a living expression." The fullest realization of this, he concluded, "is accomplished without tricks of process or manipulation, through the use of straight photographic methods."[1]

But Strand did not intend this article for *Camera Work*, the periodical edited by his mentor Alfred Stieglitz. Instead it had originally been written for the small, avant-garde publication *The Seven Arts*, founded by James Oppenheim and Waldo Frank with the support of Van Wyck Brooks.[2] Although *The Seven Arts* survived for less than a year, from November 1916 to October 1917, it effectively voiced the concerns and aspirations of many American writers, poets, critics, cultural historians, and artists who came to maturity during the First World War. This group believed that the apocalyptic nature of the war would be a catharsis for Americans, forcing them to realize that they could no longer be dependent on Europe. They knew that the war was a destructive force, but they believed it could also be a creative one. "We are living in the first days of a renascent period, a time which means for America the coming of that national self-consciousness which is the beginning of greatness," Frank and Oppenheim proclaimed in the first issue of *The Seven Arts*.[3] They optimistically spoke of the liberation of America from Europe and of the birth of a new American culture. Unlike so many other wars, this one, they believed, would not kill the American spirit, but set it free; it would not stifle creativity, but allow it to flower. Urging their readers to rid themselves of middle-class values and European ideas mistakenly grafted onto American culture, these writers insisted that new forms must be constructed to express the reality of life in America. With the zeal and enthusiasm of youthful reformers—most were born in the 1880s—they proclaimed their belief in the power of art to perfect society and thereby transform the nation.

"America needs, above all things, spiritual adventure," Frank wrote in 1917, "It needs to be absorbed in a vital and virile art."[4]

That Strand's first and most important article on photography was published in this context makes clear the link between his art and ideas and these social, cultural, and artistic reformers. Like them, Strand used a rhetorical tone, believing he was preaching to the dawn of a new era both in photography and in American culture. Applauding the "renaissance" of American photography, he praised the work of Stieglitz's organization, the Photo-Secession, asserting that with their images "America has really been expressed in terms of America without the outside influence of Paris art-schools or their dilute offspring here." Although Strand's high praise for the originality of these photographers and his assertion that they developed in innocence might be questioned today, he was correct when he noted that their work had been invigorated by experimentation and a willingness to challenge prevailing customs. Comparing the work of these photographers to the architects who had developed the skyscraper, Strand stated that both "had to face the similar circumstance of no precedent, and it was through that very necessity of evolving a new form, both in architecture and photography, that the resulting expression was vitalized."[5]

Strand and other contributors to *The Seven Arts* shared more than just a critical vocabulary and more than just a national pride or a rejection of Europe. They also were united in their understanding of the nature and function of art within society and the role and duties of the artist. The artist's expression, they believed, was not only a statement of his experience, but synonymous with an expression of America. *The Seven Arts*, Frank and Oppenheim wrote in the first issue, would be "an expression of our American arts which shall be fundamentally an expression of our American life."[6] They viewed the making of art in relation not only to the artist and the more abstract notion of the nation, but also to the general public. When a work of art that was intimately related to the real world—"rooted" in the reality of everyday life, as they would have said—was seen and appreciated by an audience, it enriched the collective experience of that community; thus art, in a cyclical fashion, nourished the world that gave it birth. This belief in the redemptive force of art, its ability to affect and change human behavior, and its power to help man improve society, was the foundation of *The Seven Arts*. The arts, Frank stated, are "not only the expression of the national life but a means to its enhancement."[7]

Art had this power, however, only when it was based in everyday reality and only when it was expressed in terms relevant to that reality. It was not enough to study the American scene, to use its people and

landscape as a framework on which to apply a European style; both the subject and the method of expressing it had to be a product of the American experience. Frank explained that Balzac or Hugo, Maeterlinck or Pushkin, "are not true for us. They have not reached up through labored fields that are our own. Absorption in them is a natural growth for their country men; for the American it is a dangerous trick. . . . We have our own fields to plow; our own reality to explore and flush with vision. Let us do this first; humbly and doggedly as lowly toilers must."[8]

The conviction that art must be based in everyday life and that the artist must construct new forms to make this reality known were the touchstones of Strand's thought, not just in his early years, but throughout his career, providing him with a simple but supple ideological framework. As early as 1915 he remarked on the formal beauty of the Texas landscape in a letter to his parents, noting that "the way the monotonous plain is broken by shacks and little white houses is quite fascinating [but] things become interesting as soon as the human element enters in," while in 1922 he chastised those painters who "have sought to evade the realities of their particular milieu," condemning them as "fugitives . . . from the hot flux of life around them, fixed not upon experiment and seeking, but upon little virtuosities of technique, fantasy or the unimportant idiosyncrasies of their own personality." Twenty-five years later he wrote of the need of artists to express the issues of their time, of "the need of society for its artists; the need of America to support its own artists if they were to exist and develop; and lastly the right of all artists to experiment, to search for new content and new forms, and to be heard."[9] Because his work did not spring from a philosophy of self expression but from the world around him, his rhetoric, his choice of subject matter, his form of expression, and even the medium he used were necessarily changed and deeply affected by the social and political events of the time. Late in his life Strand described these periods of momentous change in his art, and particularly those that occurred in 1933 and the late 1940s, as "expedition[s] into the unknown" where he was forced to alter his art radically to make it conform to the reality of his time.[10] Yet he realized that it was these expeditions, motivated to a large extent by external pressures, that repeatedly challenged him to question the aesthetic and intellectual dictums, social relevance, and moral imperatives of his work. Thus his art was consistently invigorated as he responded to the events that rocked the decades from 1910 to 1970. It is his allegiance to these basic convictions, defined so early in his life, that gives his art its sense of wholeness and unity, its strong moral tone, and its quality of revelation. For just as Strand was committed to an art founded in reality, so too was he devoted to the creation of a portrait in the broadest sense of the term, a record that laid bare not only the essential character of his subject, but also the physical and psychological ties that bound it to the larger environment.

In his first ten years as a photographer, Strand had as mentors two of the most influential and important figures in the field: Lewis Hine and Alfred Stieglitz. This was partly through circumstance, partly through choice. It would be easy to assume that Hine, the great documentary photographer who recorded immigrants streaming through Ellis Island at the turn of the century and exposed the exploitation of children in the labor force, encouraged Strand's interest in using photography to record the world around him. And it could also be as-sumed that Stieglitz, the outspoken champion of "artistic" or pictorial photography and modern painting, stimulated Strand's aesthetic and formal experimentation. But this would be wrong.

Hine's and Stieglitz's ideas about the nature and function of photography were diametrically opposed, but both men shared a strong moral approach to the medium, founded on a faith in the power of art to improve society. Born only ten years apart, Hine and Stieglitz were romantic crusaders deeply committed to their respective paths. Because of the strength of their convictions and the force of their arguments, Strand's early development is intimately connected to their ideas as well as the social and intellectual climate that fostered them. As his art evolved in the late 1910s and 1920s Strand adapted and merged Hine's social moralism with Stieglitz's aesthetic version. He wrote in 1924 of his search for an "interrelationship between social evolution and aesthetic forms," finding and photographing those forms that would speak both of the reality of his time and also of the American spirit. His mission was to discover a "communicable aesthetic symbology expressive of the social significance of [the] world," to create a union between art and life, between aesthetic and social issues, by revealing the underlying forces that animated nature and society.[11] Hine and Stieglitz, motivated by different philosophies and working from opposite ends of the social, political, and artistic spectrum, were equally influential in helping Strand to construct this union between the aesthetic and the documentary photograph.

In later years Strand did not acknowledge Hine's influence, and he even suggested that his former teacher was perplexed by his art.[12] But this does not seem entirely accurate, for Hine embodied many ideas that were fundamental to the basic premise of much of Strand's early education. Raised in a middle-class, Jewish family in New York, Strand attended public schools until he was fourteen years old, when his parents enrolled him in the Ethical Culture School. This institution, which was established in 1878, was an outgrowth of the Ethical Culture Society, a humanist movement founded in 1876 by Dr. Felix Adler on the principle of the importance of ethical factors in all personal, national, and international relations.[13] While the movement dedicated itself to demonstrating the need for moral responsibility and social action, the Ethical Culture School stressed the progressive notion that children learn best when they directly participate and are intimately involved in their immediate world. Like others founded at the time, the school reflected the faith of the progressive era in the connection between education and social reform and, concomitantly, education and national progress: they believed that analytical examination would reveal the causes of social and political problems and that moral individuals, when provided with the necessary facts, would work to change those ills. To instill a sense of shared responsibility and the efficacy of group action, the Ethical Culture School tried to build a sense of community and shared values. Initially, it was envisioned that the institution would be a "Workingman's School," composed of individuals from many different ethnic, religious, and economic classes. However, by the turn of the century, it consisted mainly of middle-class Jewish children. In addition to instruction in science, language, and mathematics, the school offered courses in crafts, such as woodworking or printing. In this way it was thought that the development of manual skills would parallel the cultivation of intellectual ones, producing an individual better suited to meet the diverse demands of society.[14]

Venice, 1911

In 1901 Hine was hired by Frank Manny, superintendent of the Ethical Culture School, to teach nature and geography. In 1904, perhaps in response to Manny's suggestion that the students should have "the same regard for contemporary immigrants as they have for the Pilgrims," Hine began to make a series of sympathetic, dignified portraits of immigrants arriving at Ellis Island.[15] This experience—that is, the act of photographing the new arrivals in a crowded and chaotic environment, the knowledge he gained about photography, and the social structures he witnessed there—led him in 1907 to seek broader horizons for his photography. In the fall of that year he began to work both for the National Child Labor Committee, recording child abuse in the work force, and for the pioneering Pittsburgh Survey, an exhaustive sociological documentation of Pittsburgh. In 1907 he also instituted a course on photography at the Ethical Culture School and for nine months Strand was one of his students. In later years Strand recalled that the course consisted of little more than Hine escorting a group of four or five students into the park and later showing them how to develop and print.[16] If this was all Hine did for Strand, even that is important because, in keeping with the progressive principles of the school, it directed the focus of the young photographer "from the classroom to the world."[17]

Hine's ideas, even as they were formulated in 1907 and 1908, were far more complex than that, however. He understood photography as a tool, as something that could be an effective weapon in his moral crusade for social reform. But like any astute crusader, Hine recognized that how he expressed himself was just as important in his quest to win converts as what he said. He saw the sociological applications and aesthetic stimulation of photography—"recording for mutual benefit," as he wrote in 1908, and "appealing to the visual sense"— as the medium's two salient features. Photography showed "the beautiful and the picturesque in the commonplace," he insisted, sharpening "the vision to a better appreciation of the beauties about one." At the same time it functioned as "a symbol that brings one immediately into close touch with reality," telling "a story packed into the most condensed and vital form."[18] Fully aware of the enormous power of these symbols, Hine realized that his contribution to the Pittsburgh Survey or the National Child Labor Committee was but one of many related and complementary projects. He therefore subordinated his artistic claims over his work and placed it at the service of the cause.

Hine, however, did more than just show the young Strand the sociological and aesthetic duality of photography or the benefit of group action. He also addressed the issues of experimentation, form, and function. In order to take his photographs, to make them have the greatest impact, and to endow them with the authority of truth, Hine was often forced to work in an unconventional manner. Not only did he wear wigs and disguises or lie about his mission in order to get into the mills or factories to record children at work, but he also created new ways to present his photographs. He experimented with posters, photomontage, and composite portraits, in the belief that reality often needed some slight adjustments to eliminate "the nonessential and conflicting interests." In his "Time Exposures" he explored ways to combine images and texts that together were more convincing of the need for reform than either alone. Just as Strand described the Photo-Secession as a group of individuals who had to work out everything they wanted to say through their own experiments, so too did Hine have to evolve a new form, created out of necessity to reveal his sociological horizon.[19]

How much immediate impact Hine had on the young Strand is debatable. It is true that at least initially Hine's stylistic influence appears to have been minimal. Strand's earliest surviving work indicates that he was far more enthralled with pictorial photography and specifically that of the Photo-Secession. It was Hine who was responsible for introducing Strand both to the work of the Photo-Secession and also to Stieglitz in the fall of 1907 when he arranged an outing to Stieglitz's Little Galleries of the Photo-Secession at 291 Fifth Avenue in New York. But it also is important to note that because Hine's ideas were so closely allied with the progressive cultural milieu that produced Strand, his teachings reinforced that heritage and encouraged Strand's direct participation with the world around him, his commitment to social responsibility, his faith in the power of analytical observation and description to affect social change, and his belief in the efficacy of group action.

Strand's friendship with Stieglitz would evolve into a complex and convoluted relationship, one that both sustained and frustrated each man; however, initially it was distant. When Strand was first introduced to Stieglitz in 1907, Stieglitz was at the height of his fame. Through his own photographs, writings, and publications, *Camera Notes* and *Camera Work*; his organization of photographers, the Photo-Secession; and his gallery, Stieglitz had become one of the most influential forces in the American art world. Perhaps because of this reputation and certainly because of Strand's own status as a high-school student, the young photographer did not immediately become a regular visitor to Stieglitz's gallery. But Strand was greatly influenced by the style of pictorial photography that Stieglitz promoted. On his first visit to The Little Galleries he saw work by Alvin Langdon Coburn, Gertrude Käsebier, George Seeley, Edward Steichen, Clarence H. White, and Stieglitz himself.[20] Impressive because of their large scale and technical complexity, these images also were extremely mesmerizing. For a student entranced by both the act of discovering

Cambridge, England, 1911

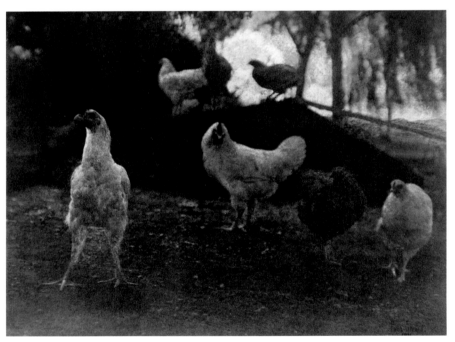

Chickens, Twin Lakes, Connecticut, 1911

Camera Work. The aim of artistic photography, readers were told, was "not to copy nature, but to appeal to the imagination."[21] Freely sacrificing accuracy for impression, detail for effect, scientific truth for creative intuition, pictorial photographers asserted that the attributes of the medium were not, or need not necessarily be, precision and verisimilitude, but rather that the photographic print could function as a decorative screen on which the photographer could project his deepest feelings and emotions.

In 1908 Strand joined the Camera Club of New York, where his interest in pictorial photography was further encouraged.[22] Such clubs had nurtured pictorialism for more than two decades and their support showed no signs of abating. Camera club members across the country exchanged lantern slides and participated in one-person and group shows; these, plus annual salons and publications, made pictorial photography the dominant style among club members. The Camera Club of New York was an active organization within this fraternal structure and Strand was an enthusiastic member, contributing prints to its annual members' exhibitions, serving on committees, and representing the club in international salons. Many of his earliest surviving photographs, such as *The Garden of Dreams* (also called *The Temple of Love, Versailles*) and *Venice*, both made during a trip to Europe in 1911, are typical of the style, subject matter, printing techniques, and even the titles of the kind of work promoted by the camera clubs. (p. 33) Like so many pictorial photographs from the turn of the century, these softly focused images are firmly rooted in the past, and celebrate a pre-industrial society. With a richly evocative yet elusive title, *The Garden of Dreams* depicts a temple at Versailles surrounded by trees and reflected in a pond in the foreground, while *Venice* recalls the picturesque qualities of that Italian city, which have entranced countless artists and photographers.[23] Adopting a standard pictorial device, Strand used water and reflection in both of these photographs to create a decorative pattern and heighten the sense of illusion. It was this sense of both illusion and allusion, of other-worldliness, of nostalgia for the past, so redolent of feelings and emotion, that the pictorialists prized above all other qualities.

Strand came late to pictorial photography, however: what had seemed innovative and challenging in 1900 seemed stale and worn by repetition by 1910. Many of his earliest surviving images reflect his search, albeit a tentative one, for an alternative path. Although photographs such as *Chickens, Twin Lakes, Connecticut* or *Cambridge, England*, also made on the same 1911 European trip, ostensibly depict a bucolic subject matter that was common among pictorial photographers, their points of view and strong formal concern are strikingly at odds with the pictorialist vision. (p. 34) Discounting their importance and complexity, Strand attributed the strength of many of these early images to his soft-focus lens, which "flattens and mushifies," allowing the beginning photographer to simplify reality and "pull things together."[24] However, the structural sophistication of these two images is not just a result of the lens Strand used. The flattened space, low perspective, and closely cropped view of *Chickens, Twin Lakes, Connecticut*, with its manifest interest in examining a fluid and uncontrollable subject, is as arresting as the abrupt compression of space and formal strength of *Cambridge, England*. In the latter image Strand composed the picture right up to the edge of the frame, allowing external bits of reality to intrude into the picture space. Neither resembles the quietly contained, closed, contemplative structures

the world through the frame of his camera and the magic of making prints in the darkroom, but unsure about what, precisely, the nature and function of photography were or what constituted its art, pictorial photography offered easy, clear, and persuasive answers. This movement contributed a precise, cogent definition of artistic photography, something that had been lacking since the medium's invention in 1839. And nowhere was it more forcefully stated or elegantly presented than in the pages of Stieglitz's publications *Camera Notes* and

of the pictorialists. Instead, these are open, fluid fragments, abstract patterns, cut from a larger whole.

Between 1914 and 1917 Strand made three groups of photographs that not only conclusively indicate his break with pictorialism but are also among the most innovative work made in America in any medium at this time. Demonstrating with remarkable force and clarity that he was one of the most accomplished artists of his generation, these prescient images remain striking even today. They show that Strand had a thorough understanding of the latest developments in both European and American art and, more significantly, that he was able to assimilate and translate this knowledge into the medium of photography. He did not simply adopt the look of avant garde art, but through a series of consciously conceived, methodical yet inspired experiments, he was able to merge these new ideas with his art.

The first group, including such works as *Morningside Park, New York*; *People, Streets of New York, 83rd and West End Avenue*; and *Wall Street, New York*, was, as he later recalled, about "the movement in New York—movement in the streets, the movement of traffic, the movement of people walking in the parks."[25] (pp. 35, 20, 12–13) It is not so much the subject matter that distinguishes these photographs from either Strand's previous work or other pictorial images: Around 1910 Stieglitz, Steichen, Coburn, and Karl Struss as well as many commercial photographers had made numerous studies celebrating New York City, and particularly its skyscrapers and the dizzying views seen looking down from these new structures; Strand unquestionably knew many of these images. Nor is it the style that separates them from previous work: their tilted picture plane and layering of space to suggest depth were common attributes of pictorial photographs influenced by Japanese art, Whistler, and Arthur Wesley Dow's theories of composition. Rather, it is their striking combination of both a strong formal concern and an interest in movement and dynamism. Like John Marin, who at this same time was beginning a series of studies of the Woolworth Building, Strand portrayed a city in which the physical environment—the streets, buildings, parks, and walkways—was as vibrant and alive as the people who inhabit it. He wanted to show that "the whole city is alive; buildings, people, all are alive," as Marin wrote in the introduction to his 1913 show at 291, "And so I try to express graphically what a great city is doing. Within the frames there must be a balance, a controlling of these warring, pushing forces."[26] Strand and Marin wanted to depict movement that was both "abstract and controlled," as Strand said, unified by a strong formal pattern yet expressive of the chaos of motion in a modern metropolis.[27] In Strand's photographs it is this sense of energy, of complexity and strength, of warring forces at times verging on chaos, of transience and impermanence opposed to the solidity of the physical structure of the city, that makes these photographs far removed from the carefully composed, timeless elegies of the pictorial photographers. Lacking the romantic overlay of Stieglitz or Struss, these photographs are truly modern statements, expressive of both the dynamism but also the potential oppression of twentieth-century life.

The comparison to Marin is not unfounded, for Strand's interest in form, movement, and even abstraction was, without doubt, encouraged not only by Stieglitz and Coburn but also by the modern paintings, sculpture, and drawings exhibited at the Armory exhibition, Stieglitz's gallery 291, and elsewhere in New York City. Between 1908 and the United States' entrance into the First World War Stieglitz intro-

Morningside Park, New York, 1916

duced to the American public the work of the most innovative modern European and American artists, including Cézanne, Picasso, Braque, Matisse, Brancusi, Picabia, and de Zayas, as well as Marin, Hartley, Weber, and Dove, along with provocative exhibitions of African sculpture and children's art. Following Stieglitz's lead and the notorious success of the 1913 Armory exhibition, other galleries began to exhibit modern art. Among these were the Washington Square Gallery, which showed Gris and Rivera; the Montross Gallery, which exhibited Gleizes, Duchamp, and Metzinger; and the Modern Gallery, which showed Brancusi, de Chirico, and Derain.[28] Strand, who began visiting 291 on a regular basis in 1913, was strongly influenced not just by these exhibitions but the whole climate they engendered, particularly the discussions at 291 and the articles printed in *Camera Work* and the avant-garde publication *291*. Years later Strand recalled that he, Stieglitz, and the other artists associated with 291 "all talked the same language."[29] That language was the vocabulary of modern art. Their concern was not to identify its stylistic attributes, but to construct a new critical vocabulary that would help them to understand the theoretical justifications of modern art and thereby begin to incorporate its radical new vision into their own work. There was a prevalent belief that if they could name it, that is, if critical terms could be formulated to explain the evolution and intention of modern art, then American painters and photographers would better understand how to make it their own. In the years from 1908 through the First World War, artists and critics associated with 291 proposed several theories, but of central importance to the development of Strand's art was the antithetical model established between art and photography.[30]

By the time of the Armory show the artists and critics associated with 291 were convinced that art must be "anti-photographic," or abstract. Because photography could replicate reality so easily and with such precision, they believed it was useless "to go on doing merely what the camera does better," as Stieglitz declared in 1913.[31] With the discovery of photography, they insisted, art should no longer simply seek to imitate form, but invent it. It should no longer merely replicate physical facts, but reveal mental and emotional states. How-

Twin Lakes, Connecticut, 1916

jects he was photographing that he extracted them from their surroundings, divorcing them from their context; he tipped over tables and chairs, stripping them of their utilitarian functions and traditional associations, and thus he presented them as pure form. In other images such as *Bowls*, the close-up details of kitchen crockery, turned on their sides or standing on end, create a confusing, ambiguous space. With effort, we can recognize these objects for what they are and begin to read into them a three-dimensionality, but this depth is insistently denied through emphatic formal repetition and complexity. As with a cubist painting, we must literally piece these photographs back together in order to understand their nominal subjects.

Made at the peak of the creative experimentation that 291 so effectively fostered, these images by Strand contain references to work by many other 291 artists. Between 1913 and 1917 Weber, Demuth, Hartley, Dove, Marin, even O'Keeffe—working in isolation in Texas—did exactly the same, eliminating obvious referential subject matter to study pure form and color. Profoundly influenced by the liberating examples of Cézanne, Matisse, Picasso, and Kandinsky, these artists were challenged also by the theories of Picabia, Duchamp, Gleizes, de Zayas, and Apollinaire. Most immediately, Strand's images recall still lifes by Hartley and Demuth also from 1916. Yet they have none of Hartley's deliberate primitiveness or Demuth's preciousness. Their intensity of vision and purity of means recalls O'Keeffe's watercolors of 1917 and 1918. (O'Keeffe, who met Strand on a trip to New York in 1917, admitted that she was greatly influenced by him.[36]) Like so many of these artists, Strand plunged into abstraction, making one of the most innovative series of photographs in the medium's history, but he then, like the others, pulled away. Non-objective art was clearly anathema to the 291 group. Their belief that art must be an integral part of American society, that it must be expressive of and responsive to deep human needs, and that it must "speak" of these needs to its audience, did not allow them to become consumed by the quest for non-objectivity. That course was too hermetic, perhaps too intellectual, to be sustained. The pressing realities of the war must also have made non-objectivity seem, if not inappropriate, then certainly slightly irrelevant. In 1921 Strand explained that Marin, "relegating 'aesthetic' formula of design, form and organization to their proper place as so much conversational twaddle . . . has gone directly to the environment in which he is rooted, to the immediate life around him, in a profoundly disinterested attempt to register the forces which animate it."[37]

Marin was not, as Strand wrote, a "fugitive . . . from the hot flux of life," and neither was Strand. He explored cubism, making consciously constructed photographs, to see, as he noted, what "its value might be to someone photographing the real world."[38] He applied that knowledge to several works made in the summer and fall of 1916, including *The White Fence*. (pp. 26–27) In a photograph that is not constructed like the abstractions, but taken, extracted from the real world and still very much connected to it and representative of it, Strand demonstrated that he could call into question the same issues of space, dimensionality, and structure that the cubists addressed. By creating a strong formal design of lights and darks, Strand unified the surface of this photograph, making it read as a geometric pattern, negating any illusion of depth. Yet at the same time, because we innately know that this is a photograph of the real world, our expectations of three-dimensional illusion are repeatedly denied by this emphatically two-dimensional object. Strand applied this same under-

ever, as they formulated a new vocabulary for art, the 291 writers and theoreticians were also challenged to redefine photography, for if art was not photography, then photography, as Marius de Zayas concluded in 1913, was "not Art." Whereas art was the subjective deformation of form, photography revealed the "objective reality of forms." De Zayas concluded that the "pure" photographer must eliminate extraneous subject matter in order "to search for the pure expression of the object."[32]

In direct response to these ideas, Strand in the summer of 1916 made his second series of experiments, a group of still lifes and abstract studies.[33] He subsequently explained that these photographs were "intended to clarify for me what I now refer to as the abstract method, which was first revealed in the paintings of Picasso, Matisse, Braque, Léger, and others. Those paintings were brought to this country through the efforts of Steichen, and Stieglitz showed them as antithetical to photography, things that were—as he used the word—'anti-photographic.' "[34] He made photographs such as *Bowls*, *Porch Shadows*, and *Chair*, he recalled, to understand "the underlying principles behind Picasso and the others in their organization of the picture's space, of their unity of what that organization contained, and the problem of making a two-dimensional area have a three-dimensional character."[35] (pp. 25, 18, 23) Strand's understanding of cubism was remarkably advanced. Unlike many other artists and critics associated with 291 who saw cubism through a veil of symbolism, Strand quickly shed those past theories. Because of his careful study, he recognized that the issues posed by Picasso or Braque were not about emotive expression, but formal analysis.

In such photographs as *Porch Shadows* and *Chairs*, Strand, like the cubists, constructed games for the mind. He got so close to the ob-

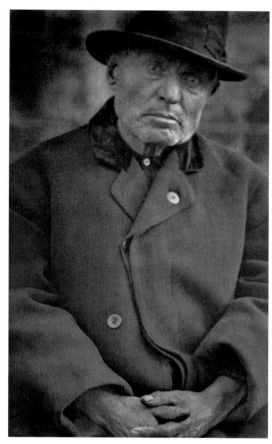

Man, Five Points Square, 1916

Strand go back to the work of his former teacher for inspiration in the fall of 1916 at precisely the time he was accepted as an intimate member of the 291 circle and hailed as the only photographer of merit after Stieglitz?[41] While the subject matter is similar to Hine's, Strand's photographs are radically different in their execution, style, and intention. Despite the pressing crowds and language difficulties, when Hine made his photographs at Ellis Island he first established contact with his subjects and then allowed them to compose themselves for the camera. Strand recorded his subjects unaware; they are "the way you see them in the New York parks—sitting around, not posing."[42] With their mouths open and their suspicious or reflective stares, these people are caught in the act of life; they talk, gesture, stare, and dream, completely unaware that they were being scrutinized by the camera. Like Edgar Lee Masters' 1915 *Spoon River Anthology*, a highly acclaimed book of verse epitaphs of the inhabitants of a Midwestern cemetery and a work that Strand often cited as the source of his interest in portraiture, the style and intention of these photographs was as startling as their subject.[43] Both Strand and Masters wanted to reveal types of Americans who had been previously overlooked by art and literature. The brutal naturalism of these photographs and their closely cropped, frontal depiction gives no sense of environment; no domestic or familiar details soften or dilute the impact of these people. Instead, detached from their surroundings, the people assume monolithic proportions; they have the strength, solidity, singularity, and elegiac quality of tombstones. Because of the candor and bluntness of the images, their lack of artifice or sentimentality, the photographs, like Masters' poems, seem to be direct statements of these New York street people. With the similarity of their style, poses, lighting, and background, and the distant expressions of the subjects, Strand's candid portraits are closer to mug shots than they are to any work of the Photo-Secession.

Strand was not content merely to see if he could make candid photographs of people in the street, however: by exhibiting them at 291 and allowing them to be published in *Camera Work*, he, like Masters, emphatically declared them to be works of art. Particularly within the context of 291 where documentary photography had been rigorously excluded from artistic photography, this was a daring act. Yet just as Duchamp, at precisely the same time, stretched the conventional limits of art and sculpture by taking such everyday objects as urinals or bottle racks and through his act of selection declaring them to be works of art, so too did Strand boldly appropriate the common photographic document and elevate it to the realm of art. Moreover, when these photographs were reproduced in *Camera Work* they were not given the more sentimental or picturesque titles they have subsequently assumed, but rather they were called simply *Photograph*.[44] It is these qualities that Stieglitz referred to when he described Strand's work as "the direct expression of today." Noting that for several years Strand had been constantly experimenting, Stieglitz continued to write that Strand's photographs were "devoid of all flim-flam; devoid of trickery and of any 'ism,' devoid of any attempt to mystify an ignorant public." They were, he concluded, highly "original."[45] It was for these reasons that Stieglitz arranged to show Strand's photographs at 291 in 1916 at the time of the Forum Exhibition of Modern American Art; reproduced them in the last two issues of *Camera Work*; and awarded them prizes in the 1917, 1918, and 1920 Wanamaker exhibitions.[46]

It is pertinent that Stieglitz described Strand as an experimenter, because for many years he had referred to 291 as a laboratory. Reflect-

standing when he made *Twin Lakes, Connecticut*. (p. 36) So complete was his domination of his subject and his desire to make it serve his purposes that he felt no compunction to be faithful to the reality in front of his camera: instead he rotated his photograph ninety degrees so that the corner of the porch defies all logic and seems to float above the clouds.

These experiments in movement and abstraction were the visual proof of what Strand came to define as the new art of photography in the age of modern painting. While insisting that photography must respect its "absolute unqualified objectivity," he explained that "it is in the organization of this objectivity that the photographer's point of view toward Life enters in, and where a formal conception born of the emotions, the intellect, or of both, is as inevitably necessary for him, before the exposure is made, as for the painter, before he puts brush to canvas." Identifying the two experiments he had been exploring, he continued, "the objects may be organized to express the causes of which they are the effects, or they may be used as abstract forms, to create an emotion unrelated to the objectivity as such."[39]

Strand's third series of experiments was made in the fall of 1916, after he spent the summer in Twin Lakes, Connecticut, creating his photographic abstractions. First using a false lens attached to the side of his camera and later a prism lens that took photographs at right angles to the direction the camera seemed to be pointing, he made a series of candid portraits, including *Blind Woman, New York; Man, Five Points Square;* and *Man in a Derby Hat, New York*. (pp. 11, 37, 14) "I wanted to see if I could photograph people without their being aware of the camera," he later said, "where [the idea] came from, I don't know exactly."[40] Superficially these portraits recall Hine's studies at Ellis Island, which Strand may have known. However, why would

ing his student training as a scientist, Stieglitz conceived of 291 as a place where people were free to experiment, to take risks. He was not interested in forming a salon, which by its very definition was exclusive and narrow, but rather he wanted to construct an open environment where people would be stimulated to see connections between all the arts—painting, photography, sculpture, literature, poetry, and music—and life. And he specifically wanted to draw parallels to the American experience at the dawn of the twentieth century. Central to his efforts were his faith in the interrelationship between the artist and his public, his belief that art was a redemptive social force, and his commitment to the group idea. Nancy Newhall explained that at 291 Stieglitz "came closest to realizing his ideal of the free group— each creating, each contributing—spontaneously working together without laws or penalties."[47] Within the group, each participant was free to extract whatever ideas were of interest or value to him, but the spirit of the undertaking was the sum total of all who contributed to it.

For Strand the group idea was one that would have enormous influence, not just in the early years of his development, but throughout his career. It would be too simple to assume that the group environment Strand found so vital at 291 or *The Seven Arts* (which described itself as "an expression of artists for the community") was merely an extension of his progressive education, which encouraged an interactive learning process. Rather it seems that after careful study of Stieglitz's efforts, and perhaps also Hine's, Strand became persuaded of both "the power of the co-operative force" and the "freedom of expression thru co-operation," as he stated in an elegy written to 291 a few months after it closed in June 1917. He hailed the gallery as an "experimental laboratory," free from the corrupting power of money that with "the laws of supply and demand, [and] all the implications of concession and compromise, make creative search impossible." The group idea also checked what seems to be Strand's growing distrust of the extreme individualism of the modern age, for he praised 291 as a "union of similar, tho[ugh] completely individual units working co-operatively, [that] became an active communal force." "Co-operation in every phase of the social structure, for the freedom of the individual," he concluded, "is the individualism of the future."[48]

Strand entered the Army shortly after 291 closed and when he was released in the summer of 1919 he felt, as he admitted in a letter to Stieglitz, very much "alone."[49] He was alone not only because it was summer and many of his friends, including Stieglitz and O'Keeffe, were away from the city, but also because, at least initially, he had no place, no group, from which he could draw energy and around which he could focus his activities. But though the war had caused 291 to close, it had not killed the enthusiastic spirit, the sense of hope and promise that in the last few years of the gallery's existence had begun to blossom in the art, literature, poetry, and criticism of those associated with it. After the war critics and writers such as Frank, Brooks, and Oppenheim, joined by Paul Rosenfeld, William Carlos Williams, Sherwood Anderson, Herbert Seligmann, and Hart Crane, as well as the artists O'Keeffe, Marin, Dove, Hartley, Demuth, Sheeler, and Strand began to gather again around Stieglitz in an informal group. This loose coalition of cultural nationalists was dedicated to revealing "the intense American nationality in which the spirit of the people is shared through its tasks and its arts, its undertakings and its songs." Their mission was "that of understanding, interpreting and expressing that *latent* America, that *potential* America which we

Looking Down, New York, 1922

believe lay hidden under our commercial-industrial national organization."[50]

In their writings Frank, Brooks, and others were emphatic that they must give Americans a sense of inherited resources and a foundation on which to build a new culture. But they were just as adamant that they could not dwell in the past: the artist must "plunge into life, feel himself impregnated with it" and express contemporary reality.[51] Applauding Masters' *Spoon River Anthology* in terms very similar to Stieglitz's praise of Strand's work, Oppenheim noted that though it lacked gracefulness or respectability "it is a vital growth from below upwards . . . Mankind was in it. And more than man, animal was in it, and plant, and gross earth." He concluded that "it is both simple and complex," because it "attempts to taste the whole radiant round of life." It did not try to separate "soul from body, the aesthetic from the emotional, the intellectual from the intuitive," but expressed a more integrated whole.[52]

During the 1920s these critics, writers, and poets signalled their allegiance to the cause through the use of a shared vocabulary as words were invested with new meanings and associations. However, they were not just inventing catchwords and slogans for a new generation; rather, their repeated use of certain words signalled their much larger concern to create a new, more expressive language, divorced from its worn-out European heritage and unencumbered by past associations. Critics repeatedly insisted that writers must "acquire a new vocabulary, or, if you will . . . take those old words that once meant so much to men and breathe the breath of life into them." They must "liberate words," Williams wrote, make them "clean" and "new" for themselves.[53] As Frank explained, this, too, was essential: "When new

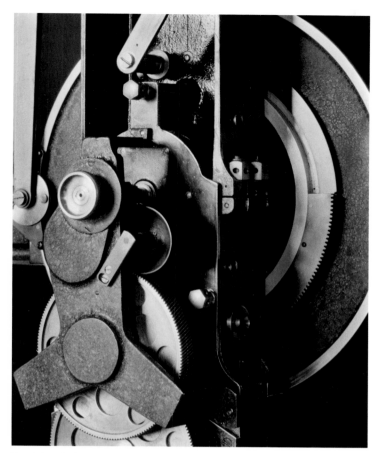

Double Akeley Motion Picture Camera, 1922

a "vision of the forces which animate that objectivity."[57] He wrote that in Marin's work "something which we call American lies not so much in political institutions as in its rocks and skies and seas. . . . He has said an American tree is entirely different from a French tree. It is that difference which he would record."[58]

Just as Strand recognized that "through their indiscriminate use and perversion, words, concepts and ideals no longer convey an even relatively sharp image and must be reintegrated before they can again convey such an image," so too did he believe that physical objects in the natural world must be reduced to their most fundamental structure and returned to a pure, basic use. Advocating a Quaker simplicity of form and spirit, he urged his fellow artists to see, as Winslow Homer had, "the elemental in America as spirit rather than as a purely material utility." In his work from the 1920s, Strand's intention was not to present an objective description of a form, but to construct a new language of form, free of "Europe or European formulae."[59] Like Williams he wanted to "liberate" form, to rid objects of their traditional associations and present them "clean and new" so that their inner spirit—the animating forces—could resonate. Well aware of Clive Bell, Strand wrote that during the 1920s the Stieglitz artists searched "the infinite complexity of our modern life" for "significant forms," objects that function as "graphic equivalents" of "a cosmic vision" of American spiritual reality.[60] The artist who did this was both a "seeker," that is someone who has "gone directly to the environment in which he is rooted," and a "constant experimenter in means and expression."[61] Throughout the twenties, in his photographs of nature and machines, his portraits of his wife Rebecca, and his filmmaking, Strand challenged himself to be both of these things.

When he was in the army Strand worked as an X-ray technician and it may have been this experience that encouraged him after his release to think of alternative applications of his photographic skills. In 1920 he and Charles Sheeler made a seven-minute film of New York, thus initiating his work in the medium that would support him for the next twenty-two years. (It is important to note that throughout the 1920s Strand made his living as a filmmaker and was only able to make photographs occasionally in his spare time.[62]) Originally titled *New York the Magnificent* and subsequently known as *Manhatta*, this film, as Strand wrote in the press release, was an attempt to capture "those elements which are expressive of New York, of its power and beauty and movement." But, as Strand also made clear, he and Sheeler purposely restricted themselves "to the towering geometry of lower Manhattan and its environs" because they believed that the "elusive spirit" of New York was to be found not so much in its people as in its structures: "the photographers have tried to register directly the living forms in front of them and to reduce through the most rigid selection, volumes, lines and masses, to their intensest terms of expression."[63] In keeping with their respect for the physicality of the buildings—their geometric strength, solidity, and complexity—Strand and Sheeler did not utilize the camera's ability to pan, but rather presented the viewer with more static shots that allowed for a greater appreciation of the "volumes, lines, and masses" of the buildings.

But clearly the physical structure alone did not create the "cosmic vision" of New York, that sense of wholeness and universality, that Strand and Sheeler wanted, because they wrapped a romantic overlay around their formal shots of the buildings. Strand himself later remembered that he and Sheeler wanted to make "a silent film carried

cultural foundations are erected the process is by the creating of new conceptions: *Words* whereby these foundations enter the experience of man. Such new words are forms of art."[54] Through their choice of words, analogies, and metaphors, it is clear that the foundation of this new culture was, quite literally, the American earth. Ambivalent about the pressing demands of their commercial-industrial society, these writers, who were nicknamed the "soil critics," expressed an intense desire for a reunification with nature, to go back, almost in an act of purification and salvation, to what Marin called "the elemental big forms—Sky Sea Mountain Plain."[55] Paradoxically, although many vacationed in the country, their entire lives had been spent in the city, and their vision of nature was often that of an idealistic outsider, influenced more by their reading of Whitman, Emerson, or Thoreau than by real experience.[56]

For a generation that came to maturity during the First World War, these ideas were very persuasive, and Strand, in a series of articles written between 1920 and 1924, was intimately involved in their formulation. Lamenting that America had "a past and a present, indeed, which sadly needs clarification," he noted that few American artists had tried "to come to grips with the difficult reality of America, to break through the crust of mere appearance." For Strand the test of American artists was whether they were able to construct images that were "sharply particularized," that created a profound sense of place and "shoved [us] into the core of our own world—made [us] look at it," made us "experience something which is our own, as nothing which has grown in Europe can be our own." It was not just subject matter that created this sense of the distinctly American place, but rather the ability of the artist to penetrate superficial reality and reveal

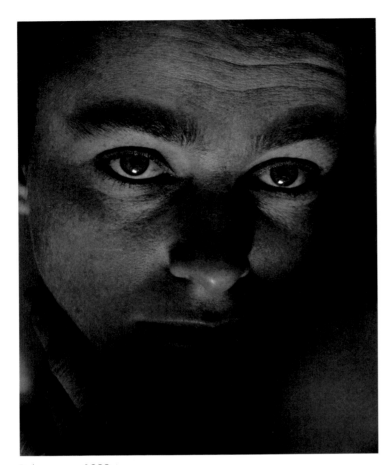

Rebecca, c. 1922

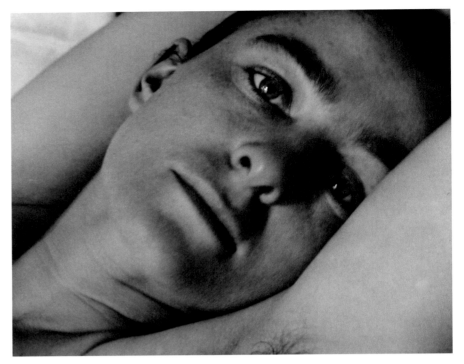

Rebecca, 1923

along by the titles which we took from Walt Whitman's poem, 'Man-nahatta'."[64] The spiritual grandfather of the cultural nationalists of the 1920s, Whitman was the cloak used to clothe and soften the moder-nity of the city's structures. He gave the photographers the emotional, at times ecstatic vocabulary with which to deal with these cold, essen-tially neutral subjects. In addition, the filmmakers added to their formal shots of the skyscrapers elements that repeatedly related the city to nature. For example, not only did they photograph the skyline glisten-ing above the water, but the film was thematically organized around a day in the life of the city. These devices combined with Whitman's exuberant romanticism show Strand's and Sheeler's belief that the un-derlying forces animating the city were natural ones.

At precisely the time he and Sheeler were filming *Manhatta*, Strand wrote to Sherwood Anderson praising his book *Winesburg, Ohio* for "penetrating thru the crassness and brutality of the American scene, to a new beauty." It is, he continued a "clear assertion of the spirit which opposes itself fearlessly to the increasing ruthlessness of the material drive."[65] During the early 1920s Strand made several still photographs of machines and buildings, the very things that were re-sponsible for much of the crassness and brutality in America. These images, however, bear no moral judgment. Like the X-rays he made while in the army, they reveal an interest in structure and also a desire to know the core of a substance. Presented with an intense, precise, scientific detail and objectivity, they speak of a photographer who was conducting a series of experiments, much as a scientist would, to break through superficial appearances and reveal facts about the essential character of these objects. But, as in *Manhatta*, the very no-tion that a machine or building has a character or a soul is a romantic one, an attempt to imbue technology with the attributes of nature and

thus to make it more understandable and controllable. Strand insisted that the machine "must be humanized lest it in turn dehumanize us." Having "irresponsibly" created this new industrial society, contempo-rary man was faced with the appalling "alternatives of being quickly ground to pieces under the heel of the new God or with the tremen-dous task of controlling the heel."[66] For Strand the salvation was pho-tography. Because the camera was a machine that could be made expressive of the human spirit and submissive to the human will, it was capable of creating a fusion between art and technology. Neverthe-less, after 1925 he stopped photographing urban-industrial architec-ture and machines; both were too much the products of the rampant materialism of American culture. His return to nature was, as Ander-son wrote of his own work, a reaction against "the industrial note of our civilization," but it was also an attempt to look beyond superficial facades and reduce experience to its most basic common denom-inator.[67] In much the same way that Anderson, Masters, Frank, or Williams used an unpretentious vernacular style to depict common incidents in common lives, so too did Strand look to the basics: to people and nature. "I am sure the Americans have already intro-duced Coney Island into heaven," he wrote to Stieglitz on a trip to Colorado and New Mexico in 1926, "it would take more than God and all the saints to stop em. But," he continued, "here the mountains are untouched—pure and wonderful—great."[68]

On his trip to the Southwest in 1926 Strand made at least one fin-ished print of Rebecca; however, this was one of the later images in a portrait series that began in 1920. These portraits of Rebecca, most of which were made between 1920 and 1923, are inevitably com-pared to Stieglitz's portraits of O'Keeffe, made at approximately the same time. Not only did the two women look and dress very much the same, but, at least superficially, Strand's and Stieglitz's photo-graphs seem similar as both men made numerous detailed studies of their lover's head, hands, and body. Beyond these stylistic similarities, however, their differences are great. In Stieglitz's "composite portrait" of O'Keeffe, she became transformed, through his complete identifi-

cation with her, into a symbol of his understanding of woman: as a giver of life, as a creative, childlike, bewitching, and seductive force.[69] Although Strand often made extremely close-up photographs of Rebecca, there is a sense of space between the photographer and his subject. It is not just Strand's reticence, but rather a sense that the photographer was allowing the subject to project herself, her personality, rather than imposing himself or his understanding of who she was on this image. Respecting the integrity of his subject, Strand wrote in 1922 that the photographer should go beyond "any empty gesture of his own personality made at the expense of the thing or person in front of him."[70] In all of his portraits of her, Rebecca retains an intense sense of physicality; she stares out at us and at the photographer as if searching for herself, seeking to define herself. In much the same way that Anderson set out to reveal the inhabitants of *Winesburg, Ohio* to each other and to themselves, so too did Strand attempt to show Rebecca to herself.

Strand did not actively pursue his portraits of Rebecca after 1923 in large part because it was a subject so closely identified with his mentor. But the idea of portraiture would continue to fascinate him, if somewhat tangentially, throughout this decade. In 1925 and again in 1927 and 1928 he went to Maine for brief vacations, and as he had done in the Southwest, he photographed plant and nature forms. With these natural objects Strand created the "sharply particularized" studies of the "core" of his world that he had written about a few years earlier. Unlike Stieglitz, who at this time was also photographing nature, Strand's intention was not to extract from his subject a visual equivalent of an emotional state, but to discover and present a revelation of fact, a record of the object's structure and significance. Such an act, he believed, would present the object not as a means to an end, but as an end in itself; it would, as Bell had written, reveal " 'the thing in itself' . . . the ultimate reality."[71] As in many of O'Keeffe's paintings from this time or Edward Weston's photographs, nature often assumes anthropomorphic forms in Strand's photographs, as driftwood and rocks, molded by the sea, assume the calligraphic suppleness and contours of knees, hair, or torsos, while the spiked leaves of plants recall outstretched fingers. Like an imagist poem, his photographs are intense, highly delineated encapsulations of a moment of experience. But though Strand made very close-up studies, the objects are never transformed into abstractions and always remain rooted in reality. Because he sought the quality of revelation, he also sought its concomitant value of timelessness. Whereas in the 1910s he wanted to show that the nature of a city was monument, change, and impermanence, here he wanted to demonstrate that the nature of nature was permanence and endurance.[72]

During these trips to Maine it also became apparent to Strand that he, like Marin, could extract details of nature that were expressive of the indigenous character of a region and that these parts, when added together, could form a portrait of a place. Tentatively expanding this idea on a trip to the Gaspé Peninsula in 1929, Strand pulled his camera back and began to investigate the relationships between man-made structures and the landscape. Whereas before he searched for rhythms within the core of a single object that addressed a universal vision of nature, now he began to look for the formal, physical, and psychological connections between disparate objects in the larger landscape that in sum constituted a sense of place. Far removed from the modern metropolis of New York City, the Gaspé provided Strand with an arena hardly touched by the twentieth cen-

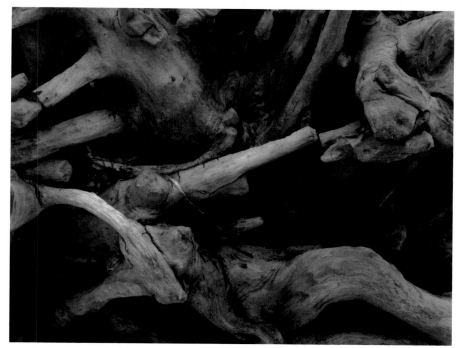

**Driftwood, Dark Roots, Georgetown, Maine, 1928*

tury, one where he could begin to address the questions of man's connection with his natural environment. His goal was not to celebrate the noble savage as the filmmaker Robert Flaherty did in *Nanook of the North*, but rather to reveal more fundamental values.

It was in New Mexico, however, in the summers of 1930, 1931, and 1932 that Strand began gradually to shift his focus from one that attempted to extract a sense of place to one that was more concerned with the broader concept of portraiture. Throughout the 1920s many of the Stieglitz artists and writers were preoccupied with the issue of portraiture, both in the specific and more universal sense. Rosenfeld's *The Port of New York*, Hartley's *Adventures in the Arts*, Frank's *City Block* or *Time Exposures*, Anderson's *Winesburg, Ohio* or *Dark Laughter*, Jean Toomer's *Cane*, John Dos Passos' *Three Soldiers* or *Manhattan Transfer*, Carl Sandburg's *Lincoln*, Demuth's poster portraits, Dove's abstract collage portraits, or even Stieglitz's composite portrait of O'Keeffe were all attempts to arrive at a new understanding of the nature of American portraiture. As Malcolm Cowley explained, these artists wanted "to portray the lives and hearts of individual Americans. They thought that if they could do this task superlatively well, their work would suggest the larger picture [of America] without their making a pretentious effort to present the whole of it."[73] Weaving together past and present, artifact and symbol, natural and man-made forms, these works attempted to construct pictures that were not only accurate portraits of specific people but also spoke to the sociological and historical factors that related the individuals to their community. Some, like *The Port of New York* or Demuth's poster portraits, purposefully strove to construct a portrait of America through a discussion of celebrated individuals; others, like *Winesburg* or *City Block*, examined the lives of common people; while still others like *Cane* or *Manhattan Transfer* were more impressionistic, lyrical records. But all were composed of smaller, separate elements, which while complete within themselves, as a whole more forcefully addressed their shared theme. They were, in short, like a series of photographs, something, as Strand wrote in 1928 of Sandburg's *Lincoln*, that "builds through the array of

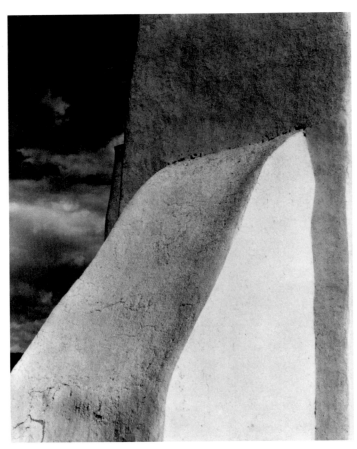

Ranchos de Taos Church, New Mexico, 1931

facts into a portrait in a real sense—And it is a portrait that reveals the organic thing Lincoln marvelously was—a beautiful single growth—like a tree."[74]

This was the kind of whole that Strand began to construct in New Mexico in his photographs of the landscape, churches, houses, and deserted buildings of the Southwest. Like so many Eastern visitors, he was enthralled by the area's extreme contrasts: of ancient religious ceremonies taking place in a plaza "full of dance halls [and] hamburger stands"; of old mining towns being torn down for tourist cabins; and most particularly by its natural contrasts of scale, color, form, even weather. Describing it as "beautiful in serenity and in violence" Strand attempted to show in his landscape photographs both the spiritual union of and the violent war between the earth and the sky.[75] But he also responded to the cultural contrasts of New Mexico: he noted, "Three distinct things are here, which interest me, besides of course the country itself—all of them really related to it—The Indian quality of life—the Mexican—and those vestiges of the white pioneer."[76] The relics of the pioneers he found most eloquently expressed in the false front buildings in the deserted mining town of Red River. Eulogizing them as the "last traces of a kind of life that once lived and lived hard in America" he wrote that these decaying buildings were "so raw and brutal, I suppose—with a dash of romantic sentimentality—but with a kind of courage and not slavish. Anyway those few false fronts, the wood rich reds or silvery from snows and rains of the years—seem to me to stand there with a kind of courage and an undeniable dignity. A false front with dignity sounds like a paradox, but there it is."[77] He found the Mexican spirit represented in the adobe buildings: "How different the house a Mexican lives in from the Mexican house a white man has taken over," he wrote to Marin in 1931. "And that Mexican spirit seems to me to have both the violence of light and of blackness in it—both things violent—and something very lovely too—like the geraniums in tin cans in the windows."[78]

Strand's portrait of New Mexico was never truly completed, however, nor was it ever intended to be understood as a portrait. In the first place, with the exception of one image of an Indian dance where he was clearly an outsider observing a very private and foreign event, he never photographed Indians. (p. 82) "I must admit" he wrote to Stieglitz, "that the Indians are not very much a part of the summer for me—I know I can't do anything for them, nor can I live with them and possibly in time get to know something about them—to penetrate that barrier that D.H. Lawrence so quickly sensed."[79] Even more fundamentally, however, beyond a few portraits of his closest friends he never photographed the people of the area. Part of a large group of artists and writers who annually descended on the New Mexican towns and villages, Strand perhaps felt too self conscious, too closely identified with casual voyeurs to allow himself to become assimilated by this native culture. Whatever the reason, he left New Mexico in the fall of 1932 without having photographed the people of the region.

Late that same year Strand left the United States to live and work in Mexico. The Depression did not severely affect him economically, but it did have profound emotional and ideological implications for him. And at the same time as the economy faltered and collapsed in 1932, so too did his marriage to Rebecca and his friendship with Stieglitz. Although he never severed all ties with Stieglitz, his departure to Mexico dramatically signalled his split from the Stieglitz group. The immediate cause for the rupture was Stieglitz's criticism of his and Rebecca's joint exhibition at An American Place in April 1932, but the roots were much deeper. By the end of the 1920s he and Stieglitz had developed into two very different photographers. The "mania for . . . self-expression," a variant of the extreme individualism that Strand found so characteristic of the modern age and the cause of many of society's problems, was by the late 1920s not only exemplified in Stieglitz's art, but the very foundation of his philosophical construct.[80] Although Stieglitz had always insisted that art must be rooted in life, intimately related to it and expressive of it, he increasingly understood "Life," as he would have intoned it, as a mystic, pantheistic force. For Strand life was a more pressing and increasingly depressing reality.

In addition, as Naomi Rosenblum has pointed out, in the late 1920s and early 1930s Strand's circle of friends expanded considerably beyond the Stieglitz coterie.[81] The critic Elizabeth McCausland and the director Harold Clurman in particular encouraged Strand's critical reappraisal of Stieglitz as well as his growing interest in contemporary politics and social issues. Complementing his idea of the multiple portrait where individual elements combined to form a more effective whole, both McCausland and Clurman stimulated his appreciation of the power of artistic, social, and political groups. Through his work with the Group Theater, Clurman showed Strand how a democratic organization of actors that did not conform to the Hollywood system of stars and celebrities could present plays that dealt with the problems of the day. And McCausland urged him to believe "in a free society, organized to permit each individual free development and yet cooperating on the basis of mutual advantage."[82]

As he moved south into Mexico, the tone, intent, and meaning of his art changed. Adopting the methods and approach of a sociologist more than a scientist, he sought revelations not so much in significant forms as in their relationships one to another and to the larger whole

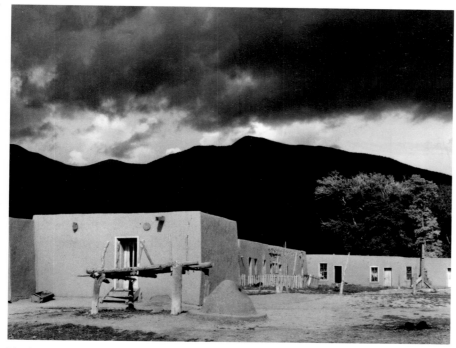

Black Mountain, Cerro, New Mexico, 1931

goal of art, which is now an expression of individualistic masturbation, should be one of beauty, of education and of battle."[86] In keeping with this philosophy of bringing art to the people, Carlos Chávez, chief of the department of fine arts in the Secretariat of Education, arranged an exhibition of Strand's photographs in the ministry of education, in a long hall that opened onto the street. As Strand noted in a letter to Stieglitz, "all sorts come in—workmen in blue jeans, women with children, government employees, 'artists,' and I presume photographers, young and old."[87]

After his exhibition, Strand traveled to the state of Michoacán and prepared a report on the arts in that region. Although specifically addressing conditions in Mexico, the report also expressed ideas that would dominate Strand's art for the next several years. Like Rivera, Siqueiros, and others, Strand firmly believed that art was not so much a result of personal temperament as a form of social expression. "Apocalyptic" artists who have "something more conscious and more symphonic to reveal" were rare, he wrote, and because the government was unable to support them when they did appear, it was unproductive and illogical to continue "educating mediocrities to fill the world with a vast lot of paintings and sculpture which have not even the value of plain usefulness." Yet, "the art impulse exists in many people," Strand continued, "a fundamental human need in a very great number to express in craft form their own perceptions and feelings." However, though he applauded the crafts, he insisted that they must be pure; freed from "the present economic system of commercial exploitation" that encouraged production of objects which had no relevance to their makers, they must spring instead from "a reverence for the elemental forces which surround [the maker] and gave him life."[88] While the crafts were created by individuals, they served, were responsive to, and molded by the needs of the society and therefore they were a direct expression of collective indigenous culture.

This indigenous culture was also the subject of Strand's photographs made in Mexico in 1933. As he had done in New Mexico, he photographed a natural landscape that was intimately reflective of the people who inhabited it—"long lived on and over by humans" as Strand wrote—but here instead of restricting himself to landscapes or vernacular architectural studies, he also made candid photographs, for the first time in seventeen years, of Indians on the streets. Celebrating their "innocence . . . in spite of continuous exploitation," Strand saw them as the visual manifestation of the nation's past: they lived, he wrote, "very much as always."[89] Shrouded in shawls or carrying pots and baskets, the Indians that Strand depicted, like those seen in Rivera's or Siqueiros' murals, assume the purity, monumentality, solidity, and elegance of classical Greek sculpture. In addition, he also photographed their artifacts, particularly their *santos*: "they are among the most extraordinary sculptures I have seen anywhere," he wrote in 1934, "those figures so alive with the intensity of the faith of those who made them. That is what interested me, the faith, even though it is not mine; a form of faith, to be sure, that is passing, that has to go. But the world needs a faith equally intense in something else, something more realistic, as I see it. Hence my impulse to photograph those things."[90]

Several years later, in 1940, Strand published a limited edition portfolio of twenty photogravure reproductions of his Mexican photographs that defined his understanding of the photographic portrait. In a carefully structured sequence he introduced his concept that the

of society. Seeking a meaningful contact with life and continually trying to define the nature and scope of that contact, he was, as Clurman noted, "at the crossroads."[83]

No one was prepared for the Depression; although many artists and writers had grave misgivings about the excesses of the 1920s, no one had predicted the utter collapse of the 1930s. Few artists suffered severe economic deprivation, yet they were among the first to ask questions. The refrain to Archibald MacLeish's 1938 poem *Land of the Free* characterized the decade: "We don't know, we can't say, we're wondering."[84] The 1930s spawned a generation that tried to answer such fundamental questions as how to preserve the basic rights of human beings to life, liberty, and the pursuit of happiness; that reevaluated what kind of government could most effectively ensure those freedoms; and that reexamined the place of art within this new, developing society. But it was also, as Cowley noted, an era that sought to restore a sense of faith, not in business or government or even so much in Marxism, communism, or socialism, as a faith in a communion with fellow man. This process of rebuilding faith was carried out not by isolated individuals but in groups. As Hoover's "rugged individualism" gave way to Roosevelt's collectivism, the motto for the age could have been, as Cowley perceptively remarked, "Not I but we; not mine or theirs but *ours*."[85]

In Mexico Strand found an atmosphere conducive to his evolving ideas and art. Slightly more than ten years after the end of the armed revolution, the country was still experiencing a revolution in the arts. Deeply committed to the aims of the new leftist government, painters such as Diego Rivera, David Alfaro Siqueiros, and José Orozco were pioneering new relationships between the state and the arts: government subsidies for artists and state-sponsored exhibitions were but two of their experiments. Like American artists and writers in the 1920s these painters wanted to embrace their racial past, giving art the social meaning, economic purity, and function it had in pre-Hispanic times. But they also added a radical edge, insisting that "the ideal

sense of a place—its spirit or its ineffable essence—was composed of the sum of its constituent parts. Strand's portrait of Mexico was established in his opening sequence of four photographs: the first image was a landscape of cactus, scrub brush, and adobe buildings in the distance, followed by a photograph of a gateway to a church (p. 98), next a *santo*, and finally a group of Indian women (p. 94). It is a sequence that owes much to his work in films. The first image serves as a location shot to establish the region; the second describes the more specific physical structures; and the third reveals the major characters. For Strand it was this mixture of nature and people, their artifacts and vernacular architecture, that formed a portrait of place. But Strand's intention was not just to describe a sense of place; rather, he believed that the fundamental truths he revealed about an undeveloped society's need for community, religious faith, and contact with nature were truths that could also be applied to more advanced technological societies. In much the same way that James Agee and Walker Evans went to rural Alabama to document the lives of American families, so too did Strand focus on a rural Mexican culture whose values had not been obscured by the technological cacophony of the industrial age. In doing this he hoped to reveal basic principles about the relationships of people to their natural, social, and religious environment.

With its wide-ranging interest in the arts, the Mexican government asked Strand in the fall of 1933 to direct a series of films. Initially uncertain whether he would be able to fill their needs both technically and logistically, Strand was nevertheless challenged by the opportunity. He later recalled that he quickly decided the first film should be for the nation's sixteen million Indians; that without speaking down to them or sentimentalizing their situation it should dramatize their struggles. Although the film was rooted in the life of Mexico's fishermen "as it exists today," Strand wanted to address issues of importance "to the lives of people everywhere. That is, give the local drama a wider significance, and still keep it dramatically true."[91] Although he had been strongly influenced by Flaherty's *Nanook of the North* and *Moana*, Strand consciously set his film in opposition to several of Flaherty's fundamental principles: his film, he told the department of education, would not generalize his subjects as Flaherty's did, but individualize them; he would not depict the heroic struggle of man against nature but man against a corrupt society; and he would not let his subjects merely adapt to their surroundings as Flaherty had done, but empower them to recognize their problems and act to change them.[92] Originally titled *Pescados* (Fishermen), released in Mexico as *Redes* (The Nets), and titled *The Wave* when it was shown in the United States in 1937, this film was produced and photographed by Strand (with the exception of a few scenes filmed by Henwar Rodakiewicz and Fred Zinneman), and he also wrote the script with Chavez's nephew, A. Velazquez Chavez. Wanting to impart the authority of actual experience to his cast, Strand, like Flaherty, tried not to employ actors but instead had the people of the village of Alvarado play themselves. (The two exceptions were the lead fisherman who was a university student and the fish merchant who was a professional actor.) Using a Marxist dialectical structure that contrasted the poverty of the fishermen with the greed and corruption of the fish merchants and politicians, the film showed the peasants' struggle for unification and their revolt against their oppressors.

As a film it is far more sophisticated, sure, and tightly integrated than *Manhatta*. Throughout the twenties Strand had continued to make commercial films, perfecting his skills and integrating the ideas of avant-garde Russian filmmakers. He exploited Sergei Eisenstein's concept of montage to great advantage. He used a montage of action, that is, multiple shots that break a scene down into component parts, in order to increase visual and emotional tension, and he used a montage of objects, abrupt cuts from one object to another, to imply a relationship or establish a sense of conflict. In addition, *The Wave* consciously echoed Eisenstein's *Potemkin* in several places: it has been noted that Strand broke down a fishing scene into one hundred shots, the same number used to construct the scene at the Odessa steps.[93] Symbolizing the growing revolution, Eisenstein began *Potemkin* with a wave crashing on shore, while Strand ended his film with the same image. The photography of *The Wave* was, as many critics noted, very well crafted. Frequently using an upward angle that became typical of much American documentary film work in the 1930s, Strand often isolated the heads of his cast, emphasizing their classic and heroic proportions. While far more panning and movement of the camera appears in this work than in *Manhatta*, because Strand lingered over static shots of posed figures, the film has a tendency at times to seem like a series of compelling but nevertheless still photographs—an extended portfolio—rather than a film of movement.

Strand returned to New York in December 1934 after the new Mexican government withdrew the funding for his series of films. In contrast to the "boisterous individualism" of New York in the 1920s, where, according to Clurman, "everything and everyone whizzed by on an isolated, trackless course . . . a world of fireflies charting itself as a constellation of planets," Strand found a city coalesced by its troubles.[94] Artists' groups, film groups, theater groups, labor and trade unions, and every form of political organization abounded as people recognized their interdependence, their need for a shared faith and cooperative action. Attracted to their commitment to produce plays that dealt with topical issues and their attempt to bind individual work into a collective endeavor, Strand became involved in Clurman's Group Theater and met Clurman and others in Moscow in May 1935.

But it was with the Nykino film group, a splinter organization from the radical New York Film and Photo League, that Strand found his most productive association, one that allowed him both to document the conditions of his time and also to experiment with his means of doing so. Although many of the Nykino members, including Leo Hurwitz, Irving Lerner, and Ralph Steiner, were younger and less experienced than Strand, he shared with them a recognition of the seductive power of film to influence public opinion and correct social or political injustices. As Hurwitz explained, "You're trying to alter people's consciousness by dramatizing real experience, clearing away distortions so that they begin to see events in a way that has some truth to it. Action may then follow in the specific contexts of people's lives."[95] But Strand, like Hurwitz and Steiner, also insisted that art could not be made secondary to content: as Steiner explained, "Filmmakers must keep in mind that the statement 'there is no art without propaganda' is also true in reverse: *there can be no effective propaganda without good art*."[96] Through the research Nykino conducted on "the esthetic of photography, editing, commentary and the relationship of the word to the picture, sound effects and music," the group believed, as Strand asserted a few years later, that "the arts of the poet, the actor and the composer [could join] hands with documentary film techniques."[97]

Strand, Hurwitz, and Steiner tested these ideas in 1935 when they

*Man with Sombrero, Mexico, 1933

worked for Pare Lorentz on *The Plow that Broke the Plains*, the first documentary film financed by Roosevelt's Resettlement Administration. Their stated task was to create a film about the causes of the great Dust-Bowl. Their aesthetic challenge, however, was far more complex. Because they were making a documentary film that by its very nature did not have a plot or characters with which the audience could identify, they had to devise new methods to evoke a sense of empathy and convince viewers of the truthfulness of their argument. They did this by creating the equivalent of a plot through contrasts of images and ideas, for example, scenes of plenty set against scenes of want. But midway through the project Strand and Hurwitz, and to a lesser extent Steiner, had a falling-out with Lorentz. Although they continued to do most of the filming, it was Lorentz who was responsible for the film's editing, its effective integration of visual images, music, and narration, and ultimately what has been called its "thoroughly patriotic" tone. As William Alexander has noted, the films of Nykino, although equally didactic, were far less optimistic, far less confident that all life's problems could be so easily solved, and far more serious and tough than those produced by Lorentz.[98]

It was because of this experience with Lorentz that Strand, Hurwitz, Steiner, Lionel Berman, and others formed Frontier Films in March 1937. They wanted to combat the power Hollywood held over the American imagination, and particularly its perpetuation, as James Rorty noted in 1936, of "this where-life-is-better daydream," and "our lazy, irresponsible adolescent inability to face the truth or tell it."[99] Dedicated to making films "that truthfully reflect the life and drama of contemporary America," Frontier Films proclaimed in its founding manifesto that it would wield the "enormous power [of film] to mold the minds of the nation . . . consistently on the side of progress." It

offered to produce feature films, documentary and dramatic shorts, and newsreels for all "progressive organizations and agencies in all fields" that were fighting for social and economic justice.[100]

Although Frontier Films produced several films in the five years of its existence, including *The Heart of Spain*, *China Strikes Back*, *Return to Life*, and *People of the Cumberland*, its most ambitious effort and one that Strand was intimately involved with was *Native Land*. Made between 1938 and 1941, the film was based on a report of the La Follette Senate Committee of the denial of civil liberties to labor activists in the 1930s. But in actuality it aimed to address both ideological and aesthetic issues far beyond that specific report. The film demonstrated that although the basic civil rights of all Americans were guaranteed under the constitution, each generation had to fight to prevent infringements on those liberties. Because of the problems inherent within the nature of a documentary film—that "the very stuff of reality" does not have, as Strand noted, "the emotional impact and the dramatic tensions which are implicit in this realism"—Strand and Hurwitz had to create a new kind of film in order to inject these elements into their filmic structure. They did this through the use of a "contrapuntal progression." Weaving together a series of stories and accounts of real incidents, they repeatedly contrasted the idea of freedom with the struggle to preserve it. To bind the "large social design with the human details," as Hurwitz phrased it, they also found it necessary to use various different kinds of film: footage that they shot of actual events, newsreel footage, even still photographs were combined with a number of reenacted story sequences that used both professional actors and laymen. Noting the aesthetic difficulties they had in making sure that these reenacted scenes had "the same character of realistic document . . . inherent in the newreels [sic] and other documentary material," Strand asserted that it was in these scenes which move in and out through the whole film, that an attempt was made to give greater impact to the meaning of events and ideas."[101] The filmmakers interwove music, narration, and dialogue with the visual structure to intensify further their arguments and to heighten the viewer's emotional response.

Fundamental to both the structure of the film and its ideological premise was the idea that the "larger event," as Hurwitz termed it, was "not evident in particular episodes. . . . The idea of the film and its dramatic growth are built on the principle that these individual events by themselves are not understandable. It therefore forces you into building up the larger event."[102] In short, *Native Land* was composed of separate elements that combined to form a work whose meaning and implications extended far beyond the sum of its constituent parts. Using words, images, music, and editing, Strand had dramatically enlarged his understanding of how to construct a portrait of an age or place. In addition, however, he also propelled his filmmaking from photographic to cinemagraphic; that is, he no longer strung together a series of still photographs or used a conventional story line with a linear progression through time, but instead he and Hurwitz created a synthetic whole.

Native Land was made at a tremendous cost, however. Frontier Films began work on the project in 1938 with only $7,000 out of a projected need of $40,000. Throughout its existence the organization paid meager weekly salaries but was unable to meet the payroll several times.[103] Another problem was that the process of making the film pointed out a serious ideological conflict within the group between the desire for self-expression and the need for solidarity. With its heri-

Mr. Bolster, Vermont, 1943

Englanders from the seventeenth to the twentieth century, while Strand photographed the region. Their challenge, as Newhall perceived it, was to create "a new form" to join "the words of the eyewitnesses" with the photographs, "so each would expand and clarify the other. . . . Our purpose has been to create a portrait more dynamic than either medium could present alone."[106] The result, *Time in New England*, was finally published in 1950 with 106 photographs by Strand and more than one hundred excerpts from such New Englanders as Cotton Mather, Samuel Adams, Nathaniel Hawthorne, Sarah Orne Jewett, and Van Wyck Brooks.

Their book was about the past: Strand's photographs of eighteenth- and nineteenth-century churches, town halls, cemeteries, weathered buildings, and even his studies of trees, rocks, and people, all seem to bear both the weight and authority of the past as well as its sense of endurance. However, to criticize *Time in New England* as a retreat from contemporary industrial society is to ignore the historical circumstances that propelled its creation.[107] For this book is not so much an escape from the present as an attempt to come to grips with it and with the profound, pervasive horror of the Second World War. In the midst of the utter insanity of Nazi concentration camps, the atomic bomb, and the growing cold war, it was an effort to find, reveal, and most important, to preserve enduring values. "I wanted to look with vivid and intimate clarity into the past," Newhall wrote, because "in those cadences was the sound of the sea and in their thought the germ of the nation." Strand too insisted that "here in this region, in these six states of the Union, were born many of the thoughts and actions that have shaped America for more than three hundred years." As he had done first in the Gaspé, then in New Mexico, and Mexico, Strand purposely sought images that were not reflective of a specific time but rather related to the larger, more universal character of the region. "I was led," he wrote in the foreword, "to try to find in present day New England images of nature and architecture and faces of people that were either part of or related in feeling to its great tradition." His photographs speak of the spiritual and moral wholeness of New England, of its peoples' interaction with nature, their simplicity, and most of all their religious faith. Dedicated to "the spirit of New England which lives in all that is free, noble, and courageous in America," it was an attempt to restore a sense of order and faith, when all faiths and particularly Strand's had been shaken to the core.[108]

The late 1940s and 1950s severely tested many liberal and radical artists and writers. All that they had placed their faith in—whether it was Marxism, communism, or socialism—was now widely discredited and openly under attack. Disillusioned by the Soviet Union's explosion of an atomic bomb, its expansion into Korea, and its brutal repression of the Hungarian revolution, they also felt betrayed by their own country—by the government's support of reactionary regimes in Greece or Turkey, for example, or the Truman Doctrine and Marshall Plan that validated the United States' economic and political influence on the internal affairs of other nations. And these artists and writers were betrayed by what now seemed to be the naive belief they had held in the 1930s that sweeping social and economic reforms were possible. Even if they were not personally criticized by the far right or under investigation by the House Committee on Un-American Activities, their past art, because of its strong social and political statement, was suspect, "smeared," as Strand wrote, as "various shades of New Deal communism."[109] The problem of how to create art within this

tage from Nykino, Frontier Films had been founded on a dual premise of both the need for artists to experiment to find the most effective means of addressing the issues of their time and the idea that individuals should and would willingly contribute to the collective efforts of the group. Nevertheless, despite considerable contributions from Ben Maddow, Lionel Berman, and Sidney Meyers, *Native Land* was essentially Strand's and Hurwitz's film; it was the result of their creative effort and the other members served their creative goals. This too caused considerable stress. Finally, as William Alexander has noted, the members' politics began to diverge during the project, as some continued their strong support of the Soviet Union even in light of the Moscow purge trials and the Nazi-Soviet non-aggression pact, while others grew disenchanted.[104]

By the time *Native Land* was released, the Japanese had bombed Pearl Harbor and labor and capital, no longer fiercely opposed as they had been during the 1930s, were now united in the World War to fight fascism. *Native Land* was praised in the press but its message seemed curiously dated. As the pressing social problems of the 1930s were buried under the clamor to support the Allied cause, Frontier Films also lost its impetus and ceased to exist after 1942. Strand briefly made films for the Department of Agriculture and then after a hiatus of several years returned to still photography.

In 1943 Strand went to New England to photograph, no doubt stimulated by his work there during the filming of *Native Land*. In 1945, after Nancy Newhall organized a retrospective exhibition of his photographs at The Museum of Modern Art, she suggested that they collaborate on a book about New England, "a portrait shown through the great underlying themes of social and cultural development."[105] Over the next few years Newhall selected a series of writings by New

Between Rimini and Borgo San Sepolcro, Italy, 1952

atmosphere of mistrust, fear, and persecution was profound. Some capitulated, renouncing their former works and associations; others could not. As Hurwitz eloquently explained, once one sees how inextricably linked one is to one's environment, once one begins to question economic and social relationships, "Well, now you have 'dangerous thoughts' in your head. The FBI, your neighbor, the Un-American Activities Committee, your colleagues, the newspaper, radio, TV may label them 'red.' But the empathy you have discovered, your connections with others, is real, to be denied at the risk of losing much of your humanity."[110] It was no good trying to say, as Strand wrote, "'Please, I am a good boy.' It won't do any good . . . As soon as [the artist] stops telling the truth, he ceases to be an artist."[111]

For Strand the solution lay in a transposition from the specific issues that had concerned him in *Native Land*, for example, to the universal, from a concern for the humanity of the poor or oppressed to a concern for the humanity of man. Others made this same transition, as a deeply felt sense of humanism, exemplified by the legendary photo essays of W. Eugene Smith or the more optimistic 1955 exhibition *The Family of Man*, pervaded the decade of the 1950s. *Time in New England* suggested some of the ways Strand in particular would make this transition. Near the end of the book are two letters written by Sacco and Vanzetti in 1927 and 1928 that not only foreshadow events in the 1940s but also indicate the direction Strand's art would take for the rest of his life. Each addressed the issues of spiritual transcendence and moral responsibility. Sacco, in a letter to his son, urged him to seek solace in nature, while cautioning him to "help the weak ones that cry for help, help the persecuted and the victim." After receiving his sentence Vanzetti wrote, "Never in our full life could we hope to do such work for tolerance, for joostice [sic], for man's understanding of man as now we do by accident." His death, he believed, would be the affirmation of his life: "this is our career and our triumph."[112] It was this heroic endurance and triumph of the human spirit, rooted in the conviction of the past and the strength of nature, that would be the subject of Strand's art after 1950.

In the late 1940s his second marriage to Virginia Stevens dissolved, and, unable to work in the increasingly hostile environment of McCarthyism, Strand moved to France in 1950. Aligning himself with the common man, he attempted to extract what he called a "dynamic realism," a "truth which sees and understands a changing world and in turn is capable of changing it, in the interests of peace, human progress, and the eradication of human misery and cruelty, and towards the unity of all people." In the European photographs he made in the 1950s and 1960s he purposefully avoided the negative aspects of life. Addressing a film conference in 1949, he said, "If everything was rotten and hopeless in the world, why make films at all?" Instead he wanted to show "what is healthy and growing in society . . . stories of human victories, however small, in the struggle for social health and well-being," and he wanted to do this by focusing on one village.[113]

Initially he and his third wife, Hazel Kingsbury, traveled all over France looking for a village. Although unsuccessful in locating any one place, Strand was nevertheless satisfied enough with his photographs to publish them in 1952 in *La France de Profil* with a text by the poet Claude Roy. But it was in the following year in Italy, in the "completely *non* picturesque" town of Luzzara, that Strand found his village.[114] Collaborating with the noted filmmaker Cesare Zavattini, he published the result, *Un Paese*, in 1955.

Strand conceived of *Un Paese* as a verbal and visual extension of Masters' *Spoon River Anthology* and Anderson's *Winesburg, Ohio*. Drawing on his years as a filmmaker, he saw his images as the foundation of his project, but he also was acutely concerned with the sequencing of the photographs and their integration with the accompanying texts. "We should not see people as [a] simple single situation," he declared, but in "the complexity of living."[115] To create this whole he adopted Emily Dickinson's credo "My business is circumference." "It is a magnificent statement of Emily Dickinson's," he wrote, "one I concur with completely. For I think it is in the total aspect, the total form that one finds the essential character of things and people."[116] Through his sequencing of photographs he constructed a series of concentric circles around the town of Luzzara, first defining the land surrounding the town, then the town itself, and finally concentrating on the people. Contrasting long shots with small details, he created a sense of filmic montage, movement, and progression. His pairing of images alludes to the formal, physical, and psychological relationships between the people, their artifacts, their homes and places of work, and most particularly, nature.

For the first time in his career, Strand saw portraits as the heart of his statement. Before moving to Europe his portraits were either made surreptitiously, as in Mexico where he used a prism lens, or they were of people he knew. A reserved individual, Strand clearly found it somewhat difficult to solicit the cooperation of unknown people. But this changed as he began to construct a working relationship with Hazel Kingsbury, who was herself a photographer. Hazel, who Strand said could "talk to a cannibal," would establish contact with the people Strand wanted to photograph, putting them at ease, while Strand was setting up his large, awkward equipment.[117] With a rapport thus established, Strand could concentrate on recording the image and expression he desired. In his Italian portraits Strand did not strive to show a fleeting "decisive moment" or even a candid expression. Rather, he wanted to transcend time and distill in one image all the episodes, events, and relationships that combined to form the character of his subjects and revealed "the core of their humanness."[118]

Rushdie Abdul Salan, Helwan, 1962

The Docks, Romania, 1967

Because he regarded the common objects of life—tools, pots, furniture—to be telling indexes of indigenous culture, Strand photographed them with the same reverence that he did the people of Luzzara. Both are depicted against clean, simple backgrounds, removed from distracting intrusions, and presented calmly and confidently to the camera, as if certain that their integrity and spirituality would be respected. Although Strand made a few photographs of group scenes, he rarely showed people interacting. Instead the individuals, as in *Lusetti Family, Luzzara, Italy,* often seem lost in a world of their own thoughts. (p. 129)

It is Zavattini's text that explains this sense of introspection. A member of the neo-realist movement in Italy after the Second World War, Zavattini wanted to explore the emotions of the mundane events of human life. He told an interviewer in 1952, "The old realism didn't express the real. What I want to know is the essence, the really real, the inner as well as the outer reality."[119] For *Un Paese* he interviewed the people of Luzzara, recording their stories in their own words. Although the twentieth century rarely intrudes into Strand's photographs—he does not show the mopeds or movie theaters, neon lights or new roads that were rapidly transforming the village—Zavattini bluntly records its presence. Many of the texts speak of the villagers' experiences during the war, telling simple but poignant details of physical and emotional suffering caused by a conflict they neither supported nor fully understood. Yet within their accounts of husbands and sons beaten or killed, destruction and poverty, there is also a sense of endurance, what Zavattini called confidence, that is in itself a triumph.[120]

When Strand remarked that he saw *Spoon River* and *Winesburg* as the antecedents of *Un Paese,* he was referring not only to their structure and nominal subject but also to their intent. The basic premise of both Masters' and Anderson's works was that because people have been unable to express themselves they have been unable to communicate with each other. Both saw the writer as the voice of the inarticulate, whose task was to reveal the inner lives of their subjects to themselves and their community so that they could know themselves and reestablish their contacts with mankind. With his belief in the revelatory and redemptive power of art still intact, Strand saw his role as a photographer in the 1950s in much the same light. A series of photographs that focused on the history, architecture, environs, and people of a small town would reveal "the common denominator of all humanity," he wrote in the early 1950s, and would be a "bridge toward a deeper understanding between countries."[121]

Strand continued this work in 1954 when he traveled to the Hebrides. In much the same way that Peter Henry Emerson had almost seventy years before documented the people of the Norfolk Broads, recording their history and dialect, details of their personal lives, and facts about their economy, so too did Strand in collaboration with Basil Davidson describe the community of South Uist in the publication *Tir a'Mhurain.* His photographs of the rugged inhabitants of this island as well as his sequencing of the plates firmly connect the people with their artifacts and environment and owe much to the lessons he had learned while working on *Un Paese.* But *Tir a'Mhurain* takes a stronger stance against the economic destruction of rural societies. "It is not too late," Davidson warned, "to ensure that this courageous, cooperative community exists as a viable alternative to urban, industrial society." But action must be taken soon, he concluded, otherwise this "land of bent grass . . . land where everything is plentiful" would "remain a dream of olden times."[122]

Despite its militant tone, by the time *Tir a'Mhurain* was published in 1962, many of the issues it elucidated and the virtues it celebrated seemed out-of-date, as the humanism of the 1950s was replaced by a skepticism and sense of malaise in the 1960s. Strand was deeply affected by a pervasive sense of change in the 1960s. During this time

he was increasingly interested in ancient cultures, such as those of Egypt, Romania, Morocco, and Ghana, which were facing monumental transformations. Caught in the throes of economic, social, political, and technological revolutions, the people of these countries were radically changing not only their perception of their country's position within the world community, but also their perception of themselves, their relationships to one another, to their environment, and to technology. Recognizing that any statement about such volatile societies would be, as he and James Aldridge wrote in the introduction to *Living Egypt*, "already past history tomorrow," Strand wanted nevertheless to document the foundation in the country's past that was actively forming its present.[123] Consistent with his vision of the last few decades, he did not depict urban centers, nor did he show the effects of poverty or disease, but instead he again focused on the people, their artifacts, their religion, and their physical surroundings. However, far more than in his photographs of the 1930s, 1940s, or early 1950s, these later works from 1958 to 1969 admit and celebrate a sense of change, even a sense of chaos. Reaching back to his work from the early 1920s, Strand photographed the gleaming new industrial structures—the dams, hydroelectric plants, and oil refineries—that were propelling Egypt, Ghana, and Romania from agrarian, rural societies into the twentieth century. His sequencing of photographs in *Living Egypt* or *Ghana*, pairing the massive new structures with the people who built and operated them, clearly demonstrated his faith in the ability of man to use technology for his betterment.

Many of Strand's photographs from the 1960s are more scattered and complex than most of the work that immediately preceded them. Using a two and a quarter inch camera he began to photograph market places and other scenes that were far more fluid and transitory than his earlier subjects. Instead of the tightly composed, closed compositions that had typified his earlier work, in many of these later photographs objects intrude at the edges of his images and people are frozen in the act of moving, talking, and gesturing. Challenging him to extract an order from a rapidly changing situation, these photographs, like his earliest views of New York, manifest his desire to express the dynamism and vitality of these societies. These cultures were not just relics of the past living in the present, as the Hebrides was, but places that were, as Strand and Aldridge wrote, at one and the same time "incredibly old" and "exhilaratingly young," that were "transforming, painfully and with great difficulty, what is already there."[124]

In the introduction to one of his last publications, *On My Doorstep*, Strand described himself as fundamentally "an explorer who has spent his life on a long voyage of discovery."[125] Writing about that voyage, he also noted that he once believed that the only way an artist could continue to develop throughout his career and reinvigorate his art was by challenging and expanding his experiences. Strand recounted that, like an explorer, he had spent several decades making both physical and aesthetic explorations, challenging himself to investigate new subjects and new methods of expression. These expeditions had led him not only to experiment with filmmaking and book production, but they had also taken him to new and often distant lands. Yet in his later years, plagued by ill health and poor sight, Strand recognized that he was unable to withstand the rigors of such travel. So he photographed what was on his doorstep, transforming his physical handicaps into an aesthetic challenge. He chose to depict the garden at his home in Orgeval, France, that Hazel and their

Columbine, Orgeval, 1974

housekeeper, Hélène LaTutour, had patiently nurtured and gradually transformed from a relic of the former tenants to something distinctly their own.

Strand's photographs of the garden's flowers and vines display the same complexity that is seen in his later images of markets or street scenes. But there is much more to these photographs than that. Throughout his career Strand had endeavored to reveal those elements that together gave a place its special character; with his individual photographs, but particularly with his films, books, and sequences of photographs, he had wanted to construct, as he wrote in *On My Doorstep*, "the composite whole of interdependencies" that constituted a sense of place.[126] This effort was based on his adamant belief that man molded his architecture, his tools, and even his natural environment so that, through time, they became a reflection of a collective personality—the spirit of a place. In such larger portraits as *The Mexican Portfolio* or *Time in New England*, the past had merged with the present, suggesting the collective, indigenous character that would form the future.

In his last years, he made portraits not of the world at large, but the microcosm of his garden. Like Stieglitz's later photographs of Lake George or Edward Weston's late studies of Point Lobos, these last images Strand made are portraits of his life, his home, and his family, showing that composite whole of interdependencies. They are deep and dense, but not dark images, complex but not cluttered. Combining delicacy with strength, they speak not of an angst or fear of impending death, not of a desire to control and order, but rather of an acceptance, of a celebration of what is, and finally of a sense of transcendence. They were, as he wrote a few days before his death in 1976, another "expedition into the unknown."

THE TWENTIES

314 West 83rd Street
New York City
July 20, 1920

My dear [Sherwood] Anderson:

Since seeing your water colors at Stieglitz' studio, I have come to know "Winesburg, Ohio," and it has given me a still greater sense of a spirit, actively strong and sensitive, penetrating thru the crassness and brutality of the American scene, to a new beauty.

Winesburg came at a time when I needed again, some clear assertion of the spirit which opposes itself fearlessly to the increasing ruthlessness of the material drive. There are moments (perhaps we all have them) when the seeming futility of any expression, comes upon one like a thick fog, in which past and present and future are apparently blotted out. Not long ago, I said to Stieglitz that I thought that of all mediums, photography was the most diabolical, for the reason that one knows beforehand that the thing done, will function to an even lesser degree than any other form of expression—and he agreed.

Nevertheless, one goes on, trying to satisfy that curious thing inside, which, with me, is forever trying to project itself in terms of a metal image upon paper. And I just want to tell you that you—your work—have given me more faith and new strength. If there is a hope in America, what you are doing is most surely a part of it—

I am asking Arthur Dove to forward this to you, as he will probably know your address—

Faithfully yours—
Paul Strand

51 *Rebecca, 1922*

*Alfred Stieglitz, 1922 52

53 *Rock, Port Lorne, Nova Scotia, 1920*

*Driftwood, Maine, 1928 54

55 *Toadstool and Grasses, Georgetown, Maine, 1928*

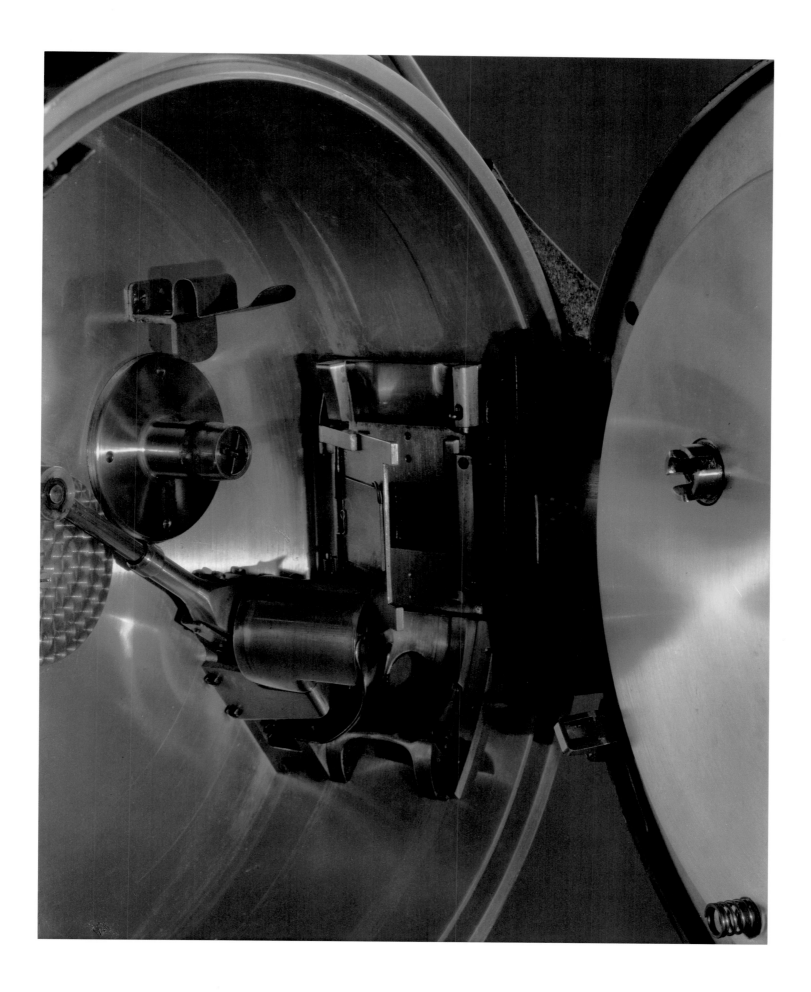

57 *Akeley Motion Picture Camera, 1923*

*Apartment Repainted, New York, 1925 58

59 *Truckman's House, New York, 1920

*Lathe #1, New York, 1923 60

61 *Rebecca's Hands, 1923*

*Woods, Maine, 1927 62

63 *Rebecca, 1923*

Estes Park, Colorado
Tuesday, July 13, 1926

Dear Stieglitz—

How are you and Georgia? It is less than two weeks since we left NY but we have heard from no one—we had no forwarding address until we came here and so the few weeks seem ages—NY—a distant and disagreeable ant heap—everybody crawling over each other—Perhaps I insult the ants—

You—your spirit—is an entity—the paradox that makes NY living—and it is never distant—For as one travels away from NY one is always finding potentially—NY—its deadness and cheapness—standardized mediocrity—in towns and towns trying to be cities. Coming up the wonderful Big Thompson Canon from Denver to Estes Park—towering rock mountains—through which a flying stream and the road wind tortuously—hot dog stands at intervals—and bungalow shacks with names of Wanda Inn—Grandpa's Retreat—etc, etc.—I am sure the Americans have already introduced Coney Island into heaven—it would take more than God and all the saints to stop em.

But here the mountains are untouched—pure and wonderful—great. Ever since we saw them—we have both felt—that this is Marin's country—he belongs here—Not the Canadian Rockies but these American mountains—entirely different—and closer it seems to me, to him. If he never comes out here, it will be a real loss. The variety here is infinite—snow mountains—great towering rock hills—pine covered moraines—and in between meadows of exquisite greens, pine dotted.—When I think of the Canadian mountains—I think of snow—aloof, almost oppressive in their aloofness. Here the approach to snow is less abrupt—yet not less big—closer somehow to human experience—Georgia knows this country and I think she will agree with what I am rather vaguely trying to say about it.

Beck is out in front of our little cabin—sunning herself—resting. She is not fit yet but some of the dragged out exhausted feeling is going. It is a slow process and after what has happened in the family—the two brothers—the effect that has had on her mental health—I know it is going to take time—I only wish we could be here in the West a year at least. She perhaps can stay in Santa Fe when I go back. These places in the mountains close in September.

I do hope that you are having quiet on the Hill and that the pain of the past weeks has given way to a new well being and returning strength—And that Georgia did not lose what she had so wonderfully gained during the Winter. Our love to you both—

As always—
Strand

65 *Wild Iris, Maine, 1927*

67 *Rock, Georgetown, Maine, 1927

GASPÉ

September 11, 1931

Dear Mr. [Samuel] Kootz:
 . . . It seems to me that, with few exceptions, (Marin's statement in Creative Art a few years ago being a notable one) the worker in any medium seldom says anything revelatory about the essential spirit of his or her work. What they say is most frequently misleading except to those who take the trouble to check against the work itself and know how to read between lines—critically. Artists tend either to think out loud about their technical problems, which sounds important to many who so take them to be the end-all and be-all of a work of art; or pressed for the "meaning," the artist frequently erects some romantic "philosophy"—some elaborate and misleading rationalization. Possibly one reason for this is that the creative process involves a balance between conscious and intuitive elements, and a critical analysis of the artist's own spirit by himself upsets the balance.
 At any rate, it seems to me to be the business of the critic and not the artist, to get through the latter's work, directly (and the public as well really) at the artist's essential attitude not towards his medium but towards his world—life itself. When I look at a painting, a photograph, hear music, read a book, that is all that interests me; what living meant or means to the person who made this thing—not so much how, but why, they made it; whether the thing made is product of their own vision; their own particular truth. If so, then what the essential qualities of that vision [are], and to what extent have they become embodied.
 Photography, so far as I am concerned, is a medium which for some reason I love to work with, which is part of my bones. In common with other media, no doubt it has its potentialities and its limitations. About its limitations in any absolute sense, I know nothing. About its potentialities, I know what it absolutely has said in the hands of fine spirits like D.O. Hill and Atget, at the service of a really great and profound one like Stieglitz. I know, in short, that it can be made the means of an utterance as clear, as grand and as alive as any I know of in the world's art. Camera materials, paint, clay, words, all are what they are— material—until they fall into the hands of someone who having lived deeply and beautifully, utilizes them as a craftsman, to put that living into form as vision, as song, as some kind of clear saying. . . .
 Thanks for your good wishes to us. The summer has been a fine one and I hope it has been so for you.

Sincerely,
Paul Strand

69 *White Shed, Fox River, Gaspé, 1929*

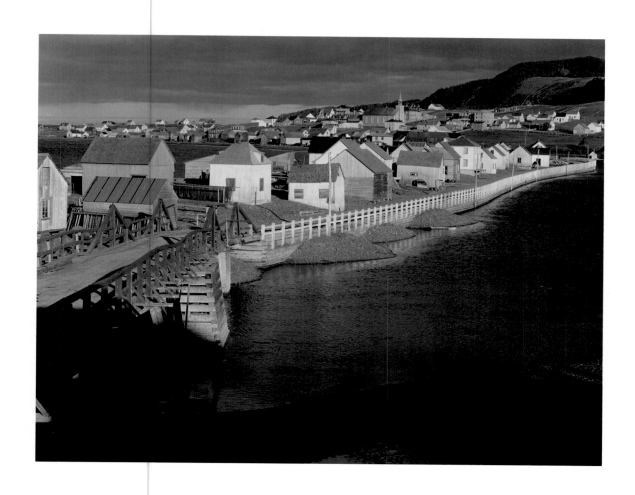

71 *Fox River, Gaspé, 1936*

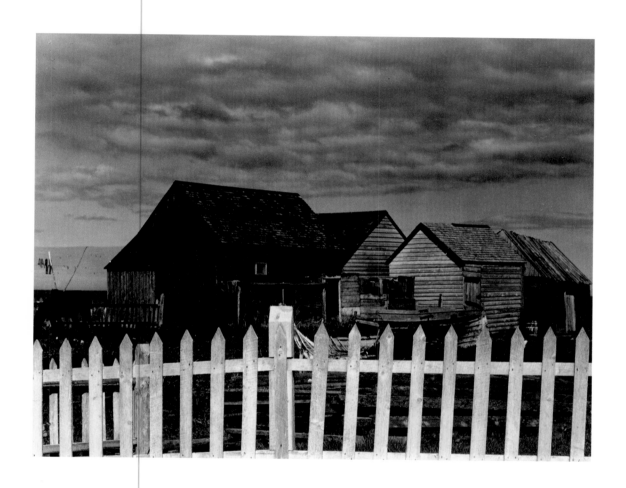

73 *Fence and Houses, Gaspé, 1929

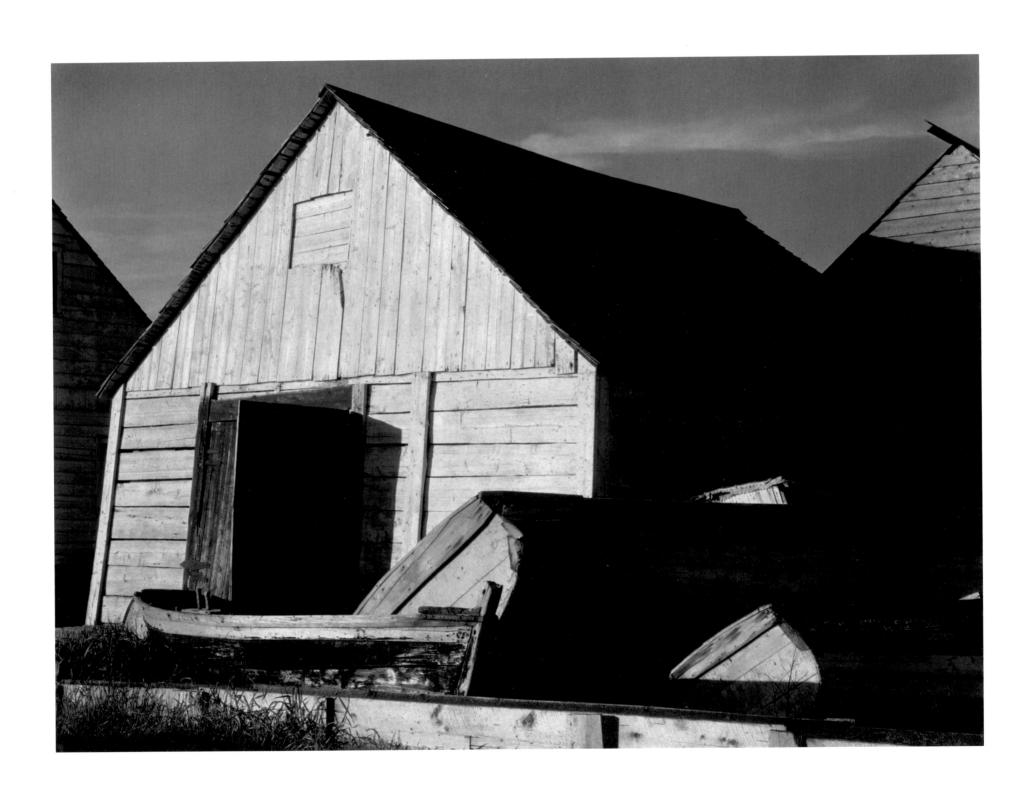

75 *Fred Briehl's Barn, Wallkill, New York, 1936*

NEW MEXICO

Taos, Box 343
July 29, 1931

Dear Herbert [Seligmann]—

 The brilliant New Mexico morning—big white clouds looking towards Ranchos. Lisa the Indian girl who helps us has just come from the Pueblo—that bright stillness over everything— You know it—Morning like this, after morning—follows with an occasional storm during the day. But there has been little rain so far and it is much needed—The other evening there was a cloud burst over U.S. Hill and for the first time I heard the roar of a wall of water, which is, they say, at times six feet deep. Sounded like steady thunder as the black area of the rain, clearly defined as tho cut with a knife, moved inexorably across the land until it disappeared amid lightning behind the mountains, leaving stars behind—And we got but a few black drops. But there is still a month more of rainy season—and I guess, August will bring those violent storms here, that make you keep one eye on the horizon, wherever you get off on dobé roads, that become a slough in two minutes—Mrs. Marin used to keep both eyes peeled—. . . .

 Again this year, I have my darkroom over the movie theater, with running water and electric light, quite perfect for my needs—It was a bit slow getting started (that first excite-ment of last summer doesn't happen twice) but I think I am on my way now, with a few things so far that I like—Though working this summer, I find myself much more sensitized to the Mexican spirit, which lives here darkly under the brilliant light—related too to the spirit of the country itself, yet quite different from the Indian—And how subtly different the house of a Mexican in which he is living—and the Mexican house which a white man has bought and "fixed up," how unsubtly different the dobe houses the white man builds—Three distinct things are here, which interest me, beside of course the country itself—all of them really related to it—The Indian quality of life—the Mexican—and those vestiges of the white pioneer, the false front houses of the mining towns at Red River and the Merino Valley— are being torn down for lumber to be used to build tourist cabins—Did you ever get to Red River when you were here? It is on what is called the circle drive—on which you go out of Taos by one road and come back 100 miles by another—The old couple who run the hotel at Red River tell of the old days when there were fifteen saloons and the people eight deep in the gambling joints trying to get their money on the table—and "everybody had money." Well, I would like to have seen that town in its heyday and that lopsided life—so raw and brutal, I suppose—with a dash of romantic sentimentality—but with a kind of courage and not slavish. Anyway those few false fronts, the wood rich reds or silvery from snow and rains of the years—seem to me to stand there with a kind of courage and an undeniable dignity—A false front with dignity sounds like a paradox—but there it is. Are the rains and snows entirely responsible for its quality of life? I don't believe it—. . . .

As always,
Paul

77 *Near Abiquiu, New Mexico, 1932*

79 *Ranchos de Taos Church, New Mexico, 1931

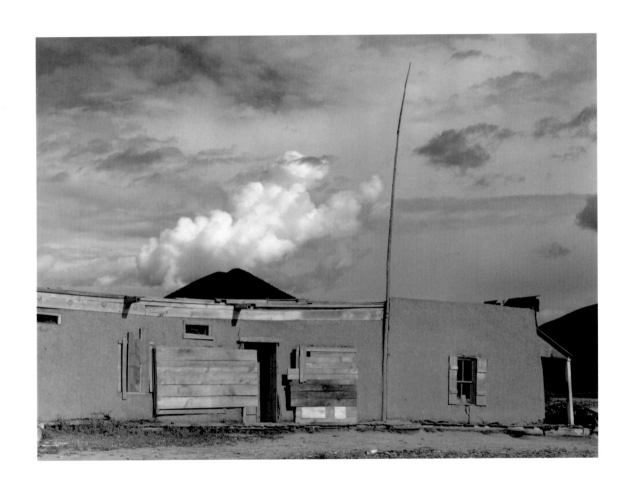

The Dark Mountain, New Mexico, 1931 80

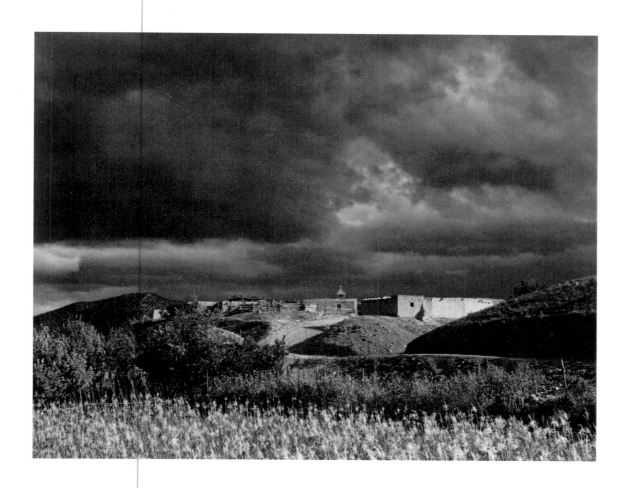

81 *Near Ranchos de Taos, New Mexico, 1931

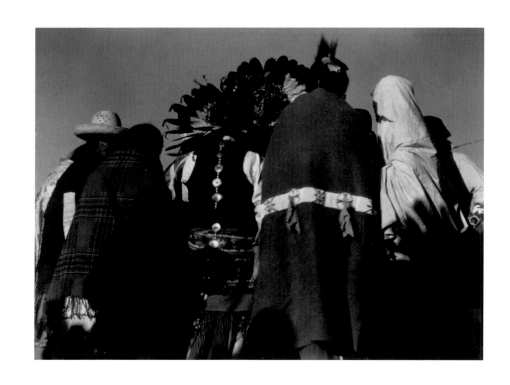

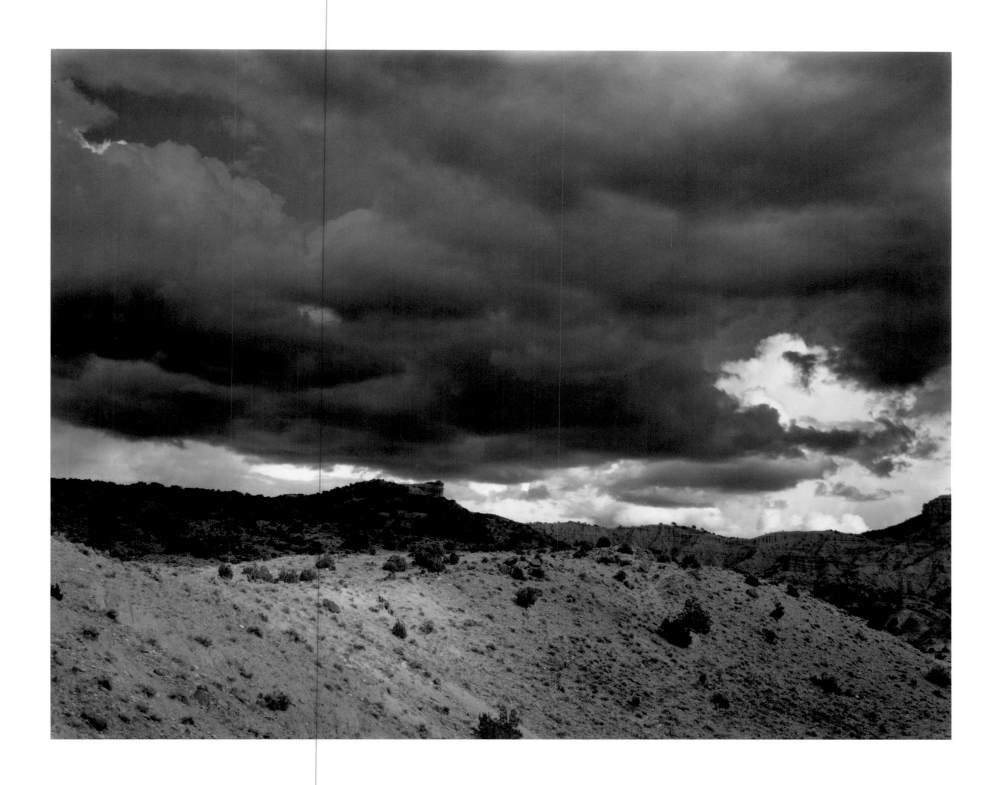

83 *Near Rinconada, New Mexico, 1932

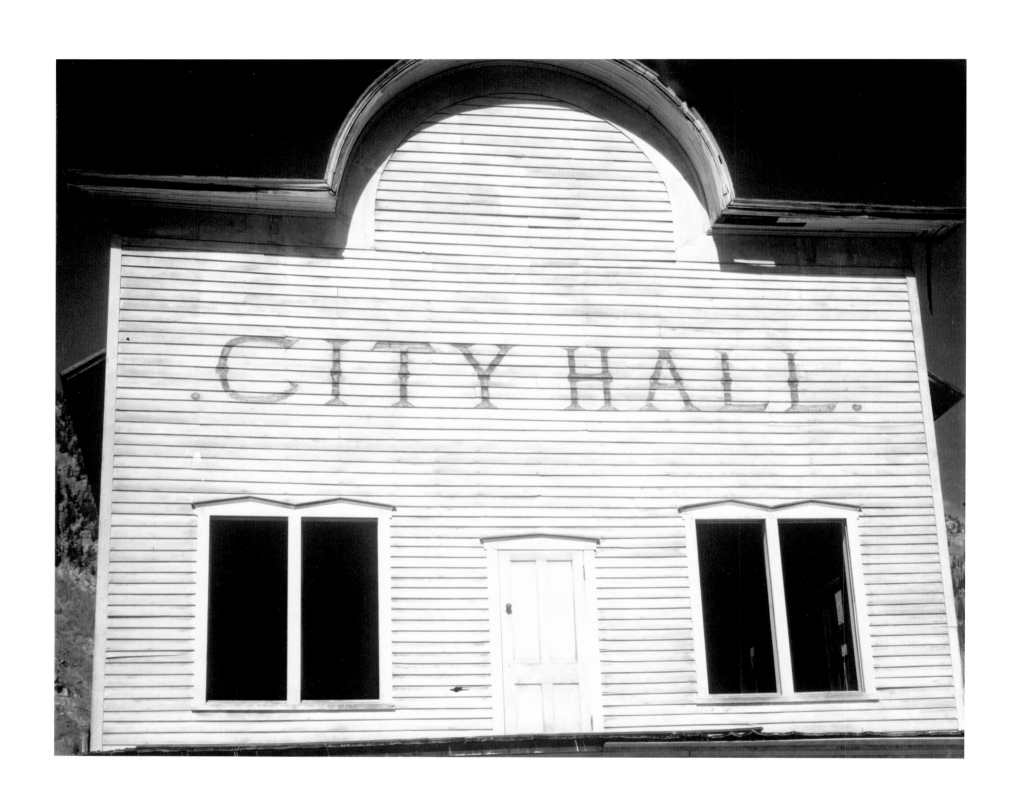

85 *Deserted Building, New Mexico, 1931

*Red River, New Mexico, 1931 86

87 *Hacienda, near Taos, New Mexico, 1930*

MEXICO

Abraham Gonzalez 66, Mexico—D.F.
September 1, 1933

Dear John [Marin]:—
 . . . Up above you will notice "Mexico—D.F." The D.F. doesn't stand for damn fool—but Federal District—But maybe I am a d.f. small letters—for having been in the big D.F. this long time. If you chide me for having left my own, my native land, my answer is, it's the same old continent anyway—And I don't feel yet that I am d-effy because the work I have done here seems healthy and well—good—
 I used to think of Mexico before I had been here—as something mysterious—dark and dangerous—forbidding—It has its mystery—as all lands have—but it is also very human—long lived on and over by humans. And not dark nor forbidding—A strange mixture of old and new—Indian and mestizo (half-breed Spanish) primitive life and gas stations—wonderful beer. A land of mountains and maguey—lovely, lovely valleys—gentle country, austere parts—tropics within few hours of the temperate climate of this high plateau—Within sight of the city—Ixtaccihuatl—the sleeping woman—snow covered and near her the white snow cone of the volcano Popocatepétl. Further south between here and the Gulf—that isolated perfect white volcanic peak of Orizaba, the tropics at its feet. A land of mountains for the greater part—all "breeds" and not like ours. When you leave the Texas border for about 70 miles—flat desert, it could still be Texas. Then suddenly appear the mountains of the North around Monterrey and Saltillo—amazing mountains. They are a continuation of the American spur—our Rockies I suppose—but how different—utterly fantastic shapes, like mountains in fairy books. And I never saw the forms within each individual mountain—defined—come right at you as those in the North—But it is all really pretty swell—going over so much of Mexico in Fifi my Ford, who is now almost 30,000 miles old—poor old gal—but awfully faithful—Some tough roads—just the old wagon tracks in use hundreds of years—and 17 hour stretches at 10 miles per hour—But one sees things off the railroad track—Here around the city—very good roads and in one hour you are in real country—little villages in which the Indians live very much as always. And these Indians are very different from those of the U.S., more friendly and more gentle—If you greet them they meet you more than half way—openly—without suspicion—yet not servile either, in spite of continuous exploitation first by their own kings—then the Spaniards—now the mestizo—their culture completely destroyed. There is nothing like the corn dance of Santo Domingo here. The American Indian has kept his culture fairly intact—his racial unity. In a certain way he has more spirit than these people, but I feel always he is pretty much on the defensive. Whereas these 16 million here are in the majority and tho beaten down and in poverty, they amazingly keep a certain innocence, that meets you with a truly friendly smile—So it makes you feel good to be among them in the little villages—
 Last but not least—Billiards—Every little town has billiards—pretty bad tables, cue and balls, but billiards outnumbers pool in Mexico—That ought to raise your respect for it to the nth degree. . . .
 Best to you and Mrs. Marin and John Jr. As always—

Affectionately
Strand

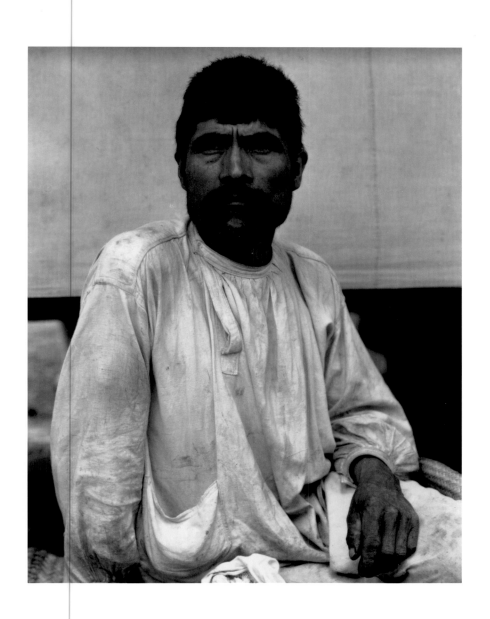

89 *Man, Tenancingo, 1933

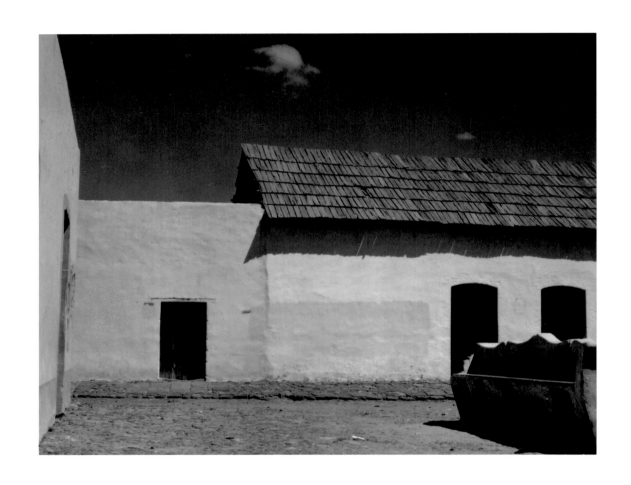

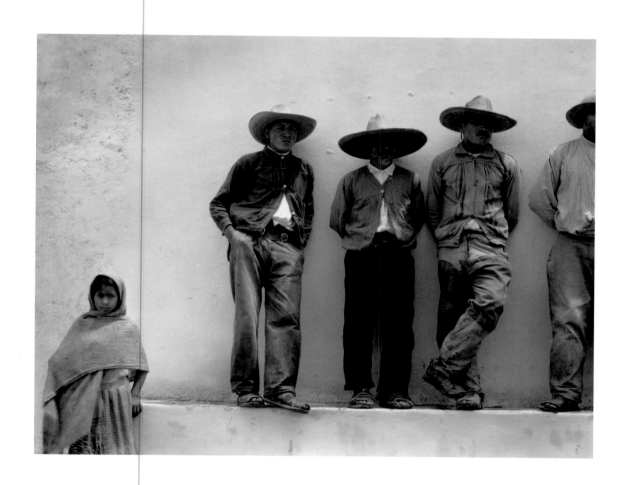

91 *Four Men and Child, Dia de Fiesta, Mexico, 1933*

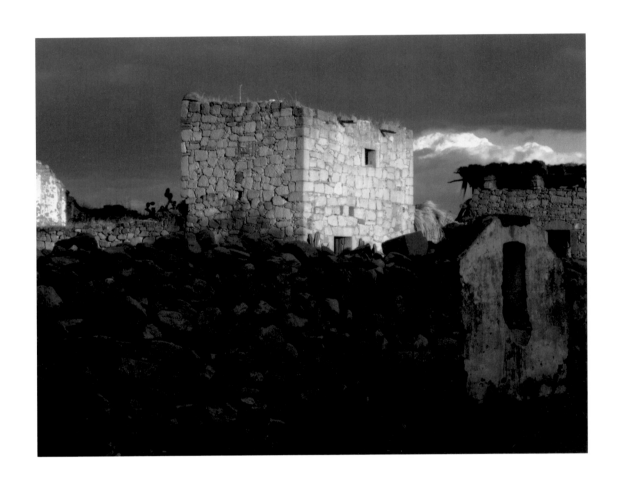

93 *Boy, Hidalgo, 1933

95 *The Nets, Janitzio, Lake Pátzcuaro, Michoacán, Mexico, 1933*

Comision de Cine, Lista de Correes
Alvarado, Vera Cruz, Mexico
September 29, 1934

Dear Irving [Browning]:
 . . . I came to Mexico almost two years ago; really to work at still photographs, and I did work. Also at the invitation of the Government I gave an exhibition of my photographs of New Mexico which was attended by some 3000 people in ten days.
 For six months I worked at still photographs of Mexico, made about sixty platinum prints, completed and mounted them. Among other things I made a series of photographs in the churches, of the Christs and Madonnas, carved out of wood by the Indians. They are among the most extraordinary sculptures I have seen anywhere, and have apparently gone relatively unnoticed. These figures so alive with the intensity of the faith of those who made them. That is what interested me, the faith, even though it is not mine; a form of faith, to be sure, that is passing, that has to go. But the world needs a faith equally intense in something else, something more realistic, as I see it. Hence my impulse to photograph these things, and I think the photographs are pretty swell.
 The next thing that happened was that Carlos Chavez, the well known Mexican composer, who at that time was Chief of the Department of Fine Arts in the Secretaria de Educacion, asked me to start motion picture work for the Department. . . . The first man I called was a young American Henwar Rodakiewicz, one of the most talented motion picture men I have met. He came to Mexico and wrote a fine screen treatment and shooting script. Later Fred Zinnemann an Austrian with considerable Hollywood experience (worked as technical director on Nana), has been co-director with Emilio Gomez-Muriel, a young Mexican; both very able. Ned Scott who did commercial photography in New York is making the stills. Barbara Messler, a friend of mine from New Mexico, came to keep the script and has done much in casting the picture. I have supervised the production and done the photography. That is our crew, working since last February in this little town in the tropics, under pretty tough conditions—climate, bad food, heat, mosquitoes, etc. The film will be called "Pescados" (unless title is changed) and deals with the lives of the fishermen here, their work, and their problems, in a full dramatic story.
 Like Flaherty we have used almost entirely as actors the people themselves. There is only one professional actor in the cast. The hero is a man from the City, a well known Mexican athlete, never before an actor. Another important part is played by a man from Mexico City who also never acted before. But outside of these three parts all others have been taken by fishermen. But unlike Flaherty (whose pictures I think are very swell) we have not tried to reconstruct the life of a primitive people, or a people's struggle for existence against the forces of nature. We have tried to do a different thing; to make a film dealing with the lives of these fishermen as it exists today, and is related to the lives of people everywhere. That is, give the local drama a wider significance, and still keep it dramatically true. . . .

Sincerely,
Strand

97 *Christo, Tlacochoaya, Oaxaca, 1933

Gateway, Hidalgo, 1933 98

99 *Virgin, San Felipe, Oaxaca, 1933

NEW ENGLAND

New England has and I think will always have a special meaning for Americans. The land and its people, their cities and towns, their factories and mills, the villages surrounded by farms, the long coast and the sea whipping against it—all these are New England. But there is something more. For here in this region, in these six states of the Union, were born many of the thoughts and actions that have shaped America for more than three hundred years.

From the very start, New England was a battleground where intolerance and tolerance faced each other over religious minorities, over trials for witchcraft, over the abolitionists. The freedom of the individual to think, to believe, and to speak freely was an issue fought out here more than once. The rights of man were here affirmed in 1775 and 1860. Men gave their lives in the struggle against political tyranny, and when it took courage to speak out against human slavery in the face of obloquy and the threat of mob violence, they spoke out. The voices of Roger Williams, Ethan Allen, Samuel Adams, and James Otis; of Garrison, Wendell Phillips, and John Brown; of Thoreau, Emerson, and many others, true spokesmen of America in their time, echoed in the air of these states.

It was this concept of New England that, like a scenario, gave the clues to the photographs in this book and brought them into relationship with the text. I was led to try to find in present-day New England images of nature and architecture and faces of people that were either part of or related in feeling to its great tradition. . . .

"Photographer's Foreword," *Time in New England*, 1950

101 *Susan Thompson, Cape Split, Maine, 1945*

*Burying Ground, Vermont, 1946 102

103 *Open Sea, Cape Split, Maine, 1946*

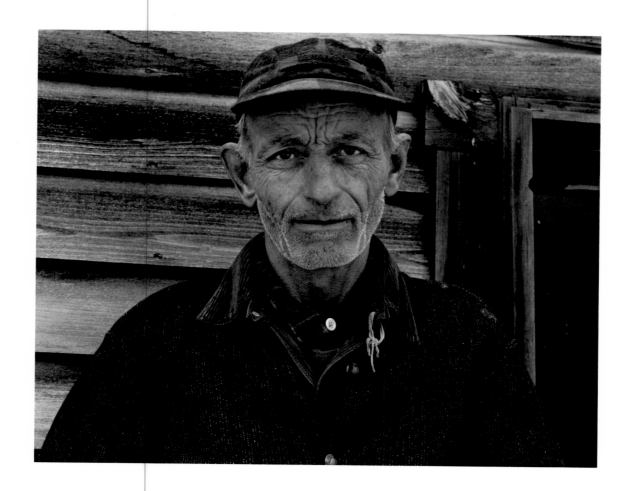

105 *Mr. Bennett, Vermont, 1944

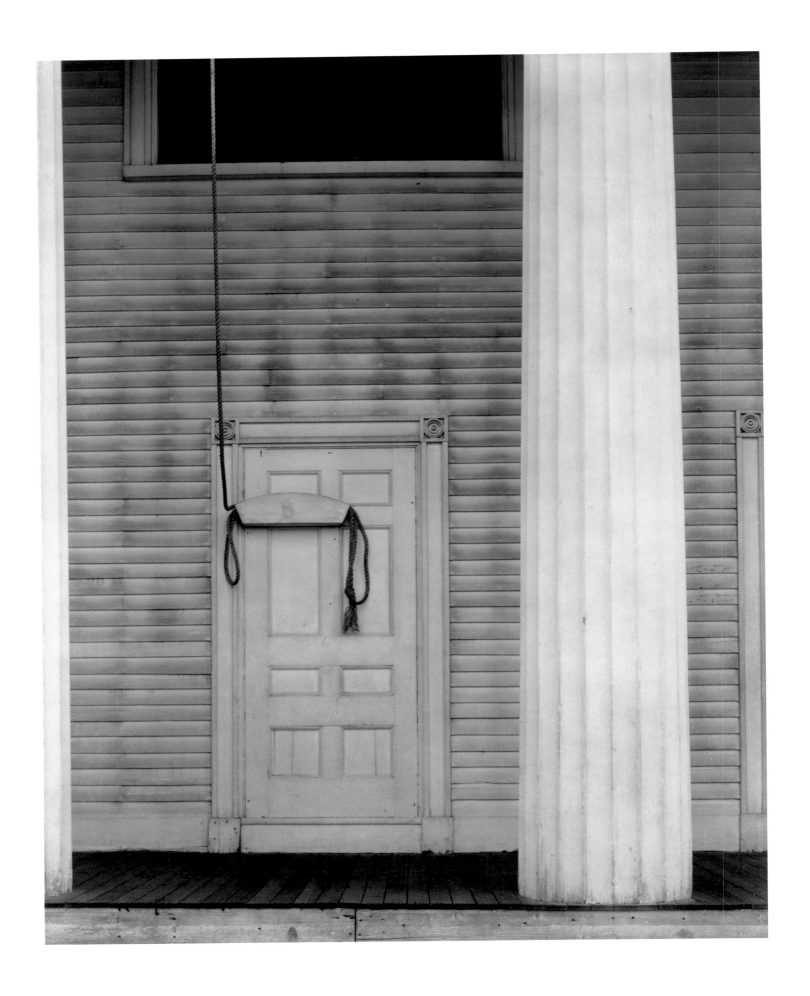

107 *Mullein, Maine, 1927*

*Parlor, Prospect Harbor, Maine, 1946 108

109 *Figurehead, "Lady with a Medallion,"* 1946

111 *Town Hall, 1946

FRANCE

The word realism has been used here so frequently that it is clearly the most important concept in this Conference—so important that I believe we should try to have complete clarity about its meaning for us. . . .

I begin with the negative statement that realism is not the mere recording of things as they are, seen through dispassionate eyes in which all things are of equal value, of equal interest—the eyes of a man who thinks he stands above life, above good and evil. Neither, as Casiraghi pointed out, does realism consist in the description, no matter how honest, of the exceptional or sensational in life. There is a certain kind of realism in the Hollywood films of violence, the torn and bleeding face of a prizefighter is true in real life. But such truth has no purpose, except to excite the sadistic and masochistic feelings of the audience—to exploit them on an emotional level. For there is such a thing as emotional exploitation, as well as economic exploitation, in fact they often go together and are equally repulsive. We here reject, I am sure, both this venal realism as well as the mere slice of life naturalism which is completely static in its unwillingness to be involved in the struggle of man towards a better and a fuller life.

On the contrary, we conceive of realism as dynamic, as truth which sees and understands a changing world and in turn is capable of changing it, in the interests of peace, human progress, and the eradication of human misery and cruelty, and towards the unity of all people. We take sides. We take sides against war, against poverty and align our art and our talents on the side of those whom Henry Wallace called the "Common Man," the plain people of the world, in whose hands lies the destiny of civilization's present and future well-being. And the word civilization, as I use it, includes the world culture. . . .

In the lives of ordinary men and women, a dynamic realism will find all the drama, the conflicts and resolutions, all the necessary content with which to create the greatest art. And to the extent that the artist of the film uses all the esthetic elements of this great medium, to the fullest, creating the richest forms, will this realism move his audiences. To the extent to which these audiences of millions can find the reality of their own lives depicted most clearly, most beautifully and forcefully by the artists; the writer, director, cameraman and composer, to that extent will they be moved.

People must find themselves in our films, but the revelation of reality must be one which is never immutable and changeless. For such reality would not be the truth. The directions of change, above all emphasis upon what is healthy and growing in society, must somewhere be expressed in relation to the truth about life as it exists today. If everything was rotten and hopeless in the world, why make films at all? So, we may say that true realism is realism which contains the seeds of purpose towards peace, human freedom—a rich and full life, not for a few men, but for man. . . .

International Congress of Cinema, Perugia, September 24–27, 1949

113 *Midi-Libre, France, 1951

115 *Levens, Alpes-Maritimes, Provence, France, 1950*

117 *Young Boy, Gondeville, Charente, France, 1951*

119 *In Botmeur, Finistère, France, 1950*

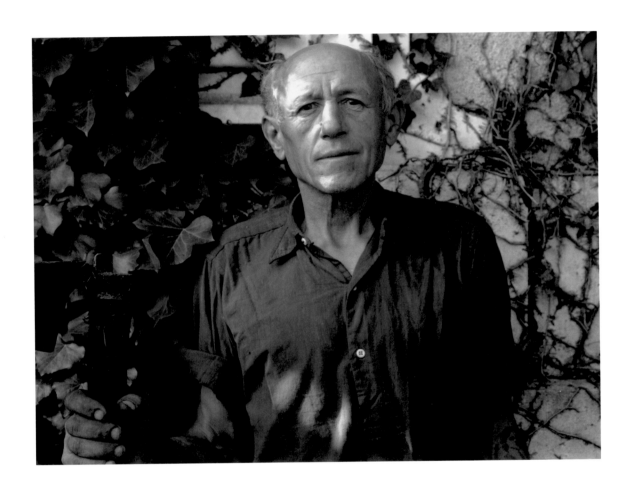

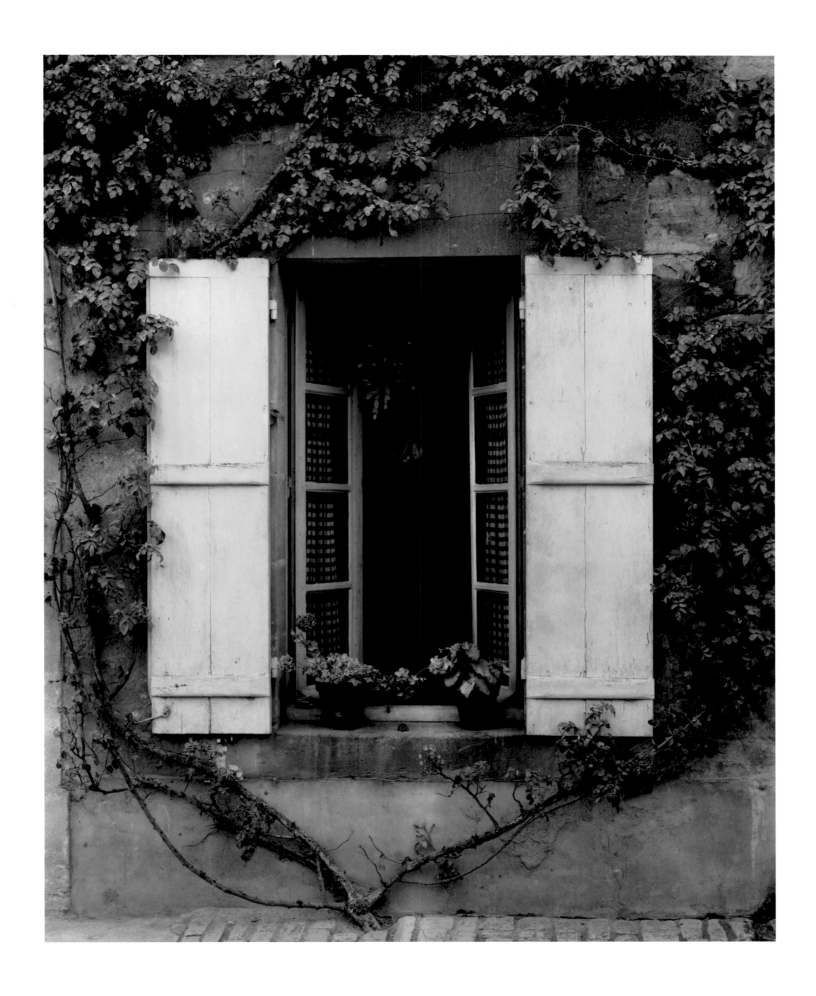

121 *White Shutters, Brittany, France, 1951*

ITALY

Orgeval, May 2, 1958

Dear Nancy and Beaumont [Newhall]:

. . . Now since you are getting out a definitive book with much historical data in it, I must take up with you a question I had hoped to thrash out when you were here. This is the matter of where the idea of "Un Paese" comes from, which was completely incorrect, grossly so, in Beau's review of the book. . . .

But to get down to the facts important for two reasons: One the idea of "portrait of a village" is part and parcel of my whole development as a photographer. Second and not less important, it comes directly out of our American culture. 100%.

When I was a young fellow, two books which appeared at the time made an especially deep impression upon me; Edgar Lee Masters' "Spoon River Anthology" and Sherwood Anderson's "Winesburg, Ohio." The kernel of the idea is with them (not Zavattini) and modified by me. In 1932, after three summers in Taos, the thought came to do such a book there. It could have been very interesting for there were still around some of the old timers—cattle runners, bootleggers, early settlers of Taos, and of course the Indians and Mexicans—an extraordinary community. And I had friends among all. However life decreed otherwise when it sent me to Mexico—and to work in films for the next ten years—as you know.

Then came New England, a related idea but a larger panorama. However in 1949 I came to Europe actually to carry this "Village Portrait" out in France. Ideas stick in the mind for years until you do them. Any number of people in N.Y. knew why I was coming here, to do just that. On arrival I began asking the French I met about villages, all sorts of suggestions and when Hazel and I returned in 1950 we set out to explore. The suggestions were one and all no good, so we drove some 20,000 klms looking ourselves for *the village*. That we never found it, was our fault I am sure, for there must be many, many. Anyway on these travels, I began to photograph ad lib so to speak and the result was La F[rance] de P[rofil] which Claude Roy put together from the heterogeneous material.

Then came Italy which seemed more alive in certain ways. . . . Zavattini . . . suggested Luzzara, on the Po, his birthplace. It was by then well into November, so we decided to go to Luzzara on our way back. Well, visually at first sight it was the last place one would pick; flat country; nondescript architecture, the non picturesque to the nth degree. However we felt we *must* do the book there no matter what, for Z loved Luzzara, knew everyone there and was known to them, an enormous asset to begin with. And that was right, no doubt of it. We in turn, coming back the following Spring, just had to get down to it and dig. The results of that were all rewarding. And it proved that our failure to find a village in France was the failure to find a writer who knew and loved a village—any village.

That is the story of how this "portrait of a village" finally happened, this very American idea, deriving directly from Masters and Anderson. You will notice in one of the reviews that the writer refers to "Spoon River." He did not get the thought from me. In fact a number of people in Italy have made the comment. And they are absolutely right, for that is the genesis. It seems to me very interesting and important that this seed from our American culture was brought finally to Italy, there very naturally to take root in this splendid collaboration with Zavattini. . . .

Affectionately,
Paul

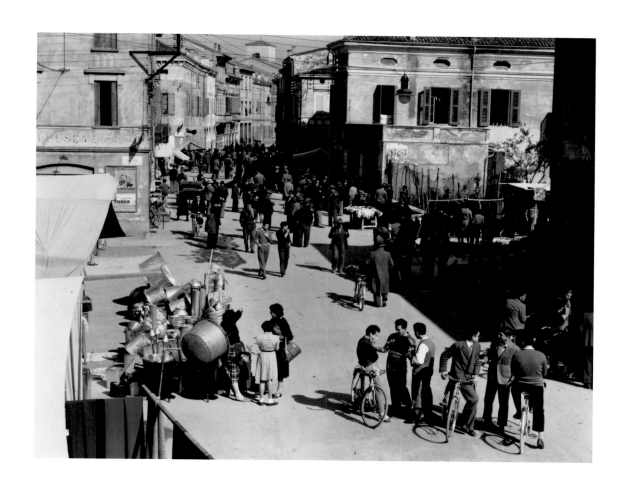

123 *The Market, Luzzara, Italy, 1953

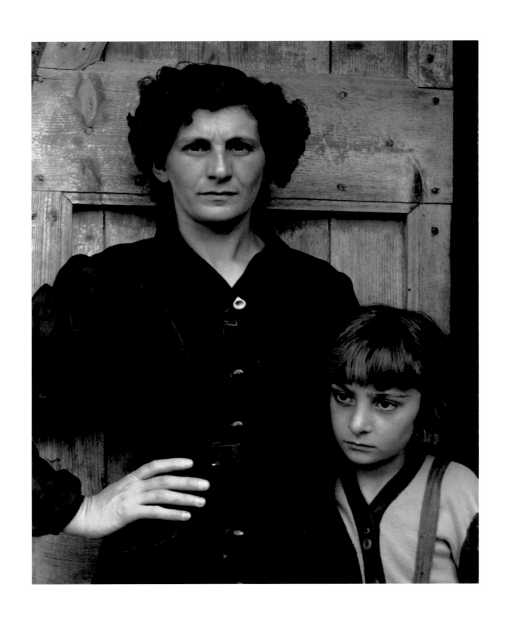

Post Mistress and Daughter, Luzzara, Italy, 1953 124

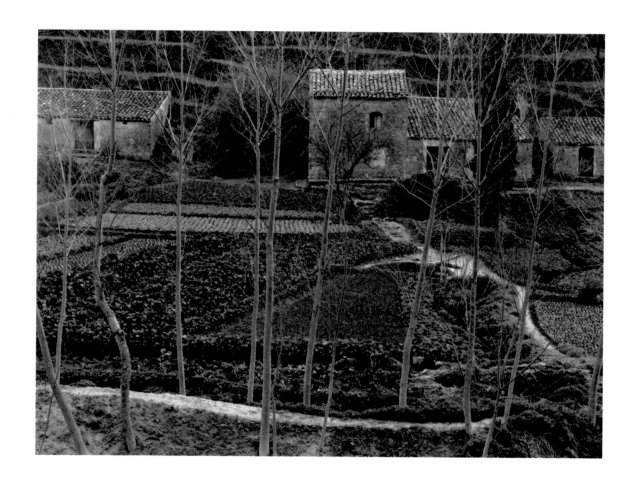

125 *Landscape, Sicily, Italy, 1954*

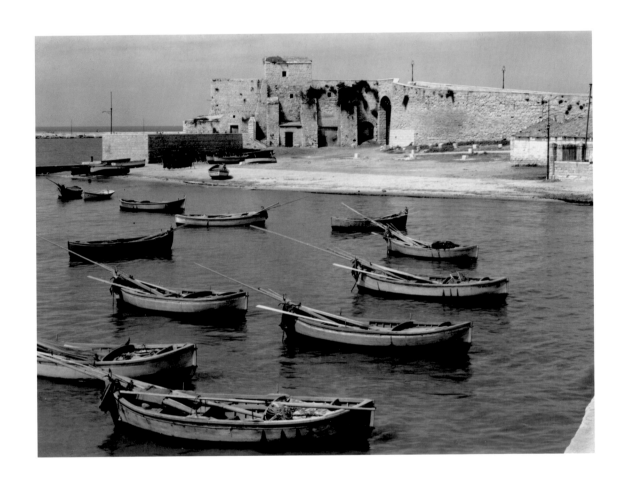

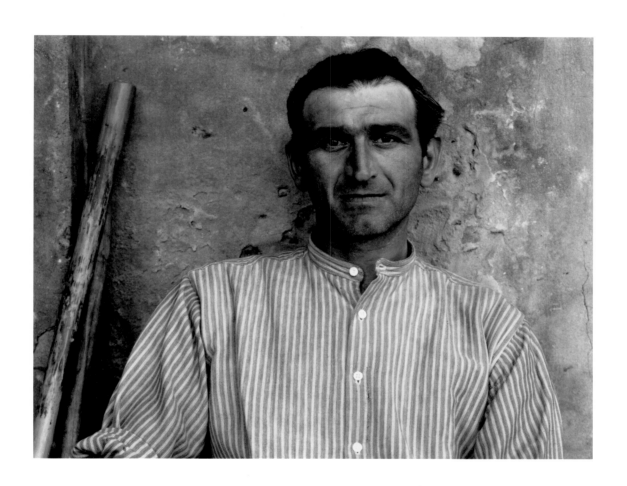

127 *Young Farmer, Luzzara, Italy, 1953*

Guastalla, Reggio Emilia
April 28, 1953

Dear Beau [Newhall]:

Thanks for your long, careful, conscientious and rather horrifying letter (about the impermanence and danger of nitrate film). I appreciate it even though my dreams will now take on a yellow green jelly consistency. But seriously—what a shame to find the Stieglitz and other negatives in this way. For year[s] I fear photographers had the idea (I know I did) that nitrate would last and acetate tended to dry up. So I made efforts actually to get nitrate on special order. What an irony. . . .

Here are some thoughts which I meant to put in that letter but forgot. Anyway it was long enough. Namely, I think the portraits in the French book carry on what I started in N.Y. in 1915—then in Mexico and later in New England. Here in Italy even more so. The concept behind this phase is different from that of the documentary or shall we say candid approach. I do not seek the special moment, the special expression or activity.

Since Van Gogh and Cézanne, portraiture in painting is almost a lost art. I mean a portrait in the sense that a person completely unknown to the world at large, not connected with those who will see the painting or photograph, has a living quality, nonetheless, as full as, say the "Cobweb with Dew." In short there is no necessity to be acquainted with the subject in order to have from the portrait complete esthetic and human satisfaction. Of course Hill did this consummately. Also Stieglitz in some things and others. I do not say this kind of portraiture invalidates the candid point of view. It is just different, very difficult and very challenging. It is one thing to photograph people; it is another to make others care about them by revealing the core of their humanness. The old masters did this as though it was the most natural thing to do, and with the greatest simplicity of means.

This book travels that road or at least tries to. I shall have photographed more than 40 people, old, middle age, young, children, men and women, before we leave. Among much else of course. I think we shall leave here about May 5th, start for Paris. So use Paris address from now on. Nancy's Arizona trip sounds fine.

Hazel joins in all the best.

Paul

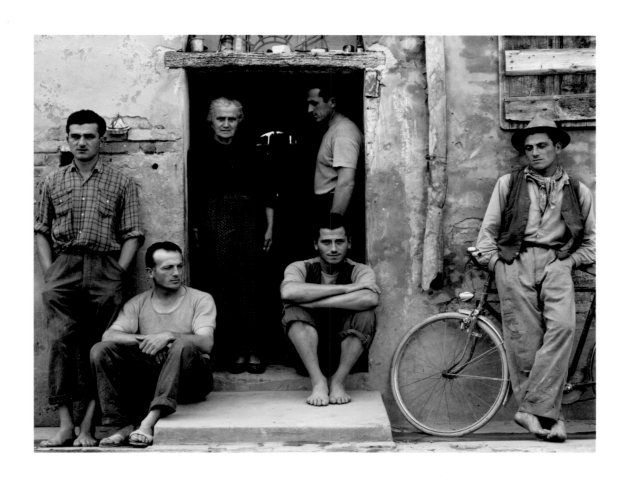

129 *Lusetti Family, Luzzara, Italy, 1953

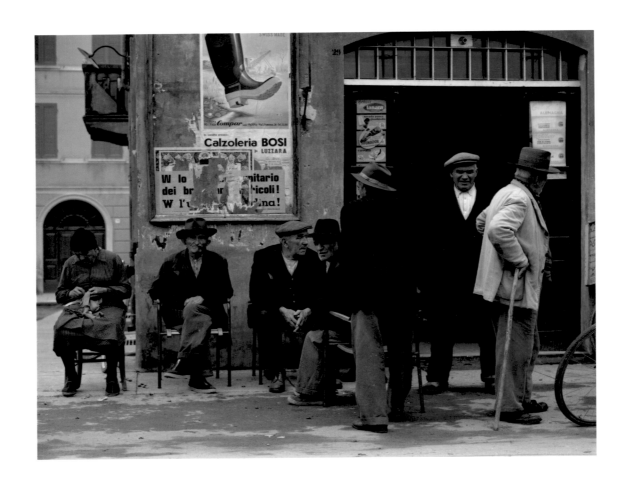

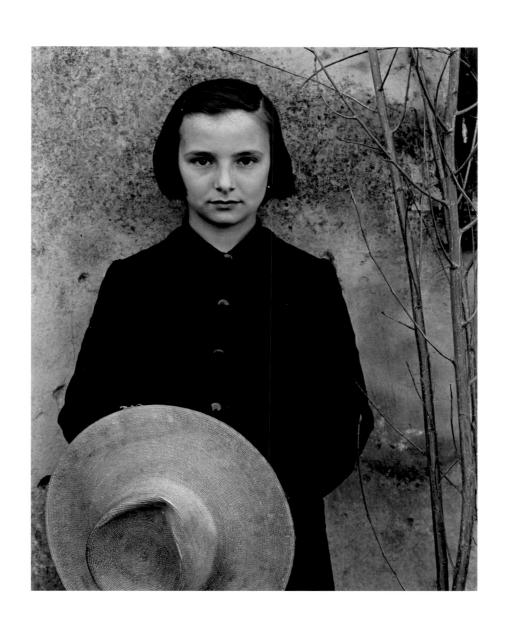

131 *Tailor's Apprentice, Luzzara, Italy, 1953*

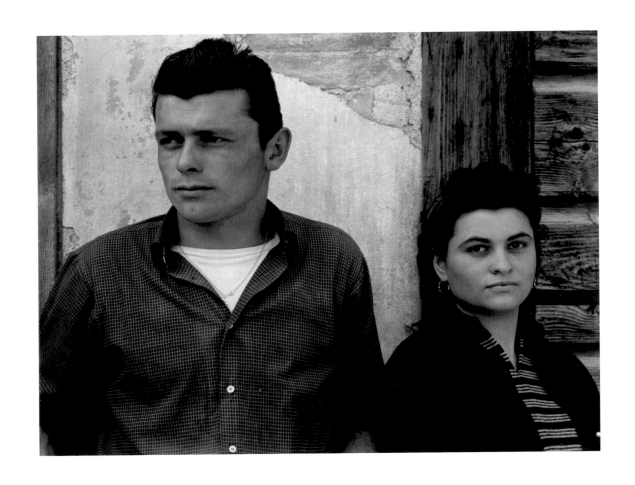

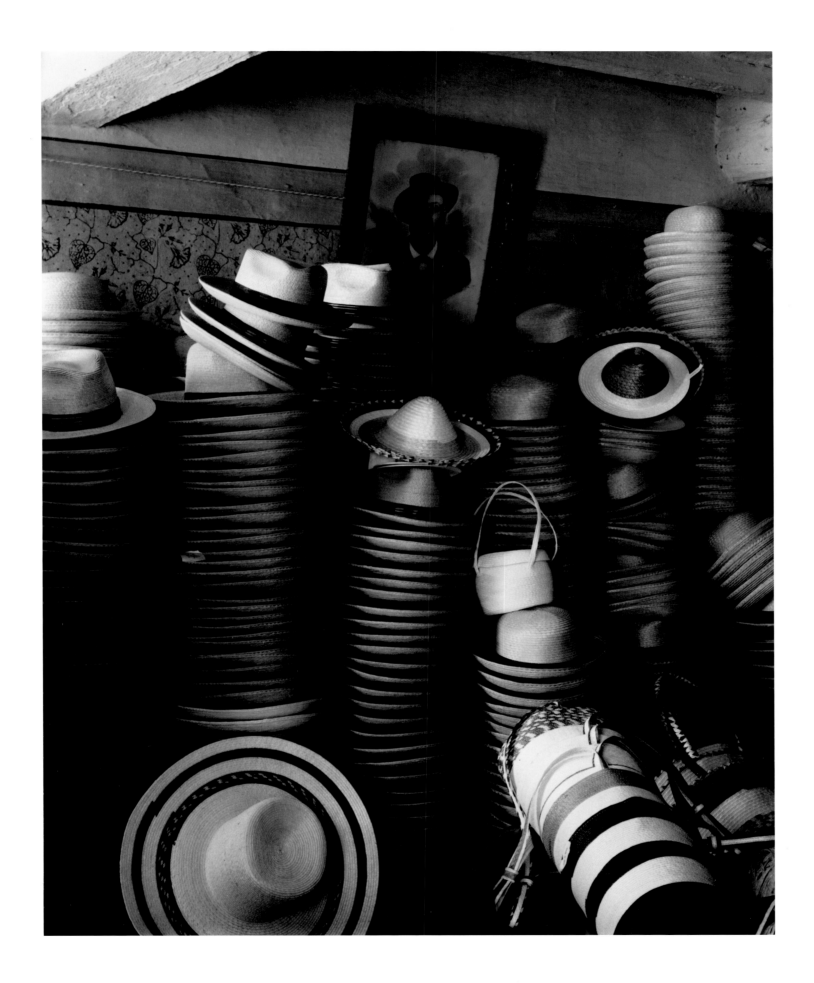

133 *Hat Factory, Luzzara, Italy, 1953*

HEBRIDES

Paris, October 28, 1954

Dear Nancy and Beau [Newhall]:

 I have been wanting to write you for some time but the load of work, weeks in the darkroom has left me so fagged by night, that I just had to wait for an interim. A few days ago the developing of the summer's negatives was finished and now while Hazel is in there, hard at it on her films, I get a chance to catch up on correspondence. . . .

 Now for the "Death Valley" book which I have looked at much and find in many ways, good, especially the text really very swell. I should think it might have been successful and hope so. My feelings about the book as a whole are perhaps negated by the exigencies of the publishers, the color plates etc., layout, cover. How free a hand you had, I can't know. I am inclined to agree with Beaumont that text and photographs could have been interwoven with greater interest. The photographs are well up to Ansel's standard but I have the feeling that text and photographs do not relate too well. In fact I find Nancy's text more interesting, richer in meanings (a splendid job of research and writing) than the photographs, not taken singly, but as a consecutive series of images. The text is full of suggestions for photography not fulfilled. The reason I think is this. I will put it in film terms—viz: you cannot make a film out of just long shots, or just close ups, or just medium shots. A book is a related problem. True the images pass more slowly as the reader turns pages, but nevertheless the eye demands to go close, to get further away etc. etc., as in the film. It is a montage problem, in which a movement must be created, of variety and meaning. Long view after long view, no matter how good in themselves, become unassimilable to the eye and the imagination, so it seems to me. I think Ansel has done the long view very well, but what of the small life, invisible in these, the flora and fauna of the valley? (That list and roads are very interesting in the back of the book.) Some of the flowers—the small forms intimate shapes—even a fancy tarantula would make the big spaces bigger, no? I don't think the foot in the door and the hand panning gold are the answer. These two photographs seem fabricated somehow. And I would like to get closer to that grave and to the remnants of human life, the bedsteads. The yucca palms so lovely in themselves vie for interest. However this is a matter of opinion. What I think is not solved, is the whole problem of montage in a book, for in a film it *has* to be faced and solved. Anyway such were my reactions for whatever they are worth to the new works you will do together. How does it go? . . .

Affectionately
Paul

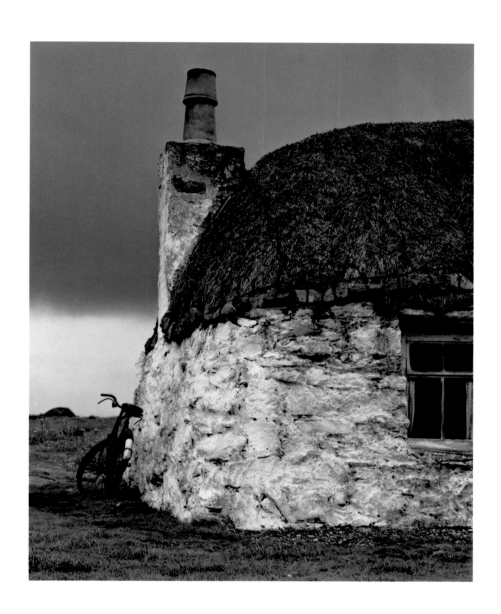

137 *House, Benbecula, South Uist, Hebrides, 1954*

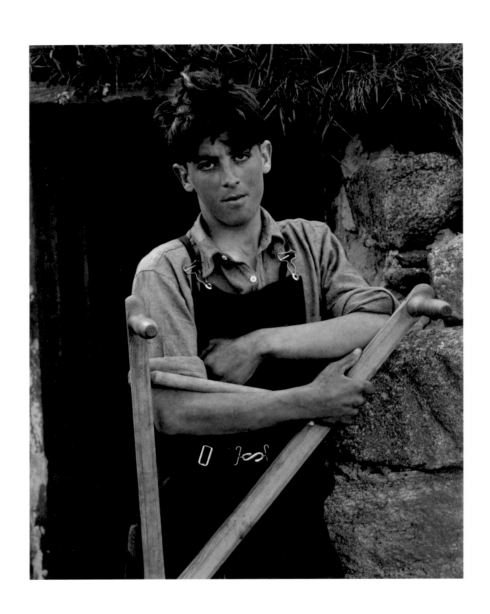

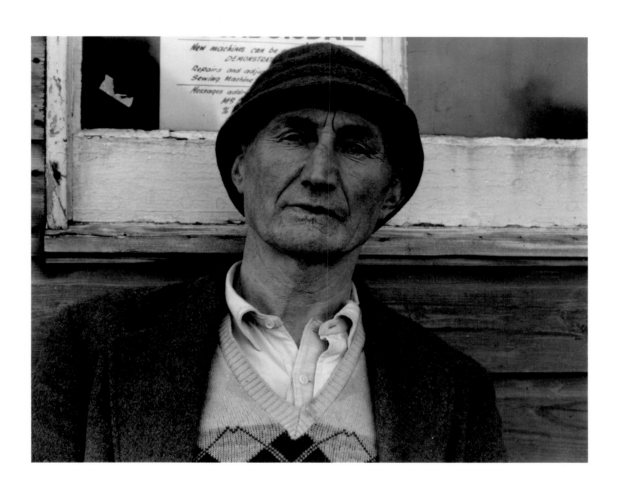

139 *Alex MacDonald, South Uist, Hebrides, 1954

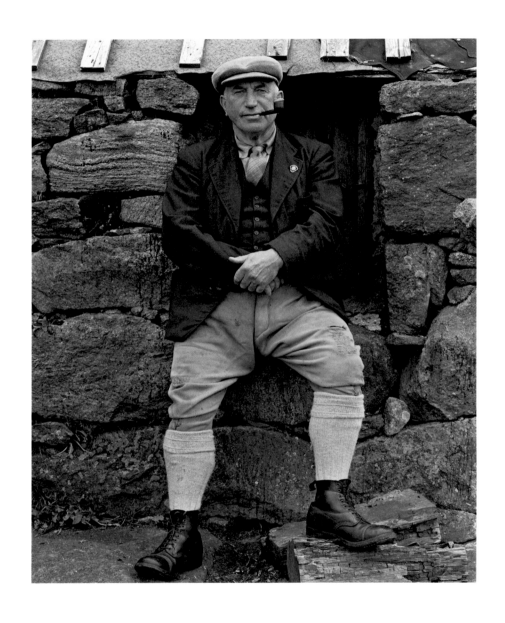

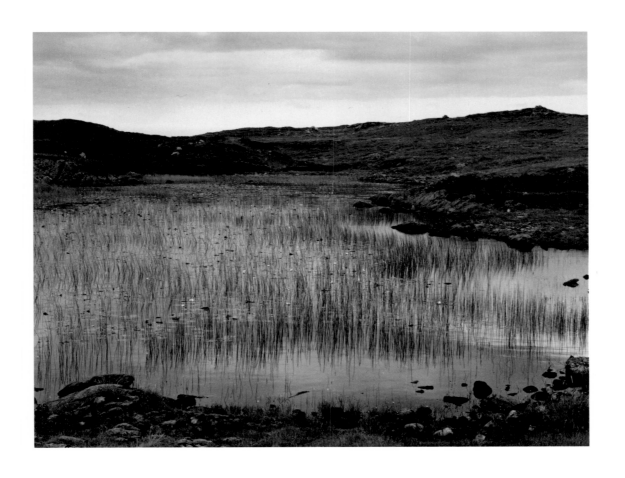

141 *Loch, South Uist, Hebrides, 1954

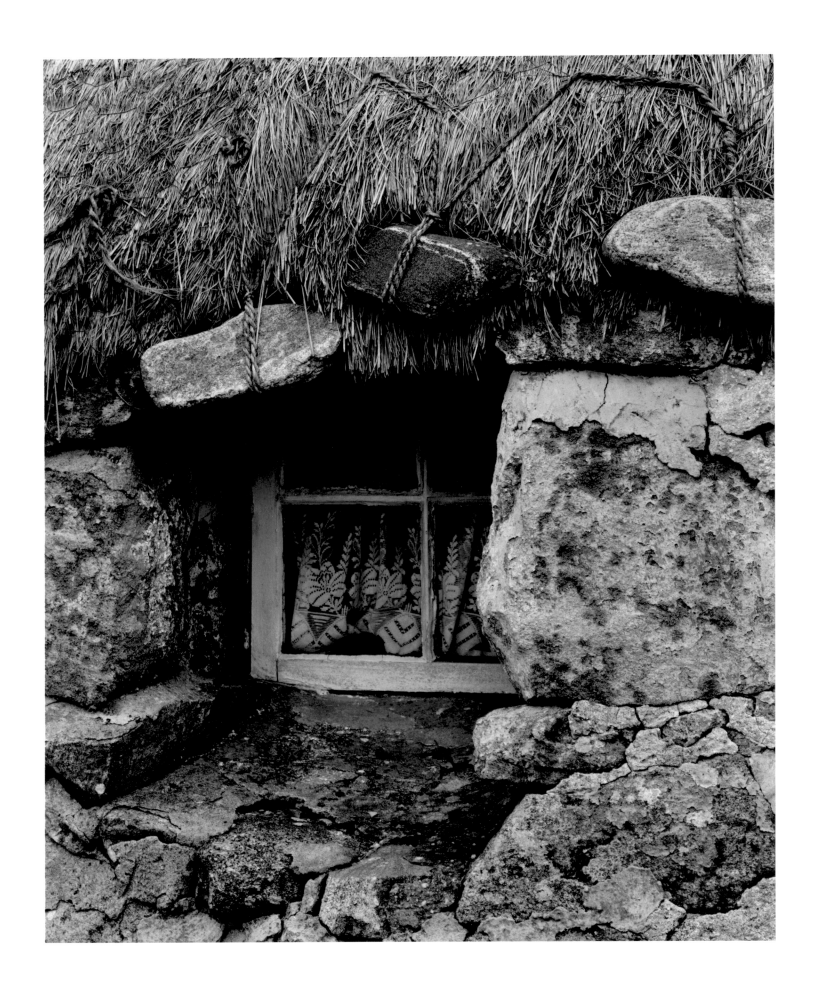

Window, Daliburgh, South Uist, Hebrides, 1954 142

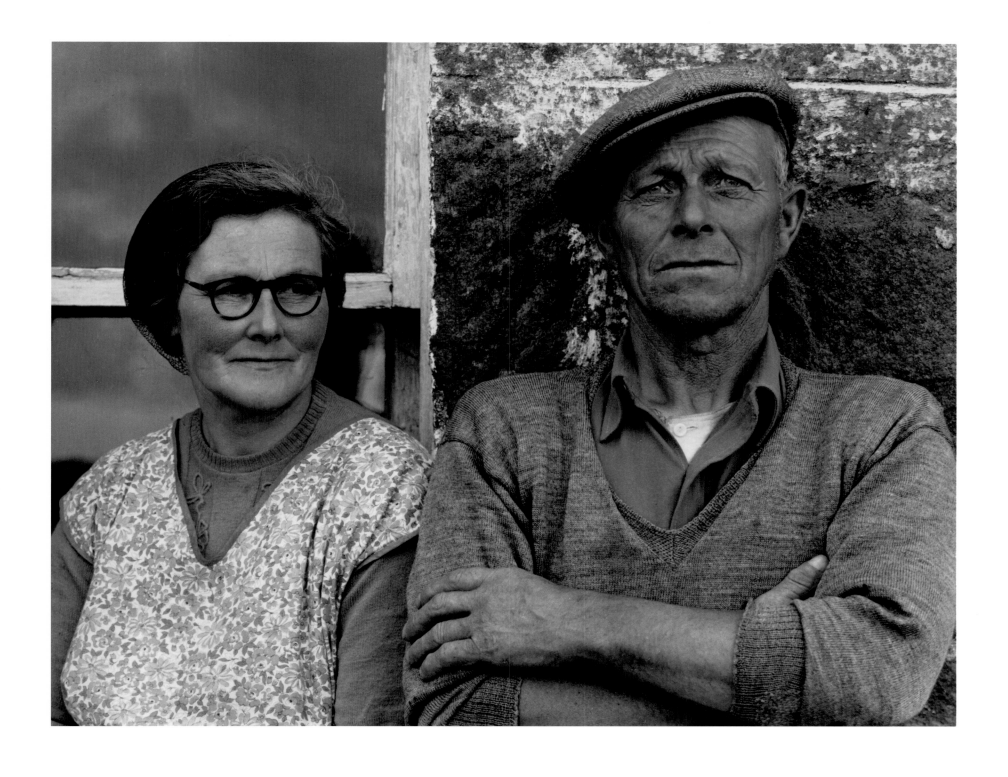

ORGEVAL

The critical moment for the photographer is the moment of seeing, a creative act which involves the perceiving of the subject to be photographed in the first place and the photographing of it in the last place. Between those two actions there is flexibility as to how long the moment may last or what it includes from the point of view of the artist.

The decision as to when to photograph, the actual click of the shutter, is partly controlled from the outside, by the flow of life; but it also comes from the mind and the heart of the artist. The photograph is his vision of the world and expresses, however subtly, his values and convictions.

Sometimes the artist's vision is concerned with the evanescent, with things that pass, oddities and exceptional happenings of life in movement. Then, the moment is decisive. A second later, and the essential relationship of objects within the frame will have shifted. The significance of the event lies in an instant's equilibrium between the temporary and the enduring.

Yet photography is not limited to such moments of immediate insight. Its tempos change according to the photographic problem. A rock hammered year after year by the sea, slow-growing plants, an architectural feature or landmark weathered by many winters—such things permit long periods of reflection in which to decide what part of the object will be included or excluded; in other words, selection becomes the arbiter of content. Even here, immediacy can be valuable once the problem has been thoroughly understood and resolved. One may put off the moment of photographing from three o'clock today to three o'clock tomorrow, only to find something has changed that can never be recovered.

For the artist the moment of seeing can also be a moment of revelation. Such moments are closely related to those of the scientist when he discovers his hypotheses concur with the structures and organizations of nature, either by a lucky chance or as a result of patient research. In art as in science, both chance and research contribute to opening up new dimensions of harmony for man within his environment.

One of the most visionary scientists I have known was Harlow Shapley, the great American astronomer. . . . In his book *Beyond the Observatory,* he wrote:

Continually our eyes are opened wider, the depth of our vision is increased. We see the stars evolve, the planetary surfaces like that of our earth change with the flowing of time. We learn that primitive plants and elementary animals develop through the ages into complicated organisms, including those with high sensitivity to their environment. Man, too has evolved and so have his social organizations. Why, then should we not expect the penetrating urge toward change that permeates the universe to include the growth of men's groping philosophies? The answer is we do expect it; to some extent we witness it. And we note that evolution itself evolves.

To come on this quotation by chance was like an encounter with my late friend, who as a scientist, was saying things such as I have tried to express through photography over sixty years. Both artist and scientist are committed to processes which complement each other's vision. For this portfolio, which includes some of the most recent photographs I have made, my observatory has been *The Garden.*

145 *Dry Leaf, La Briardière, Orgeval, 1956*

147 *Crocus and Primroses, Orgeval, 1957*

Yellow Vine and Rock Plants, Orgeval, 1960 148

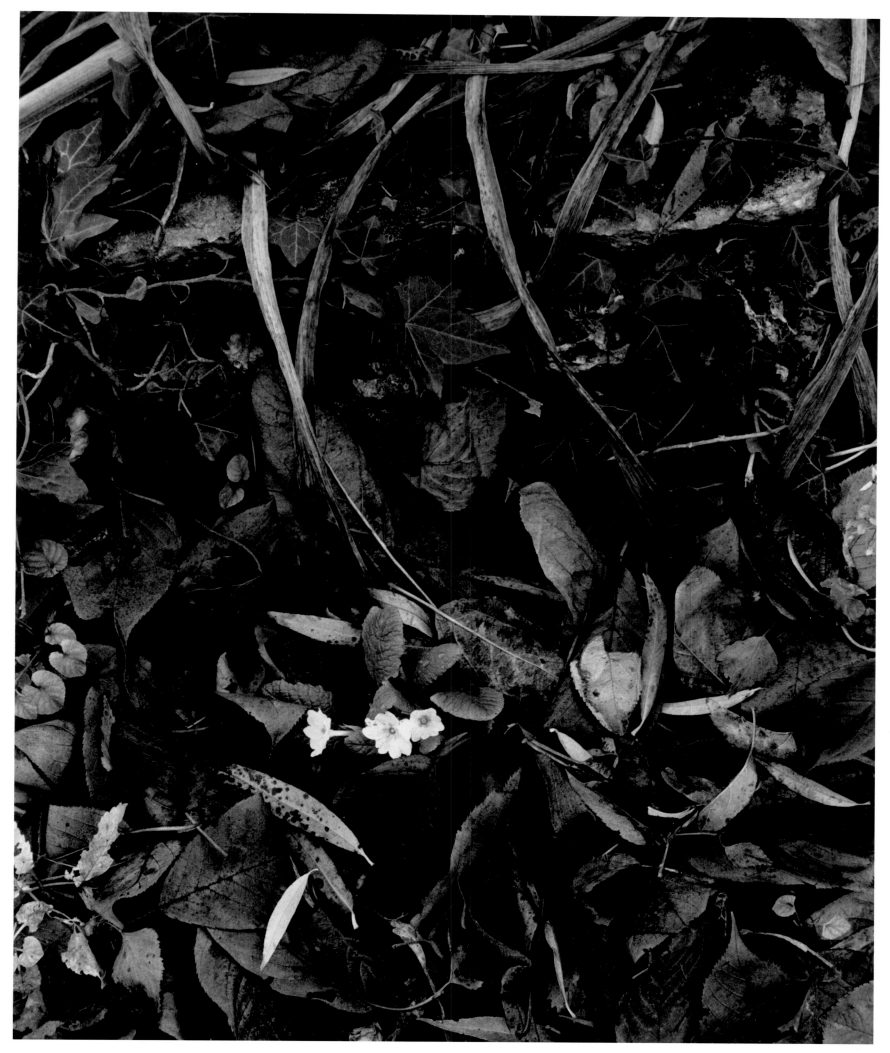

149 *Orgeval, 1974

AFTERWORD

Those who knew and worked with Paul Strand agree that he had a genius, perhaps unmatched by that of any photographer of this century, to transmit a sense of universal vision deeply *into* the image, where it waits and resonates with inner life. Over more than sixty years of creative work, he studied and reflected upon the subtleties of light playing on his subjects. He created images serene within their boundaries, using materials and methods available to him in a fashion that can be described factually but with results that verge upon alchemy.

That is not to say that Paul was, in any apparent way, a mystic. He was a most practical man, with no traces of didacticism. Although well-read and with an almost courtly manner, he approached the making of prints as well as photographic reproductions for his books with the earthy, hands-on determination of a medieval craftsman.

Strand's well-documented struggles with making his own photographic prints reflected the economically-driven technology of the medium. For the early years of his work, platinum paper was used as the material of choice. When it was no longer available, he shifted to silver paper, and combinations of gold toners and varnishes to get the strong blacks, the luminosity of surface, and the tonal scale that he demanded. Perhaps the greatest measure of his success is that during his long working life—and also his extensive travels—the resulting prints, and the vision they contain, remain unmistakably, unchangeably his own. The irony, of course, is that the technical advances in photography that were meant to reduce costs and effort greatly increased Paul's.

In early publications of his work, when hand-pulled gravures were still relatively common, he supervised the making of the printer's positives and plates and stood watch over the press, insistent that reproduction quality be as close as possible to his original intention. As the exquisite hand-pulled gravure gave way to its mechanized successor, rotogravure, Paul chose this method over letterpress whenever possible. *La France de Profil*—rightly judged one of the most beautifully printed books in photography—represents his greatest success with rotogravure. As rotogravure, too, went into demise, Paul asked for help in finding the most gifted printers and in exploring new methods. In the 1960s we were lucky to find the most technically innovative printer at that time, Sidney Rapoport—lucky, too, that Sid had the devotion and patience to benefit from Paul's insight even when it meant a great amount of extra time and expense.

In fact, Paul's primary interest, beginning in the 1940s, was in the making of books. His original prints were seldom exhibited; when asked to participate in an exhibition, he often pulled rotogravure tearsheets from his books, matted them, and sent them off, as he infre-

Paul and Hazel Strand in the Garden, Orgeval, 1974, by Jerome Leibling

quently trusted his prints to museums. Even at his home in Orgeval it could be difficult, even impossible, to see his finest prints.

To visit Orgeval was an unforgettable experience. In the late 1960s, the nineteenth-century farmhouse forty kilometers southwest of Paris was not yet hemmed in by suburban homes. A high rock wall shut out the world and sheltered a carefully tended garden; espaliered rows

of pear and apple trees, seasonal vegetables and herbs, and the famously recorded pansies stretched down the center of the stone driveway. The shaded areas were characterized by ground ivies and myrtle with iris, bachelor buttons, coreopsis, and many other naturalized varieties appearing in random array. The garden was largely his wife Hazel's creation, and Paul's photographic preoccupation in the last years of his life. Thanks to Hazel, they had been very productive years.

The daughter of a New England canoe-maker, Hazel was a respected professional in her own right who had worked for years with the fashion photographer Louise Dahl-Wolfe. Hazel, despite her New England upbringing, moved easily in New York's artistic circles. When she married the sixty-year-old Paul in 1951, he might have been ready to settle down. It was Hazel who planned the trips during which he accomplished some of his finest work—in the Hebrides, Italy, France, Egypt, Morocco, Ghana, and Romania. She was also the companion he had been searching for all his life, who knew the practical side of life and who helped him in the darkroom. Hazel and Paul may have been the only ones who knew how truly rare his greatest prints were. In many cases only one and sometimes two examples existed, and he was unwilling and perhaps unable to duplicate his original inspiration.

It was with the thought that it might be possible to help Paul create more of his masterworks that I introduced Richard Benson to him in 1973. Paul was dubious and Hazel outraged at the idea. To the suggestion that Richard assist Paul in the darkroom at Orgeval, she replied, "Never!" Only she had been allowed in the darkroom, and never to make a print. Yet, Paul, as he could do so unexpectedly, decided to give the experiment a chance and tested Richard with several of his most difficult and complex negatives. I have no idea how many sheets of paper were torn up by Richard in his attempts, but Paul was delighted with the results. He and Hazel respected and came to love Richard like the son they never had.

Beginning in 1975, Paul and Richard began an enormous project—four portfolios and editions of four single photographs on platinum paper—which became one of the most demanding projects of Strand's career. Paul supervised every step, every detail in the process. Often bedridden by the cancer that was killing him, Paul dictated introductory essays for two of the portfolios. The disease had spread to his shoulder, and toward the end—in a truly heroic effort—he could only muster the strength to sign one or two portfolios a day. In March 1976, after approving the final master print of Portfolio IV, he stopped taking all food and water and died two weeks later.

Paul was a methodical and careful man; so it was in keeping with his way of working that a day after returning from Père Lachaise cemetery, Hazel and I began to consider the final organization of his prints and negatives in France, his library, and her plans for the future. Paul always seemed to have a stack of yellow Kodak boxes by his bedside, which, we discovered, contained exquisite platinum and some satista prints. Many were of subjects that had never before been published or, as far as I knew, exhibited. As Paul had been protective of these prints, Hazel continued to be protective of Paul and of his

photographs. Similarly, a stack of prints was found under her bed after her death in 1982. Of the more than six hundred prints, at least sixty were unqualified masterpieces.

The wish that these two groups of prints should be seen, and the knowledge that Paul had found in Richard the one craftsman who could bring his vision to reality through the medium of ink, led to experimentation with the most advanced printing technologies, culminating in the publication of this book. Richard brought incomparable skills to bear on his work with Strand's original negatives, and when these were too damaged or just unavailable he studied Strand's prints and lantern slides. Like Paul's, Richard's skills extended beyond the darkroom, to the pressroom where he evolved a method of printing with a six-color press, in what he calls "colorful shades of gray."

Even more inexplicable is what we see and are continually learning to see in Strand's images. That they are timeless, utterly of place and equally universal and beyond place, is true. That they possess an inner life that allows, if we will, the casting off of veils before our eyes to penetrate a deeper reality, is also true. And yet that still does not convey the experience.

The closest adequate description is what Herman Melville once called "This 'all' feeling." In a letter to Nathaniel Hawthorne, Melville wrote: "You must often have felt it, lying on the grass on a warm summer's day. Your legs seem to send out shoots into the earth. Your hair feels like leaves upon your head. This is the all feeling." It is a feeling accessible, at least temporarily, through the profound medium of sight in a Strand image.

A more contemporary novelist sums up my feelings about this book. In *Hearing Secret Harmonies*, the last volume of his panoramic cycle, *Dance to the Music of Time*, one of Anthony Powell's characters says: ". . . you bear out a deeply held conviction of mine as to the repetitive contacts of certain earthly souls in the earthly lives of other individual souls."

Twenty years ago, a Strand Retrospective Exhibition at the Philadelphia Museum of Art led to a monograph. Peter Bradford was the designer and Wendy Byrne did all the inner material work. Stevan Baron was the production manager. All three knew Paul and Hazel, worked with them, and enjoyed a mutual respect. For the present volume, Peter, Wendy, and Steve were once again the design and production team. Richard Benson applied the experience of working with Paul Strand in the darkroom and his more than twenty-five years of lithographic printing experience to create the superb reproductions in this book. Anthony Montoya, director of the Paul Strand Archive of Aperture Foundation, contributed his insights and extensive knowledge of images and qualities of individual prints.

The production of this book has been an intense, challenging, and rewarding experience. And that is because in these images and in the process of bringing them to a new life, Paul Strand's and Hazel Kingsbury Strand's presences are so strongly felt: uncompromising, trusting, and generous.

Michael E. Hoffman, Executive Director
Aperture Foundation

CHRONOLOGY

New York, 1913

1890
Born 16 October, New York City, to Jacob and Matilda (Arnstein).
Grandparents emigrated from Bohemia. Extended family lived at home of Strand's maternal aunt on 314 West 83rd Street, New York.

1902
Receives first camera.

1904
Begins studies at Ethical Culture School, New York.

1907
Studies photography in after-school club under Lewis Hine who taught nature and geography. With class, goes to Alfred Stieglitz's Little Galleries of the Photo-Secession at 291 Fifth Avenue, New York.

1908
Art appreciation class with Charles Caffin. Accredited photography class with Hine.

1909
Joins Camera Club of New York early in year. (Had been a "non-resident" member since October 1908.)
Graduates from Ethical Culture School.
Continues photographing in spare time using Camera Club of New York facilities.

1909–1911
After graduation, works in father's and uncle's imported German enamelware business until it is sold in 1911.

April 12–May 31, 1910
Exhibits two portraits in Camera Club of New York Annual Members' Print Exhibition.

March–April 1911
Travels in Europe for six weeks, to Italy, Switzerland, Germany, Holland, Belgium, France, England, and Scotland.

April 1911
Exhibits *Temple of Love,* from Versailles (later titled *Garden of Dreams* or *Versailles*), at Camera Club of New York Annual Members' Exhibition. Wins third prize. *Temple of Love,* the first of Strand's photographs to be published, appears in *Photoisms* 2 (July 1911).

Summer 1911
Works briefly in an insurance company in New York.

Fall 1911–1918
Supports himself working as a commercial photographer making portraits and hand-tinted photographs of college campuses.

September 1912
Exhibits *Temple of Love* at London Salon and receives Honorable Mention.

1913
Begins to go to exhibitions at "291" and later to show his photographs to Alfred Stieglitz.

January 1914
Included in exhibition at Ehrich Gallery, New York.

April–May 1915
Makes trip across United States to photograph college campuses, but also photographs Niagara Falls, the Grand Canyon, New Orleans, Texas, Colorado, and California. Makes photographs of the San Diego and San Francisco Expositions.

October 1916
Six photographs are published in *Camera Work,* no. 48, all titled *New York* (later assigned individual titles: *Wall Street; Telegraph Poles; Fifth Avenue and 42nd Street, New York; Snow Backyards, New York; Apartments, New York;* and *City Hall Park, New York*).

March 13–28, 1916
First one-person exhibition at 291, *Photographs of New York and Other Places by Paul Strand,* including *Wall Street; Fifth Avenue and 42nd Street, New York; City Hall Park, New York; Maid of the Mist;* and views from his European and United States trips.

March 1–17, 1917
Photograph *Wall Street* wins first prize at *Twelfth Annual Exhibition of Photographs,* John Wanamaker, Philadelphia.

March 29–April 9, 1917
Included in exhibition, *Three Photographers: Photographs by Sheeler, Strand and Schamberg,* at de Zayas' Modern Gallery, New York. According to reviews, photo-

graphs included "architectural themes" and a "magnificent mountain bit."

June 1917
Eleven photographs published in last issue of *Camera Work*, nos. 49–50, eight titled *Photograph—New York* (later titled *Man in a Derby Hat, New York; Blind Woman, New York; Man, Five Points Square; Sandwich Man, New York;* two works, each titled *From the Viaduct, New York;* and two works, each titled *Portrait, Washington Square Park*); and three titled *Photograph* (later titled *The White Fence; Porch Shadows;* and *Bowls*). Article, "Photography," published in *Seven Arts,* is reprinted in last issue of *Camera Work.*

March 4–16, 1918
Included in *Thirteenth Annual Exhibition of Photographs,* John Wanamaker, Philadelphia. *Wheel Organization* awarded second prize; *The White Fence* awarded fifth prize; *Sleepy* awarded $5 prize.

March 6–24, 1918
Photographs of *Blind Woman* and *The Auto* included in *Exhibition of Pictorial Photography: American and European,* organized by Alfred Stieglitz at the Young Women's Hebrew Association at 31 West 110th Street, New York.

1918–1919
During First World War, trains in X-ray procedures at Mayo Clinic, then serves in the Army Medical Corps as X-ray technician at Hospital 29, Fort Snelling, Rochester, Minnesota.

March 1919
One photograph included in *Exhibition on Modern Art,* organized by Alfred Stieglitz at the Young Women's Hebrew Association.

August 1919
After release from Army, returns to New York, then travels to Georgeville, Québec.

1920–1921
Works at freelance advertising photography with Hess-Bright ball bearings as one client. Also makes slow-motion films of athletic events.

March 1–13, 1920
Included in *Fourteenth Annual Exhibition of Photographs,* John Wanamaker, Philadelphia. Awarded first prize for group of four photographs, *Automobile, White Sheets, Motor,* and *Still Life.*

Spring/Summer 1920
With Charles Sheeler, makes first film; premiere at the Rialto Theater, on Broadway, in New York, under the title *New York the Magnificent,* on July 24, 1921. Later titled *Manhatta* when it was shown at the Cameo Theater, New York, in 1926.

August 1920
Travels with Herbert Seligmann to Nova Scotia and makes landscape photographs and close-up photographs of rocks. Works as cameraman for group of physicians in New York making medical films for training.

January 1922
Marries Rebecca Salisbury.

June 8–10, 1922
Photographs of *Bowls* and *Building* included in *Loan Exhibition of Modern Art* organized by Stieglitz at the Municipal Building, Freehold, New Jersey.

Summer 1922
Buys Akeley motion picture camera and begins making close-up photographs of it.

1922–1924
After medical company goes out of business, works freelance with Akeley camera as motion picture cameraman making newsreel footage for Pathé and Fox; production shots for feature films, documentaries, Famous Players and MGM; and films of sporting events and graduation ceremonies at Princeton for the senior class record.

September 1922
Two machine photographs included in Annual Members' Print exhibition at the Camera Club of New York.

March 23, 1923
At invitation of Clarence White, delivers lecture at the Clarence H. White School of Photography, New York, "The Art Motive in Photography," subsequently published in the *British Journal of Photography,* October 5, 1923.

1925
Does photography for film *Crackerjack.*

March 9–28, 1925
Included in the *Seven Americans* exhibition at Anderson Galleries, New York, with Charles Demuth, John Marin, Marsden Hartley, Georgia O'Keeffe, Alfred Stieglitz, and Arthur Dove; catalogue introduction by Sherwood Anderson. Eighteen photographs of *New York, Leaves,* and *Machine Forms.*

August 1925
Travels to Georgetown Island, Maine, at the suggestion of Isabel and Gaston Lachaise.

Summer 1926
Travels to Colorado and New Mexico.

1927–1928
Spends summers at Georgetown Island, Maine.

1928
Works on film, *Where the Pavement Begins.*

March 19–April 7, 1929
One-person exhibition at The Intimate Gallery, New York, *Forty New Photographs by Paul Strand,* includes photographs of machine forms and nature studies taken in Maine, Colorado, and New Mexico.

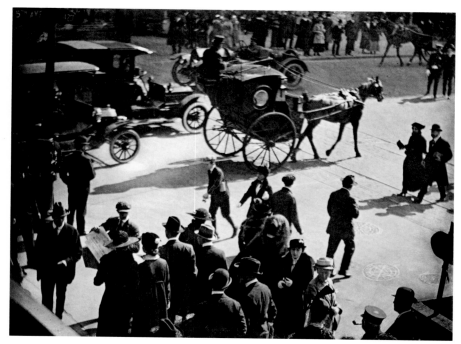

Fifth Avenue and 42nd Street, New York, 1915

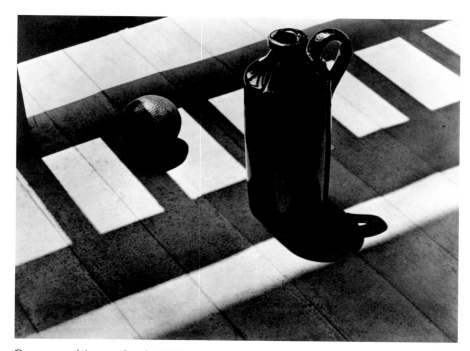

Orange and Jug on Porch, 1916

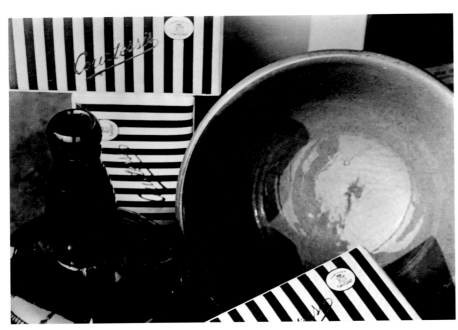

Cigarette Boxes with Bowl and Bottle, 1917

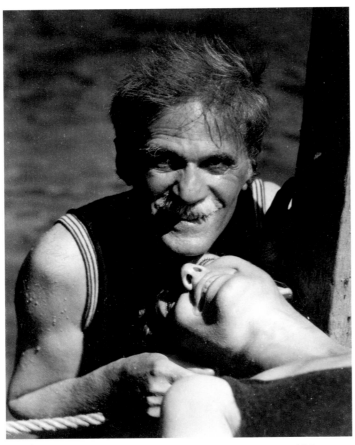

**Alfred Stieglitz and Rebecca Strand at Lake George, 1922*

Helps raise money to enable Stieglitz to found An American Place, 509 Madison Avenue, New York, which opens in the fall of 1929.

Fall 1929
Travels to the Gaspé Peninsula, Canada.

1930–1932
Travels to New Mexico during summers and photographs extensively.

November 2, 1931
Included in exhibition, *American Photography, Retrospective Exhibition,* organized with the help of Stieglitz at the Julien Levy Gallery. Exhibition includes photographs by Gertrude Käsebier, Charles Sheeler, Edward Steichen, Stieglitz, and Clarence White.

April 10–May 1932
Exhibition at An American Place, New York, *Photographs by Paul Strand, Paintings by Rebecca Strand.* Includes photographs of nature forms, New Mexico, Colorado, and the Gaspé.

December 1932
Travels to Mexico. Rebecca remains in Taos. They later divorce, and she marries William James in 1937.

1933
In Mexico, where he makes a series of photographs.

February 3–15, 1933
One-person exhibition at Sala de Arte, Mexico City.

1933–1934
Carlos Chavez, Mexican composer and conductor, appoints Strand Chief of Photography and Cinematography, Department of Fine Arts, Secretariat of Education of Mexico. Photographs, supervises production, and with A. Velazquez Chavez, writes story for the film *Redes* for the Mexican government.

Late 1934
Returns to New York from Mexico. Joins Harold Clurman, Lee Strasberg, and Cheryl Crawford, Group Theater directors working to establish a permanent repertory company that would perform avant-garde theater.

1935
Associated with film group, *Nykino.*

Summer 1935
Travels to Moscow and joins Harold Clurman and Cheryl Crawford. Meets Sergei Eisenstein, Alexander Dovchenko, Nikolai Ekk, and other directors in film and theater. Returns to the United States and with Ralph Steiner and Leo Hurwitz, photographs *The Plow That Broke the Plains,* produced by the United States Government Resettlement Administration, directed by Pare Lorentz.

1936
Film *Redes* is released in the United States as *The Wave.*

Summer 1936
Travels to the Gaspé and makes still photographs.
Marries Virginia Stevens.

1937
Organizes Frontier Films, a non-profit educational film production group, with Leo Hurwitz, Lionel Berman, Ralph Steiner, Sidney Meyers, Willard Van Dyke, David Wolff (pseud. for Ben Maddow), and others. Serves as president of Frontier Films until 1942.
With Leo Hurwitz, edits *Heart of Spain,* from material filmed by Herbert Klein and Geza Karpathi. First Frontier Films release.

October 27–December 27, 1937
Photographs *East Siders* and *Abstraction* included in the exhibition *Beginnings and Landmarks: "291"* at An American Place.

1940
With Virginia Stevens, publishes *Photographs of Mexico* portfolio of twenty photogravures of Mexico with introduction by Leo Hurwitz.

December 1940–January 1941
Strand included in group exhibition at The Museum of Modern Art, *Sixty Photographs.*

1942
Native Land released by Frontier Films. Photographed by Strand; directed by Strand and Leo Hurwitz; story written by Strand, Hurwitz, and David Wolff (pseud. for Ben Maddow).

1943
Camera work on films for wartime government agencies including photography for *It's Up to You.*

Winter 1943–1944
Travels to Vermont and makes photographs.
Begins to work primarily in still photography.

September 1944
Six photographs included in exhibition at Philadelphia Museum of Art, *Alfred Stieglitz: "291" and After. Selections from the Stieglitz Collection,* including *Clapboards,* 1916; *Dishes,* 1916; *Shadows,* 1916; *Rock Textures,* 1929; *Leaves I,* 1929; and *Leaves II,* 1929.

October 20–November 7, 1944
Chairman of the Committee of Photography of the Independent Voters Committee of the Arts and Sciences for President Roosevelt. With Leo Hurwitz and Robert Riley, edits montage of photographs depicting twelve years of the Roosevelt administration, displayed at the Vanderbilt Gallery, New York, as part of the "Artists' Tribute to President Roosevelt."

April 25–June 10, 1945
One-person exhibition, *Photographs 1915–1945 by Paul Strand,* The Museum of Modern Art, New York. Catalogue by Nancy Newhall.

1945–1946
Begins work on *Time in New England* with Nancy Newhall, traveling in New England and making photographs.

1948
Writes "A Platform for Artists" as part of the Progressive Party platform on Fine Arts.

1949
Divorced from Virginia Stevens. Meets Hazel Kingsbury.

July 1949
Travels to Czechoslovakia Film Festival at which *Native Land* is awarded prize.

Spring 1950
Travels with Hazel Kingsbury to France to begin work on *La France de Profil.*
Time in New England published.

February 21, 1951
Marries Hazel Kingsbury.

1951
France becomes his home.

1952
La France de Profil published, with text by Claude Roy.

1952–1954
Photographs in Italy.

1954
Travels to island of South Uist in the Outer Hebrides and makes photographs.

1955
Publishes *Un Paese,* a book of photographs of Italy with text by Cesare Zavattini.
Buys house in Orgeval and builds his first fully equipped darkroom.

1955–1958
Works on series of portraits of prominent French intellectuals and close-up views of his garden in Orgeval.

January 18–March 18, 1956
Included in exhibition *Diogenes with a Camera III,* The Museum of Modern Art, New York, organized by Edward Steichen.

1959
Travels to Egypt to photograph.

1960
Travels to Romania to photograph.

1962
Travels to Morocco to photograph and conduct research on Arab life.
Tir a'Murhain, Outer Hebrides, is published with text by Basil Davidson.

June 1963
Awarded to Honor Roll of the American Society of Magazine Photographers, New York.

1963–1964
Invited by President Nkrumah of Ghana to make photographic essay of the country.

March 19–April 16, 1967
Exhibition at the Mannheimer Kunstverein, Mannheim, Germany, where he is awarded the David Octavius Hill Medal through the Gesellschaft Deutscher Lichtbildner, Mannheim, Germany.
Returns to Romania to complete photographic study.
Oversees second printing of *The Mexican Portfolio* (previously titled *Photographs of Mexico*).

1969
Exhibition at Kreis Museum, Feital, Federal Republic of Germany.
Living Egypt published, with text by James Aldridge.

1969–1970
One-person exhibition for the Administration Générale des Affaires Culturelles Françaises of Belgium. Travels throughout Belgium and The Netherlands.

1970
Receives Swedish Photographers Association and Swedish Film Archives Award. Exhibition of photogravures in Stockholm; film series including *Heart of Spain, The Wave,* and *Native Land.*

November 1971–January 1972
Retrospective exhibition at Philadelphia Museum of Art, with catalogue titled *Paul Strand: A Retrospective Monograph. The Years 1915–1968.* Exhibition travels through 1973 to Museum of Fine Arts, Boston; The City Art Museum, St. Louis; The Metropolitan Museum of Art, New York; and the Los Angeles County Museum of Art.

1973
With Hazel Strand, travels to New York for opening of retrospective at The Metropolitan Museum of Art. They remain in New York until 1975.
Undergoes surgery for cataracts.

1974
Calvin Tomkins publishes profile of Strand in *The New Yorker,* September 16, 1974.

1975
Returns to Orgeval to work with Catherine Duncan on text of a book on his garden.

Fall 1975
Works with Richard Benson on developing and printing photographs for portfolios *On My Doorstep* and *The Garden.*

1976
Ghana: An African Portrait published with text by Basil Davidson.

March 31, 1976
Dies in Orgeval, France.
Portfolios *On My Doorstep* and *The Garden* are published posthumously.

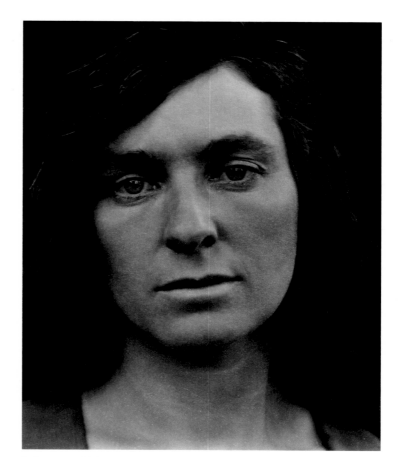

Rebecca, 1920

Rebecca, c. 1922

LIST OF
WORKS EXHIBITED

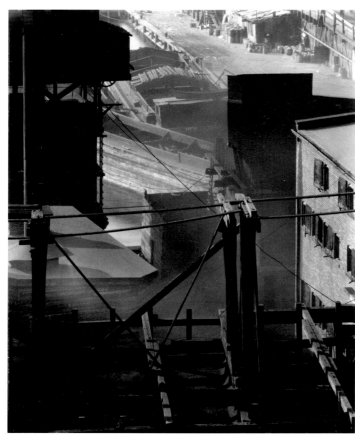

The Docks, New York, 1922

Dimensions are provided in centimeters, followed by inches in parentheses.

Cambridge, England, 1911
Platinum print
25.4 × 28.5 (10 × 11 1/4)
Paul Strand Archive,
Aperture Foundation
Page 34

Chickens, Twin Lakes, Connecticut, 1911
Gum bichromate over platinum print
25.8 × 33.7 (10 3/16 × 13 1/4)
The Art Institute of Chicago,
Ada Turnbull Hertle Fund
Page 34

Venice, 1911
Platinum print
24.1 × 31.7 (9 1/2 × 12 1/2)
Charles Allem
(Washington only)
Page 33

New York, 1913
Platinum print
26.3 × 24.7 (10 3/8 × 9 3/4)
The J. Paul Getty Museum
(Washington, Chicago, St. Louis only)
Page 152

Fifth Avenue and 42nd Street, New York, 1915
Platinum print
24.9 × 33.0 (9 13/16 × 13)
The Philadelphia Museum of Art, The Paul Strand Retrospective Collection, 1915–1975, Gift of the Estate of Paul Strand
Page 153

Fifth Avenue, New York, 1915
Platinum print
31.1 × 21.0 (12 1/4 × 8 1/4)
Courtesy Galerie Zur Stockeregg, Zurich
Page 17

Wall Street, New York, 1915
Platinum print
24.8 × 32.2 (9 3/4 × 12 11/16)
The Philadelphia Museum of Art, The Paul

Strand Retrospective Collection, 1915–1975, Gift of the Estate of Paul Strand
Pages 12–13

Blind Woman, New York, 1916
Gelatin silver print, 1920s
32.7 × 24.8 (12 7/8 × 9 3/4)
Southwestern Bell Corporation
Paul Strand Collection
Page 11

Bowls, 1916
Gelatin silver print, 1920s
33.3 × 24.6 (13 1/8 × 9 11/16)
Southwestern Bell Corporation
Paul Strand Collection
Page 25

Chair, 1916
Satista print
33.0 × 24.6 (13 × 9 11/16)
San Francisco Museum of Modern Art,
Purchase
Page 23

Jug and Fruit, 1916
Satista print
34.0 × 22.0 (13 3/8 × 8 5/8)
Gilman Paper Company Collection
Page 22

Man in a Derby Hat, New York, 1916
Platinum print
32.6 × 25.3 (12 13/16 × 9 15/16)
The Philadelphia Museum of Art, The Paul Strand Retrospective Collection, 1915–1975, Gift of the Estate of Paul Strand
Page 14

Man, Five Points Square, 1916
Platinum print
31.5 × 19.1 (12 7/16 × 7 1/2)
Museum of Fine Arts, Boston,
Sophie Friedman Fund
(Washington, Chicago, New York only)
Page 37

Morningside Park, New York, 1916
Platinum print
24.0 × 33.1 (9 7/16 × 13 1/16)
Michael E. Hoffman
Page 35

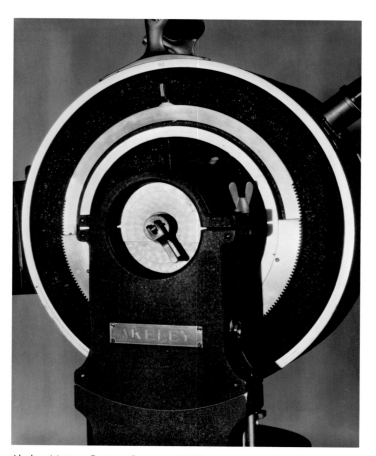

Akeley Motion Picture Camera, 1922

**Driftwood, 1927*

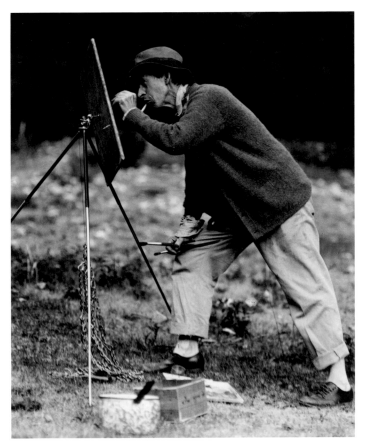

John Marin, 1930

Deserted Church, near Taos, New Mexico, 1931

Double Akeley Motion Picture Camera, 1922
Gelatin silver print
24.5 × 19.4 (9 5/8 × 7 5/8)
The Museum of Modern Art, New York, Gift
of Mrs. Armand P. Bartos
Page 39

Looking Down, New York, 1922
Gelatin silver print
24.1 × 19.4 (9 1/2 × 7 5/8)
Southwestern Bell Corporation
Paul Strand Collection
Page 38

Rebecca, c. 1922
Platinum print
24.6 × 19.5 (9 11/16 × 7 11/16)
Personal Collection of Margaret Weston,
Weston Gallery
Page 40

Rebecca, c. 1922
Platinum print
24.1 × 19.4 (9 1/2 × 7 5/8)
Mr. and Mrs. C. David Robinson
Page 155

Rebecca, 1922
Platinum print
24.4 × 19.4 (9 5/8 × 7 5/8)
Southwestern Bell Corporation
Paul Strand Collection
Page 51

The Docks, New York, 1922
Gelatin silver print
24.1 × 19.3 (9 1/2 × 7 9/16)
Southwestern Bell Corporation
Paul Strand Collection
Page 156

Akeley Motion Picture Camera, 1923
Gelatin silver print
24.5 × 19.4 (9 5/8 × 7 5/8)
The Museum of Modern Art, New York,
Gift of the Photographer
Page 57

Lathe #1, New York, 1923
Gelatin silver print
24.0 × 18.9 (9 1/2 × 7 7/16)
Southwestern Bell Corporation
Paul Strand Collection
Page 60

Rebecca, 1923
Platinum print
19.4 × 24.5 (7 5/8 × 9 5/8)
The Metropolitan Museum of Art,
New York, Gift of Marilyn Walter Grounds
Page 40

Rebecca, 1923
Platinum print
19.4 × 24.6 (7 5/8 × 9 5/8)
The Art Institute of Chicago,
Ada Turnbull Hertle Fund
Page 63

Rebecca's Hands, 1923
Palladium print
25.3 × 20.2 (10 × 7 15/16)
Museum of Fine Arts, Boston,
Sophie Friedman Fund
(Washington, Chicago, New York only)
Page 61

The Court, New York, 1924
Gelatin silver print
24.6 × 19.3 (9 11/16 × 7 5/8)
San Francisco Museum of Modern Art, The
Helen Crocker Russell and Walter H. and
Ethel W. Crocker Family Funds Purchase
Page 56

Apartment Repainted, New York, 1925
Gelatin silver print
23.9 × 19.4 (9 3/8 × 7 5/8)
Southwestern Bell Corporation
Paul Strand Collection
Page 58

Mullein, Maine, 1927
Platinum print
24.5 × 19.5 (9 5/8 × 7 5/8)
Courtesy Peter C. Daub, Zürich
Page 107

Driftwood, 1927
Platinum print
24.5 × 19.2 (9 5/8 × 7 9/16)
Southwestern Bell Corporation
Paul Strand Collection
Page 157

Rock, 1927
Gelatin silver print
24.1 × 19.2 (9 1/2 × 7 9/16)
Southwestern Bell Corporation
Paul Strand Collection
Page 66

Rock, Georgetown, Maine, 1927
Gelatin silver print
24.1 × 19.2 (9 1/2 × 7 9/16)
Southwestern Bell Corporation
Paul Strand Collection
Page 67

Wild Iris, Maine, 1927
Gelatin silver print
24.3 × 19.2 (9 9/16 × 7 9/16)
National Gallery of Art,
Southwestern Bell Corporation
Paul Strand Collection
Page 65

Woods, Maine, 1927
Platinum print
24.5 × 19.1 (9 5/8 × 7 1/2)
Southwestern Bell Corporation
Paul Strand Collection
Page 62

Driftwood, Dark Roots, Georgetown,
Maine, 1928
Gelatin silver print
19.4 × 24.3 (7 5/8 × 9 5/8)
Southwestern Bell Corporation
Paul Strand Collection
Page 41

Driftwood, Maine, 1928
Platinum print
24.3 × 19.2 (9 9/16 × 7 9/16)
Southwestern Bell Corporation
Paul Strand Collection
Page 54

Toadstool and Grasses, Georgetown,
Maine, 1928
Gelatin silver print
24.2 × 19.1 (9 1/2 × 7 1/2)
Southwestern Bell Corporation
Paul Strand Collection
Page 55

Fence and Houses, Gaspé, 1929
Gelatin silver print
11.8 × 14.9 (4 5/8 × 5 7/8)
Southwestern Bell Corporation
Paul Strand Collection
Page 73

Houses, Gaspé, 1929
Platinum print
11.8 × 14.9 (4 5/8 × 5 7/8)
Southwestern Bell Corporation
Paul Strand Collection
Page 72

Percé Harbor, Gaspé, 1929
Gelatin silver print
11.6 × 14.6 (4 9/16 × 5 3/4)
Southwestern Bell Corporation
Paul Strand Collection
Page 70

White Shed, Fox River, Gaspé, 1929
Gelatin silver print
9.2 × 11.8 (3 5/8 × 4 11/16)
The J. Paul Getty Museum
(Washington, Chicago, St. Louis only)
Page 69

Apache Fiesta, 1930
Platinum print
9.1 × 12.0 (3 5/8 × 4 3/4)
Museum of Fine Arts,
Museum of New Mexico,
Purchased with funds raised in honor of

Beaumont Newhall and Eliot Porter with a
special gift from Edna and Bela Kalman
Page 82

Hacienda, near Taos, New Mexico, 1930
Platinum print
24.3 × 19.3 (9 9/16 × 7 9/16)
Southwestern Bell Corporation
Paul Strand Collection
Page 87

John Marin, 1930
Gelatin silver print
11.8 × 9.2 (4 5/8 × 3 5/8)
Paul Strand Archive,
Aperture Foundation
Page 158

Black Mountain, Cerro, New Mexico, 1931
Platinum print
11.8 × 14.9 (4 11/16 × 5 7/8)
The J. Paul Getty Museum
(Chicago, St. Louis only)
Page 43

City Hall, Colorado, 1931
Gelatin silver print
19.4 × 24.5 (7 5/8 × 9 5/8)
Southwestern Bell Corporation
Paul Strand Collection
Page 84

Deserted Building, New Mexico, 1931
Gelatin silver print
19.4 × 24.5 (7 5/8 × 9 5/8)
Southwestern Bell Corporation
Paul Strand Collection
Page 85

Deserted Church, near Taos,
New Mexico, 1931
Platinum print
24.5 × 19.7 (9 5/8 × 7 3/4)
Private Collection, Courtesy Weston
Gallery
Page 158

Near Ranchos de Taos, New Mexico, 1931
Platinum print
11.7 × 14.9 (4 5/8 × 5 7/8)
Southwestern Bell Corporation
Paul Strand Collection
Page 81

Ranchos de Taos Church, New Mexico, 1931
Platinum print
15.0 × 11.7 (5 15/16 × 4 5/8)
Kunsthaus Zürich
Page 42

Ranchos de Taos Church, New Mexico, 1931
Gelatin silver print
11.8 × 14.9 (4 5/8 × 5 7/8)

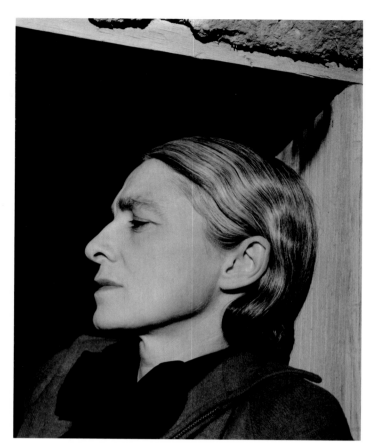

Rebecca, Taos, New Mexico, 1931–1932

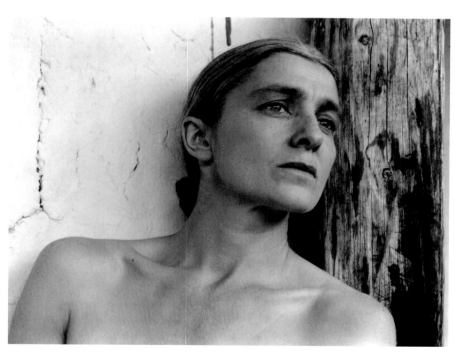

**Rebecca, New Mexico,* 1931

*Rebecca, New Mexico, 1932

Roberta Hawk, Taos, New Mexico, 1932

Southwestern Bell Corporation
Paul Strand Collection
Page 79

Rebecca, New Mexico, 1931
Platinum print
9.4 × 12.1 (3 11/16 × 4 3/4)
National Gallery of Art,
Southwestern Bell Corporation
Paul Strand Collection
Page 159

Red River, New Mexico, 1931
Gelatin silver print
19.2 × 24.5 (7 9/16 × 9 5/8)
Southwestern Bell Corporation
Paul Strand Collection
Page 86

The Dark Mountain, New Mexico, 1931
Platinum print
11.8 × 15.0 (4 5/8 × 5 15/16)
University Art Museum, University of
New Mexico
Gift of The Paul Strand Foundation
Given in honor of Beaumont Newhall
Page 80

Rebecca, Taos, New Mexico, 1931–1932
Platinum print
24.7 × 19.5 (9 3/4 × 7 11/16)
The J. Paul Getty Museum
(Chicago, St. Louis only)
Page 159

Near Abiquiu, New Mexico, 1932
Platinum print
11.7 × 14.9 (4 5/8 × 5 7/8)
Courtesy Galerie Zür Stockeregg, Zürich
Page 77

Near Rinconada, New Mexico, 1932
Platinum print
19.1 × 24.2 (7 1/2 × 9 1/2)
Southwestern Bell Corporation
Paul Strand Collection
Page 83

Near Saltillo, Mexico, 1932
Platinum print
11.6 × 14.6 (4 9/16 × 5 3/4)
Personal Collection of Margaret Weston,
Weston Gallery
Page 92

Ranchos de Taos Church, New Mexico, 1932
Platinum print
14.9 × 11.7 (5 7/8 × 4 5/8)
The Museum of Modern Art, New York, Gift
of the Photographer
Page 78

Rebecca, New Mexico, 1932
Platinum print
14.9 × 11.8 (5 7/8 × 4 5/8)

Southwestern Bell Corporation
Paul Strand Collection
Page 160

Roberta Hawk, Taos, New Mexico, 1932
Platinum print
14.8 × 11.7 (5 13/16 × 4 5/8)
Center for Creative Photography, Tucson
Page 160

Boy, Hidalgo, 1933
Platinum print
14.6 × 11.6 (5 3/4 × 4 9/16)
Southwestern Bell Corporation
Paul Strand Collection
Page 93

Christo, Tlacochoaya, Oaxaca, 1933
Platinum print
24.5 × 19.2 (9 5/8 × 7 9/16)
Southwestern Bell Corporation
Paul Strand Collection
Page 97

*Four Men and Child, Dia de Fiesta, Mexico,
1933*
Platinum print
11.8 × 14.8 (4 5/8 × 5 13/16)
Museum of Fine Arts, Boston,
Sophie Friedman Fund
(Washington, Chicago, New York only)
Page 91

Gateway, Hidalgo, 1933
Platinum print
24.6 × 19.3 (9 11/16 × 7 5/8)
The Saint Louis Art Museum, Purchase
Page 98

Man with Sombrero, Mexico, 1933
Platinum print
14.8 × 11.9 (5 13/16 × 4 11/16)
Southwestern Bell Corporation
Paul Strand Collection
Page 45

Man, Tenancingo, 1933
Platinum print
14.8 × 11.6 (5 13/16 × 4 9/16)
Southwestern Bell Corporation
Paul Strand Collection
Page 89

Village, Tlaxcala, Mexico, 1933
Platinum print
11.4 × 14.6 (4 1/2 × 5 3/4)
The J. Paul Getty Museum
(Chicago, St. Louis only)
Page 90

*The Nets, Janitzio, Lake Pátzcuaro,
Michoacán, Mexico, 1933*
Gelatin silver print, c. 1942–1945
11.6 × 14.8 (4 5/8 × 5 7/8)

The J. Paul Getty Museum
(Washington, Chicago, St. Louis only)
See note on page 164

Virgin, San Felipe, Oaxaca, 1933
Platinum print
24.5 × 19.2 (9 5/8 × 7 9/16)
Southwestern Bell Corporation
Paul Strand Collection
Page 99

Women of Santa Ana—Michoacán, 1933
Platinum print
11.6 × 14.7 (4 5/8 × 5 7/8)
Paul Strand Archive,
Aperture Foundation
Page 94

Boat Houses, Wolf River, Gaspé, 1936
Platinum print
19.1 × 24.8 (7 1/2 × 9 3/4)
Weston Gallery
Page 74

Fox River, Gaspé, 1936
Platinum print
11.8 × 14.9 (4 5/8 × 5 7/8)
Paul Strand Archive,
Aperture Foundation
Page 71

Fred Briehl's Barn, Wallkill, New York, 1936
Platinum print
24.0 × 19.0 (9 7/16 × 7 1/2)
The Southland Corporation
Page 75

Iron Latch, East Jamaica, Vermont, 1943
Gelatin silver print
24.0 × 19.2 (9 7/16 × 7 9/16)
Southwestern Bell Corporation
Paul Strand Collection
Page 161

Mr. Bolster, Vermont, 1943
Gelatin silver print
14.6 × 11.5 (5 3/4 × 4 9/16)
Museum of Fine Arts, Boston,
Sophie Friedman Fund
(Washington, Chicago, New York only)
Page 46

Mr. Bennett, Vermont, 1944
Gelatin silver print
11.8 × 14.8 (4 5/8 × 5 13/16)
Southwestern Bell Corporation
Paul Strand Collection
Page 105

Toward the Sugar House, Vermont, 1944
Gelatin silver print
24.2 × 19.3 (9 1/2 × 7 5/8)
National Gallery of Art,

Southwestern Bell Corporation
Paul Strand Collection
Page 104

Bell Rope, 1945
Gelatin silver print
24.4 × 19.2 (9 5/8 × 7 9/16)
The Museum of Fine Arts, Houston,
Museum purchase
Page 106

Susan Thompson, Cape Split, Maine, 1945
Gelatin silver print
14.9 × 11.8 (5 7/8 × 4 5/8)
The Cleveland Museum of Art,
Leonard C. Hanna, Jr., Fund
Page 101

Burying Ground, Vermont, 1946
Gelatin silver print
14.8 × 11.7 (5 13/16 × 4 9/16)
Southwestern Bell Corporation
Paul Strand Collection
Page 102

Figurehead, "Lady with a Medallion," 1946
Gelatin silver print
24.3 × 19.2 (9 1/2 × 7 1/2)
Museum of Fine Arts, Boston,
Sophie Friedman Fund
(Washington, Chicago, New York only)
Page 109

Open Sea, Cape Split, Maine, 1946
Gelatin silver print
11.8 × 14.9 (4 11/16 × 5 7/8)
The J. Paul Getty Museum
(Washington, Chicago, St. Louis only)
Page 103

Parlor, Prospect Harbor, Maine, 1946
Gelatin silver print
24.1 × 19.1 (9 1/2 × 7 1/2)
Southwestern Bell Corporation
Paul Strand Collection
Page 108

Side Porch, 1946
Gelatin silver print
24.3 × 19.2 (9 9/16 × 7 9/16)
Southwestern Bell Corporation
Paul Strand Collection
Page 110

Tombstone, Winged Skull, 1946
Gelatin silver print
19.2 × 24.0 (7 9/16 × 9 7/16)
Southwestern Bell Corporation
Paul Strand Collection
Page 161

*Iron Latch, East Jamaica, Vermont, 1943

*Tombstone, Winged Skull, 1946

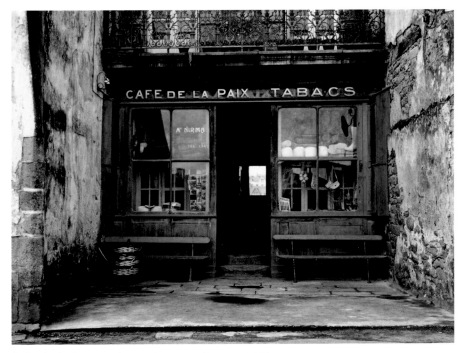

Café de la Paix, Audierne, Finistère, France, 1950

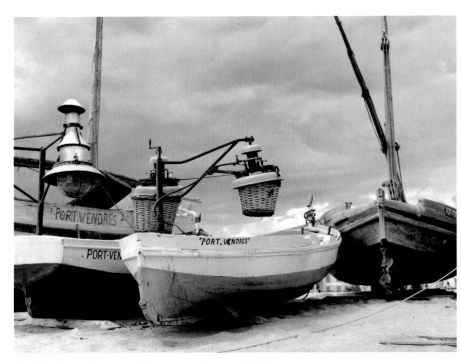

Port Vendres, Pyrénées-Orientales, France, 1950

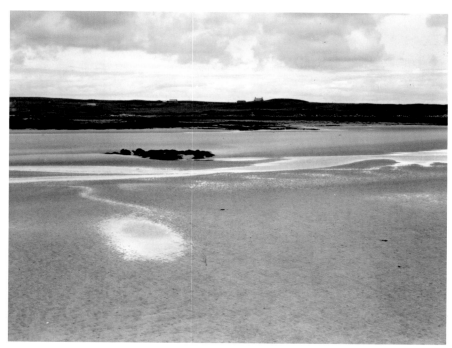

*Tide Going Out, South Uist, Hebrides, 1954

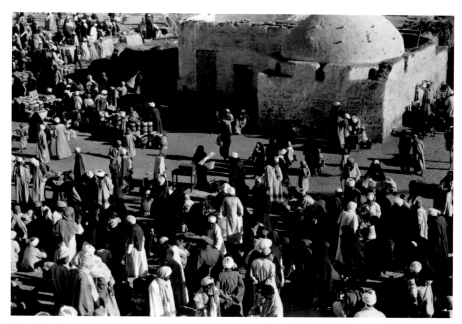

*The Market, Aswan, Egypt, 1959

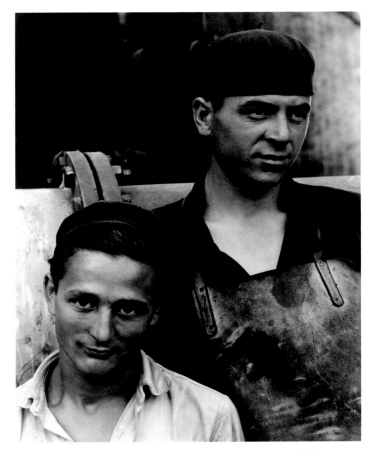

Ion Diaconu and Ilie Costache, Sapinesti, Romania, 1960

Oil Refinery, Tema, Ghana, 1963

The Market, Aswan, Egypt, 1959
Gelatin silver print
16.8 × 24.0 (6 5/8 × 9 7/16)
Southwestern Bell Corporation
Paul Strand Collection
Page 163

Yellow Vine and Rock Plants, Orgeval, 1960
Gelatin silver print
24.5 × 19.3 (9 11/16 × 7 5/8)
Paul Strand Archive,
Aperture Foundation
Page 148

*Ion Diaconu and Ilie Costache, Sapinesti,
Romania,* 1960
Gelatin silver print
22.9 × 17.8 (9 × 7)
Paul Strand Archive,
Aperture Foundation
Page 164

Rushdie Abdul Salan, Helwan, 1962
Gelatin silver print
18.1 × 22.7 (7 1/8 × 8 15/16)
The Philadelphia Museum of Art, The Paul
Strand Retrospective Collection, 1915–
1975, Gift of the Estate of Paul Strand
Page 48

Oil Refinery, Tema, Ghana, 1963
Gelatin silver print
23.6 × 19.0 (9 1/4 × 7 1/2)
Michael E. Hoffman
Page 164

Fungus, The Garden, Orgeval, 1967
Gelatin silver print
24.0 × 18.8 (9 7/16 × 7 3/8)
The Philadelphia Museum of Art, The Paul
Strand Retrospective Collection, 1915–
1975, Gift of the Estate of Paul Strand
Page 146

The Docks, Romania, 1967
Gelatin silver print
24.4 × 19.4 (9 5/8 × 7 5/8)
Paul Strand Archive,
Aperture Foundation
Page 48

Columbine, Orgeval, 1974
Gelatin silver print
28.9 × 27.6 (11 3/8 × 10 7/8)
Weston Gallery
Page 49

Orgeval, 1974
Gelatin silver print
28.2 × 22.8 (11 1/8 × 9)
Southwestern Bell Corporation
Paul Strand Collection
Page 149

Note: *The Nets, Janitzio, Lake Pátzcuaro,
Michoacán, Mexico,* 1933, reproduced on
page 95, is a variant of the photograph
included in the exhibition.

NOTES

1. Paul Strand, ''Photography,'' *Camera Work,* nos. 49–50 (June 1917), 3–4.

2. *The Seven Arts* 1 (August 1917), 524–526. When published in *Camera Work,* it was noted that this article was ''reprinted, with permission, from *Seven Arts.''*

3. Waldo Frank and James Oppenheim [Editorial], *The Seven Arts* 1 (November 1916), 55, 52.

4. Waldo Frank, ''Vicarious Fiction,'' *The Seven Arts* 1 (January 1917), 302.

5. Paul Strand, ''Photography,'' *Camera Work,* nos. 49–50 (June 1917), 4.

6. Frank and Oppenheim [Editorial], 52–53.

7. Frank and Oppenheim [Editorial], 52.

8. Waldo Frank, ''Concerning a Little Theater,'' 1916, reprinted in *Salvos* (New York, 1924), 50.

9. Paul Strand to Mr. and Mrs. Jacob Strand, 11 April 1915, quoted in Naomi Rosenblum, ''Paul Strand: The Early Years, 1910–1932,'' Ph.D. diss., City University of New York, 1978, 36–37; Paul Strand, ''John Marin,'' *Art Review* 1 (January 1922), 22; and Paul Strand, ''Stieglitz: An Appraisal,'' *Popular Photography* 21 (July 1947), 88.

10. Paul Strand, *On My Doorstep: A Portfolio of Eleven Original Photographs, 1914–1973* (New York, 1976), unpaginated.

11. Paul Strand, ''Georgia O'Keeffe,'' *Playboy* 9 (July 1924), 19.

12. Strand wrote to Stieglitz, ''Lewis Hine, my first teacher in photography at school, was here. He amused me much by saying that he thought my work would offer much to a psychoanalyst.'' Undated letter (late November 1920), Paul Strand Archive, Center for Creative Photography, University of Arizona, Tucson, hereafter cited as PSA/CCP.

13. See Felix Adler, *The Fiftieth Anniversary of the Ethical Movement, 1876–1926* (New York, 1926), 3–29.

14. For further discussion of both the Ethical Culture School and progressive education, see Lawrence A. Cremin, *The Transformation of the School: Progressivism in American Education, 1876–1957* (New York, 1964).

15. Naomi Rosenblum, ''Biographical Notes,'' *America and Lewis Hine: Photographs 1904–1940* (New York, 1977), 17. Whether Hine had been photographing before this is unclear.

16. Unpublished notes by Nancy Newhall in the collection of Beaumont Newhall, Santa Fe, New Mexico; hereafter cited as Newhall Collection.

17. Quoted by Rosenblum, ''Biographical Notes,'' *America and Lewis Hine,* 17.

18. Quoted by Maren Stange, *Symbols of Ideal Life: Social Documentary Photography in America, 1890–1950* (Cambridge, England, 1989), 92, and by Alan Trachtenberg, ''Ever—the Human Document,'' *America and Lewis Hine,* 121, 133.

19. Trachtenberg, ''Ever—the Human Document,'' 133, 128.

20. Calvin Tomkins, no doubt as a result of his interviews with Strand, wrote in ''Profiles: Look to the Things Around You,'' *The New Yorker* (16 September 1974), 46, that on this visit Strand discovered the work of David Octavius Hill, Robert Adamson, and Julia Margaret Cameron. Although Stieglitz did publish the work of these three photographers in *Camera Work* in numbers 11, 28, 37, and 41, they were not included in the regular exhibition at The Little Galleries of the Photo-Secession. It is possible, but unlikely, that Stieglitz showed examples of these nineteenth-century photographers' work to Hine's class. Probably Strand discovered their work at a slightly later time through reproductions in *Camera Work.*

21. A. Horsley Hinton, ''Some Motives,'' *Camera Notes* 3 (October 1899), 55. These ideas, it should be noted, were echoed in Hine's own teachings: as early as 1906 he had written that a beginning photographer should select simple compositions and seek ''by the arrangement of lines and masses of light and shadow, to re-tell some of these emotions he has experienced'' in front of nature; ''The Silhouette in Photography,'' *The Photographic Times* 38 (October 1906), 488–489.

22. Strand became a non-resident member in October 1908 and a full member in 1909.

23. Repr. Kaspar Fleischmann, *Paul Strand* (exh. cat., Galerie für Kunstphotographie, Zurich, 1988), 15.

24. Strand quoted in *Paul Strand: Sixty Years of Photographs* (Millerton, New York, 1976), 142.

25. As quoted in *Paul Strand: Sixty Years,* 144.

26. John Marin, catalogue for 1913 exhibition at 291, reprinted in *Camera Work,* nos. 42–43 (April–July 1913), 18. I am grateful to my colleague Ruth Fine for first pointing out to me the common bonds between Marin and Strand.

27. Strand told Calvin Tomkins (''Profiles,'' 48), ''One of the elements I wanted to work with then was people moving in the street. I wanted to see if I could organize a picture of that kind of movement in a way that was abstract and controlled.'' In order to do this Strand often extensively reworked his negatives to reduce or eliminate distracting details. For example, in *Fifth Avenue, New York, 1915* (repr. *Paul Strand: A Retrospective Monograph, The Years 1915–1946* [Millerton, New York, 1971], 23), he retouched both a street sign and a manhole cover to make them less obtrusive.

28. For an excellent, detailed discussion of the introduction of modern art to America, and specifically New York City, see Marius de Zayas, ''How, When, and Why Modern Art Came to New York,'' *Arts Magazine* 54 (April 1980), 96–126.

29. *Paul Strand: Sixty Years,* 143.

30. For further discussion of the ideas expounded at 291, see Judith K. Zilczer, ''The Aesthetic Struggle in America, 1913–1918: Abstract Art and Theory in the Stieglitz Circle,'' Ph.D. diss., University of Delaware, 1975, and Sarah E. Greenough, ''Alfred Stieglitz's Photographs of Clouds,'' Ph.D. diss., University of New Mexico, 1984, 44–105.

31. Stieglitz as paraphrased in ''The First Great 'Clinic to Revitalize Art,' '' *New York American,* 26 January 1913, 5–CE.

32. De Zayas, ''Photography,'' *Camera Work,* no. 41 (January 1913), 17, and ''Photography and Artistic Photography,'' *Camera Work,* nos. 42–43 (April–July 1913), 13, 14.

33. Naomi Rosenblum in *Paul Strand: The Early Years,* 56–57, argues persuasively that Strand first made his photographic abstractions in 1916. Strand also briefly returned to his abstract experiments after his release from the Army in 1919. He wrote to Stieglitz on 22 October 1919. ''I've been photographing every day for the past four days, trying out the Protar, on some still lifes—the first since those in *Camera Work*—Ransacked the kitchen for bowls, eggs, platters and God knows what—a real adventure—Using portrait film and have really gotten quality and a plasticity that the earlier things never dreamt of having''; PSA/CCP.

34. *Paul Strand: Sixty Years,* 144. As recounted in this interview given toward the end of his life, Strand's list of those artists shown at 291 is interesting: he neglected Cézanne, whose work clearly seems to have influenced the young photographer, but included Léger whom Stieglitz did not exhibit.

35. Interview quoted by William Inness Homer, *Alfred Stieglitz and the American Avant-Garde* (Boston, 1977), 246.

36. A few days after she met Strand and saw his work, O'Keeffe wrote ''I've been wanting to tell you again and again how much I liked your work—I believe I've been looking at things and seeing them as I thought you might photograph them—Isn't that funny—making Strand photographs for myself in my head,'' 3 June 1917, quoted in *Georgia O'Keeffe: Art and Letters,* Jack Cowart and Juan Hamilton, Letters selected and annotated by Sarah Greenough (exh. cat. National Gallery of Art, Washington, 1987), 161. At this time in her career, photography, and specifically

Strand's images and to a lesser extent Stieglitz's, seems to have shown O'Keeffe how she could walk the fine line between abstraction and reality, merging the lessons she had learned from Matisse and Kandinsky with her desire to record the wonder of the west Texas landscape.

37. Paul Strand, "Marin," *Art Review*, 1922, 22.

38. Interview quoted by Homer, *Alfred Stieglitz and the American Avant-Garde*, 246.

39. Paul Strand, "Photography," *Camera Work*, nos. 49–50 (June 1917), 3.

40. *Paul Strand: Sixty Years*, 144.

41. Rosenblum in *Paul Strand: The Early Years*, 58–61, writes that "the immediate inspiration for Strand's 1916 portraits is not readily apparent." Suggesting that they refer back to Stieglitz's earliest European studies as well as images by Jacob Riis, she notes that Strand may "have been shown Hine's Ellis Island portraits while a student at E[thical] C[ulture] S[chool] but it is doubtful that he retained a memory of these images." She further suggests that Strand could have been influenced by Stieglitz's portraits of his friends at 291 or Coburn's portraits in *The Men of Mark* or *More Men of Mark*. However, although there are stylistic differences, Stieglitz's and Coburn's images do not explain Strand's radical choice of subject matter.

42. Tomkins, "Profiles," 51.

43. Rosenblum in *Paul Strand: The Early Years*, 157, notes that *Spoon River Anthology* was reprinted in 1924 (as it had been every year since its publication in 1915), and states that Strand implied he did not discover Masters' work until 1926. This seems highly unlikely. When first published in 1915, *Spoon River* was highly acclaimed and very popular, especially among those associated with 291 and *The Seven Arts*. It was hailed as an "extremely significant" for the future development of American literature: "in this lies a great hope for a national art"; Oppenheim, [Editorial] *The Seven Arts*, 1 (December 1916), 155–156. See letter from Strand to Nancy and Beaumont Newhall, 2 May 1958 (reprinted in this catalogue) for further discussion of Masters' influence.

44. It is unclear who actually titled Strand's photographs when they were reproduced in *Camera Work*, for Stieglitz frequently took the liberty of changing the titles of work by "his" artists. Only a year after it was reproduced in *Camera Work* as *Photograph* Strand's study of the blind woman was exhibited in the *Exhibition of Pictorial Photography: American and European* at the Young

Women's Hebrew Association in New York, where it was titled *Blind Woman*. However, as Stieglitz organized this exhibition, it is again unclear who assigned this title.

45. Stieglitz, "Our Illustrations," *Camera Work*, nos. 49–50 (June 1917), 36, and letter to R. Child Bayley, 17 April 1916, Collection of American Literature, Beinecke Rare Book and Manuscript Library, Yale University, New Haven.

46. Stieglitz awarded Strand's photograph *Wall Street* first prize in the 1917 Wanamaker exhibition; Karl Struss won fifth prize and Edward Weston won three tenth prizes. Strand won second and fifth prizes in the 1918 Wanamaker show for *Wheel Organization* and *The White Fence*, while Sheeler won first and fourth prizes and Morton Schamberg won third. Stieglitz selected four of Strand's images as first prize winners in the 1920 Wanamaker show: *Automobile, White Sheets, Motor,* and *Still Life*. The Wanamaker exhibitions form a fascinating footnote to the history of American photography at the turn of the century, and a curious and contradictory chapter in Stieglitz's career. The Wanamaker department store held the first exhibiton in 1899 and when Stieglitz was first asked to be a judge in 1912 the annual exhibitions were decidedly populist. Although Stieglitz had spent the last ten years insisting that only the finest examples of the art of photography should be exhibited, in this 1912 exhibition Stieglitz, along with the photographers William Rau and Elias Goldensky, accepted 2027 photographs to be shown. In the years between 1912 and 1920 the Wanamaker exhibitions represent a microcosm of the transition from pictorial photography to a modern aesthetic as Stieglitz gradually reduced the number of photographs exhibited and placed more attention on the innovative work of Strand, Sheeler, and Schamberg.

47. *Stieglitz Memorial Portfolio* (New York, 1947), 27.

48. Strand, "What was 291?" unpublished manuscript, PSA/CCP. Warning against the "unrestrained manifestation of self" that flourished in the United States, Felix Adler urged members of the Ethical Culture Society to recognize and cultivate those "binding ties" that link the individual both to the larger society and to his past. See Adler, *The Fiftieth Anniversary of the Ethical Movement*, 18–24.

49. Paul Strand to Alfred Stieglitz, 9 August 1919, PSA/CCP.

50. Unsigned, "The Spirit of Walt Whitman Stands behind *The Seven Arts*," *The Seven Arts* 2 (May 1917), vii, and "To the Friends

of *The Seven Arts*," *The Seven Arts* 2 (October 1917), unpaginated.

51. Ernest Bloch, "Man and Music," *The Seven Arts* 1 (March 1917), 496.

52. James Oppenheim [Editorial], *The Seven Arts* 1 (December 1916), 154–156.

53. William Carlos Williams, *The Great American Novel* (Paris, 1923), 17, 26. Williams also believed it was imperative to "re-name" things that had been "lost in the chaos of borrowed titles . . . nameless under an old misappellation"; *In the American Grain* (New York, 1925, 1956), unpaginated. For further discussion of Williams' connection with the Stieglitz group in the 1920s, see Bram Dijkstra, *The Hieroglyphics of a New Speech: Cubism, Stieglitz, and the Early Poetry of William Carlos Williams* (Princeton, 1969).

54. Waldo Frank, "For a Declaration of War," *Salvos* (New York, 1924), 15. Frank further described his generation as involved in a "great war . . . it is the war of a new consciousness against the forms and language of a dying culture"; *Salvos*, 14.

55. "John Marin by Himself," *Creative Art* 3 (October 1928), xxxix.

56. Malcolm Cowley in *The Exile's Return*, (New York, 1934, 1976), 213, noted, "About the year 1924 there began a great exodus toward Connecticut, the Catskills, northern New Jersey and Bucks County, Pennsylvania. . . . It remained true, however, that most of them lived in their country homes as they might live in a summer hotel. The ownership of an old house full of Boston rockers and Hitchcock chairs did not endow them with a past. The land for which they were overassessed was not really their[s]; it did not stain their hands or color their thoughts. They had no functional relation to it: they did not clear new fields, plant crops, depend on its seasons or live by its fruits." O'Keeffe was amused with all the talk by the Stieglitz writers and artists to create "the great American novel" or the great Amercan painting, when in truth most of them had rarely ventured west of the Mississippi. See Georgia O'Keeffe, *Georgia O'Keeffe* (N Y, 1976), unpaginated.

57. Paul Strand, "American Water Colors at the Brooklyn Museum," *The Arts* 2 (December 1921), 149, 151, 152, 150.

58. Paul Strand, "John Marin," *Art Review*, 23.

59. Paul Strand, "The Subjective Method," *The Freeman* 2 (2 February 1921), 498; Paul Strand, "American Water Colors," *The Arts*, 151, and Paul Strand, "John Marin," *Art Review*, 23.

60. Strand, "Georgia O'Keeffe," *Playboy* 9 (July 1924), 16, 19, 20. In a letter of 18 April

1924 to J. Dudley Johnston of the Royal Photographic Society Strand urged photographers to read both Clive Bell and Roger Fry; PSA/CCP.

61. Strand, "John Marin," *Art Review*, 22.

62. Throughout the twenties Strand made films for Fox Films, Pathé, Metro-Goldwyn-Mayer, and Paramount. Occasionally he was the photographer for feature-length films, such as *Crackerjack* in 1925, but more often he took whatever jobs were available recording boxing matches, polo games, the Kentucky Derby, college football games, and even the laying of water pipes. He was praised for his skilled productions: a reviewer noted that his "artistic knowledge of composition, lighting, and grouping has resulted in a host of exceptionally beautiful backgrounds" in the film *Crackerjack*, with the result that "picture plays" were now being judged both by their artistic achievements as well as the strength of their stories; Charles C. Burr, "Cameraman's 'Mood' Big Factor in Films that Would Suceed," undated clipping (c. 1925) in Scrapbooks, PSA/CCP. Strand, however, did not regard this work as very significant; he saw it as but a means of support that allowed him, albeit very occasionally, to make still photographs.

63. Strand, unpublished press release, c. summer 1921, PSA/CCP. See Jan-Christopher Horak, "Modernist Perspectives and Romantic Desire: Manhatta," *Afterimage* 15 (November 1987), 8–15, for a thorough discussion of this film.

64. Paul Strand to Richard Shale, 31 March 1975, PSA/CCP. Horak in "Modernist Perspectives," 13, points out that the lines used in *Manhatta* are not exclusively from Whitman's poem "Manahatta." He also argues persuasively against the previous suggestion "that the intertitles were added by commercial interests against the wishes of Sheeler and Strand," noting Sheeler's connection with William Carlos Williams and the latter's deep appreciation for Whitman. In addition it should also be added that Whitman was the guiding force of the cultural nationalists: "The spirit of Walt Whitman stands behind *The Seven Arts*," the editors proclaimed. "What we are seeking, is what he sought: that intense American nationality in which the spirit of the people is shared though its tasks and its arts, its undertakings and its songs"; *The Seven Arts* 2 (May 1917), vii.

65. Paul Strand to Sherwood Anderson, 20 July 1920, Sherwood Anderson Collection, Newberry Library. Reprinted in this catalogue.

66. Paul Strand, "Photography and the New God," *Broom*, 1922, reprinted in

A Photographic Vision, ed. Peter Bunnell (Salt Lake City, 1980), 205.

67. Sherwood Anderson to Peter Ochremenko, January 1923, quoted in *The Letters of Sherwood Anderson*, ed. Howard Mumford Jones and Walter B. Rideout (Boston, 1953), 92.

68. Paul Strand to Alfred Stieglitz, 13 July 1926, PSA/CCP, reprinted in this catalogue.

69. At the turn of the century, composite portraits were very common. These multiple photographs superimposed on one another were used to construct generalized images of types of people. The fact that Stieglitz adopted this term to describe his multiple portrait of O'Keeffe indicates that his intention was less to document truths about O'Keeffe at a specific moment in time and more to build a synthetic whole of his vision of woman in general. For further discussion of Strand's portrait of Rebecca, see Belinda Rathbone, "Portrait of a Marriage: Paul Strand's Photographs of Rebecca," *J. Paul Getty Museum Journal* 17 (1989), 83–98.

70. Strand, "Alfred Stieglitz and a Machine," privately printed, 14 February 1921, reprinted in *Manuscripts*, no. 2 (March 1922), 7. Strand mistakenly wrote this about Stieglitz's portraits of O'Keeffe; however, as even O'Keeffe herself recognized, Stieglitz, no matter whether he was photographing skyscrapers, landscapes, or portraits, was "always photographing himself"; *Georgia O'Keeffe: A Portrait by Alfred Stieglitz* (exh. cat., The Metropolitan Museum of Art, New York, 1978) unpaginated.

71. Clive Bell, *Art* (New York, 1913), 53–54.

72. Reflecting on this quality of permanence, Strand was fascinated to discover at this time that a flower or plant, when blown by the wind, always returned to the same position it had before it was blown; see *Paul Strand, Sixty Years*, 152.

73. Cowley, *The Exile's Return*, 298.

74. Paul Strand to Alfred Stieglitz, 1928, PSA/CCP. For further discussion of the composite novel and experimentation in American literature in the 1920s, see Richard Gid Powers, "Toward a New Literature: Novelistic Experimentation in America during the First Decades of the Twentieth Century," Ph.D. dissertation, Brown University, 1969, and Stephen Lee Sniderman, "The Composite in Twentieth Century American Literature," Ph.D. diss., University of Wisconsin, 1970.

75. Paul Strand to John Marin, 28 September 1930, and 8 August 1932, John Marin Archive, National Gallery of Art, Washington.

76. Paul Strand to Herbert Seligmann, 29 July 1931, Herbert Seligmann Collection, The Pierpont Morgan Library, New York, reprinted in this catalogue.

77. Paul Strand to John Marin, 7 August 1931, John Marin Archive, National Gallery of Art, Washington, and Paul Strand to Seligmann, 29 July 1931.

78. Paul Strand to Marin, 7 August 1931.

79. Paul Strand to Stieglitz, 27 August 1930, PSA/CCP.

80. Paul Strand to J. Dudley Johnston, 18 April 1924, PSA/CCP.

81. Rosenblum, *Paul Strand: The Early Years*, 209–215.

82. See Harold Clurman, *The Fervent Years: The Group Theater and the Thirties* (New York, 1945, 1983), and Elizabeth McCausland to Paul Strand, 31 March 1932, PSA/CCP.

83. Harold Clurman to Paul Strand, fall 1934, PSA/CCP. Clurman, an extremely articulate and perceptive person, continued to analyze Strand's actions in this letter, noting that he was attracted to the Group Theater because it was "a real group, that might grow and expand, and really go forward into the world, really do battle with it. You went away to Mexico (because the Group Theater which held you as a symbol did not, being a theater, give you a function or a form) to find something different than '291,' something like The Group only in your own 'line.' You become interested in Communism—as a philosophy which makes of the Group idea a whole political, economic, social method of practical action and historically justified necessary struggle. It is interesting that at this point you begin to do *movies*, work with people—aided, encouraged by Chavez, a man with the sense of a Group, and the sense of Art as a means in the struggle, as an integral part of the struggle." A letter from McCausland to Strand, 1 February 1932, clearly indicates that Strand was concerned that he, like Stieglitz, was in an "ivory tower," and "retreating" into his art; PSA/CCP.

84. Archibald MacLeish, *Land of the Free—U.S.A.* (London, 1938).

85. Cowley,—*And I Worked at the Writer's Trade: Chapters of Literary History, 1918–1978* (New York, 1979), 101. Ironically, Alfred Kazin in *Starting out in the Thirties* (Boston, 1962), 50, identified Cowley not as part of the collective "we," but as an outsider: "all those critics in power—Cowley, the Van Dorens, Canby, Chamberlain—were outsiders . . . writers from the business and professional class could only interpret in an abstract and literary way the daily struggle that was so real to me in Brownsville."

86. Anita Brenner, *Idols Behind Altars* (New York, 1929, 1967), 259.

87. Paul Strand to Alfred Stieglitz, 5 February 1933; PSA/CCP. Strand wrote to Irving Browning, 29 September 1934, that 3,000 people had visited the show in ten days; PSA/CCP, reprinted in this catalogue.

88. "Report of Paul Strand on Trip to Michoacán, June 1933"; unpublished manuscript, PSA/CCP. Many of the ideas Strand expressed in this report had their roots in 291. Stieglitz, for example, would have agreed with Strand when he wrote, "it is a problem and paradox of all art, whether it be the useful arts or the fine arts, that the artist needs to and should live by his work, but that in its very essence art has nothing to do with 'business,' whose needs corrupt and always will corrupt the impulse out of which art is born." Stimulated by the populist character of the decade and the 1932 exhibition of folk art at The Museum of Modern Art, the 1930s witnessed an increased interest in the study and preservation of the crafts and folk art. The depiction of these objects in paintings or photographs or the inclusion of its melodies in songs or symphonies became an emblem of solidarity with the common man.

89. Paul Strand to John Marin, 1 September 1933, John Marin Archive, National Gallery of Art, Washington, reprinted in this catalogue.

90. Paul Strand to Irving Browning, 29 Sept 1934, PSA/CCP, reprinted in this catalogue.

91. *Sixty Years*, 156–157, and Paul Strand to Irving Browning, 29 September 1934, PSA/CCP, reprinted in this catalogue.

92. See Strand's "An Analysis of 'The Wave' "; unpublished manuscript, PSA/CCP.

93. William Alexander in *Films on the Left: American Documentary Film from 1931 to 1942* (Princeton, 1981), 71.

94. Clurman, *The Fervent Years*, 19.

95. Michael and Jill Klein, "Native Land: An Interview with Leo Hurwitz," *Cinéaste* 6 (1974), 4.

96. Steiner, "Revolutionary Movie Production," *New Theatre* (September 1934), 23.

97. "American Documentary Film Tradition and the Making of 'Native Land,' " unpublished manuscript, 1942, PSA/CCP.

98. For differing accounts of the break between Strand, Hurwitz, Steiner, and Lorentz, see Tomkins, "Profiles," 70–74; Ralph Steiner, *A Point of View* (Middletown, Connecticut, 1978), 13–14; W. L. White, "Pare Lorentz," *Scribner's Magazine* 105 (January 1939), 8–10; and Peter Ellis (Herbert Klein),

"The Plow that Broke the Plains," *New Theater* 3 (July 1936), 18–19. For a thorough summary and a discussion of the "thoroughly patriotic" tone of *The Plow that Broke the Plains*, see Alexander, 97–102, 107–109. Although Hurwitz and Steiner had outlined a film that demonstrated the exploitation of the land for commercial profit and although Lorentz (who had never made a film before) had accepted their idea, he supposedly presented the three filmmakers with a script that was more lyrical and symbolic than it was literal and factual. Hurwitz and Strand rewrote the script and shot footage that fit their idea of the scenario. Lorentz did not accept their revision and although Strand and Hurwitz continued to make footage for the film, Lorentz worked more closely with Steiner.

99. James Rorty, *Where Life is Better* (New York, 1936), 13.

100. Paul Strand, "Frontier Films," unpublished manuscript, PSA/CCP.

101. Paul Strand, "American Documentary Film Tradition and the Making of Native Land," unpublished manuscript, 1942, PSA/CCP, and "Native Land: An Interview with Leo Hurwitz," 5.

102. "Native Land," 6.

103. See Alexander, *Films on the Left*, 209–231, for detailed account of this period.

104. Alexander, *Films on the Left*, 223–230.

105. Nancy Newhall to Paul Strand, 1 June 1946, Newhall Collection.

106. Nancy Newhall, "Editor's Foreword," *Time in New England* (New York, 1950), v. Newhall sometimes sent Strand descriptions of the kinds of photographs she needed to illustrate ideas that were evolving in her selection of texts. For example, on 1 June 1946 she wrote, "We need many more images with concrete associations: the sea, the country, the people. As: an image not unlike our beloved little gaspe[sic] town, to go with the Spectral ship symbol of isolation and hope and faith and fear. An iamge [sic] of peace and established loveliness, to go with the feeling Old Sam Sewall had about his Newburyport, and which appears again and again. Might be a common with elms, or rolling countryside with glimpse of town in summer. An image of vast prospects—clouds, horizons—like the Mt Washington sequence in Native Land, or that first lovely glimpse of Maine islands under clouds in our beginning sequence, for Nathaniel Ames and the Revolution boys on the future. An image—very difficult—to accompany the love of books and excitement of scholarship, so beautifully exprssed by Bradford, and Van Wyck Brooks. Nearest I can come to it at present is the closeup of the window with puttied

panes, teapot, tomatoes, books beyond, which conveys a quiet and busy life''; Newhall Collection.

107. See Eric Himmell, ''Pilgrim's Progress,'' *Camera Arts* 1, no. 6 (November–December 1981), 12.

108. Newhall, *Time in New England*, v, and Strand, ''Photographer's Foreword,'' *Time in New England*, vi, reprinted in this catalogue.

109. ''Address by Paul Strand,'' *Photo Notes*, special number (January 1948), 2.

110. Lecture by Hurwitz, quoted by Alexander, *Films on the Left*, 231.

111. ''Address by Paul Strand,'' *Photo Notes*, 3

112. *Time in New England*, 244.

113. Strand [Paper delivered at the International Congress of Cinema,] *Photo Notes* (spring 1950), 9, 11, reprinted in this catalogue.

114. Strand to Nancy Newhall, 15 April 1953, Newhall Collection.

115. See Paul Strand to Nancy and Beaumont Newhall, 2 May 1958, Newhall Collection, reprinted in this catalogue, for a discussion of the lineage of *Un Paese*; see Strand's review of *An American Exodus* in *Photo Notes* (March–April 1940), 2–3, for a discussion of the integration of photographs and text; and Paul Strand, quoted in ''Symposium Report,'' *Photo Notes* (Spring 1949), 9.

116. Paul Strand to Nancy Newhall, 16 July 1955, Newhall Collection.

117. Strand to Nancy and Beaumont Newhall, 28 April 1953, Newhall Collection.

118. Paul Strand to Beaumont Newhall, 28 April 1953, Newhall Collection.

119. *The New York Times*, ''Obituary,'' 16 October 1989, D-15.

120. Zavattini [Introduction], *Un Paese* (Turin, 1955), 6–13.

121. Paul Strand, Application for Fulbright Fellowship, 1949?, copy in Strand to Newhall correspondence, Newhall Collection.

122. Basil Davidson, ''Commentary,'' *Tir a'Mhurain* (London, 1962), 146.

123. Paul Strand and James Aldridge, ''Introduction,'' *Living Egypt* (Dresden, 1969), 5.

124. Strand and Aldridge, *Living Egypt*, 5.

125. *On My Doorstep* (Millerton, New York, 1976), unpaginated.

126. *On My Doorstep*, unpaginated.

SOURCES

FOR PAUL STRAND WRITINGS REPRINTED IN THIS BOOK

Pages 10, 16: ''Photography,'' *Camera Work*, nos. 49–50 (June 1917), 3–4.

Page 50: Letter to Sherwood Anderson, 20 July 1920. Sherwood Anderson Papers, The Newberry Library, Chicago.

Page 64: Letter to Alfred Stieglitz, 13 July 1926. Alfred Stieglitz Archive, Collection of American Literature, Beinecke Rare Book and Manuscript Library, Yale University, New Haven.

Page 68: Letter to Samuel Kootz, 11 September 1931, Paul Strand Archive, Center for Creative Photography, University of Arizona, Tucson.

Page 76: Letter to Hebert Seligmann, 29 July 1931, The Pierpont Morgan Library, New York.

Page 88: Letter to John Marin, 1 September 1933, John Marin Archive, National Gallery of Art, Washington.

Page 96: Letter to Irving Browning, 29 September 1934, Paul Strand Archive, Center for Creative Photography, University of Arizona, Tucson.

Page 100: ''Photographer's Foreword,'' *Time in New England*. (New York, 1950).

Page 112: Report to the International Congress of Cinema, Perugia, 24–27 September 1949. Reprinted as ''Realism: A Personal View,'' *Sight and Sound* 18 (January 1950), 23–26. *Photo Notes* (Spring 1950), 8–11, 18.

Page 122: Letter to Nancy and Beaumont Newhall, 2 May 1958, Collection of Beaumont Newhall, Santa Fe, New Mexico.

Page 128: Letter to Beaumont Newhall, 28 April 1953, Collection of Beaumont Newhall, Santa Fe, New Mexico.

Page 134: Letter to Nancy and Beaumont Newhall, 28 October 1954, Collection of Beaumont Newhall, Santa Fe, New Mexico.

Page 144: *The Garden*, Millerton, New York, 1976.

BIBLIOGRAPHY

SELECTED PUBLICATIONS ON PAUL STRAND

Adams, Ansel. "A Decade of Photographic Art." *Popular Photography* 22 (June 1948), 44–46, 156–159.

Alexander, William. *Film on the Left.* Princeton, 1981.

Alfred Stieglitz Presents Seven Americans: 159 Paintings, Photographs, and Things Recent and Never Before Publicly Shown [exh. cat., The Anderson Galleries] (New York, 1925).

"An American Photographer Does Propaganda Movie for Mexico." *Life* 2 (10 May 1937), 62–65, 70.

American Photography Retrospective Exhibition [exh.cat., Julien Levy Gallery] (New York, 1931).

Backhaus, Hans Joachim. "Paul Strand: Forschungsreise durch vier Jahrzehnte." *Fotografie* 4 (April 1969), 16–23.

Bauer, Catherine. "Photography: Man Ray and Paul Strand." *Arts Weekly* 1 (7 May 1932), 193, 198.

Berger, John. "Painting—or Photography?" *The Observer Weekend Review* (24 February 1963), 25. Reprinted as "Painting or Photography?" in *The Photographic Journal* 103 (June 1963), 182–184; and *Photography Annual, 1964* (New York, 1963), 8–10.

——. "Arts in Society: Paul Strand." *New Society* (30 March 1972), 654–655.

"Book Reviews: Paul Strand Photographs 1915–1945." *Quarterly Review* 15 (Summer 1945), 219–222.

Breuning, Margaret. "Seven Americans." *New York Evening Post* 14 (March 1925), 11.

Brown, Milton W. "Cubist—Realism: An American Style." *Marsyas* 3 (1943–1945), 139–160.

——. "Paul Strand and His Portrait of People." *The Compass* (31 December 1950), 12.

——. "Paul Strand Portfolio." *Photography Yearbook 1963.* London, 1962.

Burdett, Winston. "The Screen." *Brooklyn Eagle* (21 April 1937).

Caffin, Charles. "Paul Strand in 'Straight' Photographs." *The New York American* (20 March 1916), 7. Reprinted as "Straight Photography" in *Camera Craft* 5 (May 1916), 205; and *Camera Work* 48 (October 1916), 57–58.

"The Camera Club's Annual Members' Print Exhibition." *American Photography* 4 (June 1910), 371.

"Cameraman's 'Mood' Big Factor in Films that Would Succeed." *Variety* (March 1925), 42.

Cary, Elizabeth Luther. "The World of Art: Recent Pictorial Photography at the Camera Club Exhibition." *The New York Times Book Review and Magazine* (10 September 1922), 10.

Chiarenza, Carl. "Tir a'Mhurain—Outer Hebrides." *Contemporary Photographer* 4 (Fall 1963), 63–65.

Clurman, Harold. "Photographs by Paul Strand." *Creative Art* 5 (October 1929), 735–738.

Cohn, Herbert. "Two Rare Film-Makers Made *Native Land.*" *Brooklyn Eagle* (16 May 1942), 14.

Coke, Van Deren. "The Cubist Photographs of Paul Strand and Morton Schamberg." In *One Hundred Years of Photographic History: Essays in Honor of Beaumont Newhall.* Albuquerque, 1975.

——. "A Talk with Paul Strand: France, Summer 1974." *History of Photography* 4 (April 1980), 165–169.

Coleman, A. D. "Two by Strand: Land Imposes Limitations." *Popular Photography* 65 (December 1969), 90–91, 126.

"A Collection of Photography. Paul Strand." *Aperture* 14 (Fall 1969), unpaginated.

"Comment." *The Dial* 79 (August 1925), 177–178.

Cortissoz, Royal. "Paul Strand." *Camera Work* 48 (October 1916), 58.

Crichton, Fenella. "London Letter." *Art International* 20 (April-May 1976), 20.

"A Criticism." *The Camera* 21 (April 1917), 203–204.

Crowther, Bosley. "*Native Land,* Impassioned and Dramatic Documentary Film on American Civil Liberties, Presented at The World." *The New York Times* (12 May 1942), 16.

Davis, Douglas. "The Right Movement." *Newsweek* 78 (6 December 1971), 106.

"Democracy Fights Back." *Popular Photography* 10 (February 1942), 49–50.

Deschin, Jacob. "Picture Books. New Volumes Are Based on Regional Themes." *The New York Times* (22 October 1950), X-15.

——. "Diogenes III at Museum." *The New York Times* (22 January 1956), X-19.

——. "Viewpoint. Paul Strand at 76." *Popular Photography* 60 (March 1967), 14, 16, 18, 58.

——. "Strand Portfolio Again Available." *The New York Times* (28 January 1968), D-35.

——. "Paul Strand: An Eye for Truth." *Popular Photography* 70 (April 1972), 68–73, 108–111, 176.

Duncan, Catherine. "Life in Stillness: The Art of Paul Strand." *Meanjin Quarterly* 28 (Summer 1969), 565–569.

——. "Paul Strand. The Garden: Vines and Leaves." *Aperture* 78 (1977), 46–61.

Dyke, Willard van. "The Interpretive Camera in Documentary Films." *Hollywood Quarterly* 1 (July 1946), 405–409.

Evander, Hendrik. "Redes." *Frente a frente* 6 (November 1936).

Evans, Walker. "Photography." In *Quality: Its Image in the Arts.* Ed. Louis Kronenberger. New York, 1969, 169-179.

"Experts Show Prints at Photo League." *New York World-Telegram* (7 December 1939), 7.

"La exposición de fotografías de Paul Strand." *El Universal* (5 February 1933).

"Exposure: Six Top-Flight Professional Photographers Discuss Their Black and White Exposure Methods." *Photo Arts* 2 (Spring 1948), 34–35, 120, 122, 123.

Fitz, W. G. "A Few Thoughts on the Wanamaker Exhibition." *The Camera* 22 (April 1918), 201–207.

Fourteenth Annual Exhibition of Photographs [exh. cat., John Wanamaker] (Philadelphia, 1920).

Frampton, Hollis. "Meditations around Paul Strand." *Artforum* 10 (February 1972), 52–57.

Fulton, Deogh. "Cabbages and Kings." *International Studio* 81 (May 1925), 144–147.

Goff, Lloyd L. "Book Reviews." *The New Mexico Quarterly Review* 15 (Summer 1945), 219–222.

Green, Charles. "Paul Strand." *New Masses* 55 (15 May 1945), 30–31.

——. "Highlands and Islands." *Times Literary Supplement* (28 December 1962), 1007.

Grossman, Sid. "Documentary Film Problems Discussed at Writers' Congress." *Photo Notes* (June 1939), 4.

Hammen, Scott. "Sheeler and Strand's 'Manhatta': A Neglected Masterpiece." *Afterimage* 6 (January 1979), 6–7.

Harris, Susan A. "Paul Strand's Early Work: A Modern American Vision." *Arts Magazine* 59 (April 1985), 116–118.

Homer, William Innes. "Stieglitz, 291, and Paul Strand's Early Photography." *Image* 19 (June 1976), 10–19.

Horak, Jan-Christopher. "Modernist Perspectives and Romantic Desire: Manhatta." *Afterimage* 15 (November 1987), 8–15.

Hurwitz, Leo. "On Paul Strand and Photography." *Photo-Notes* (July-August 1941), 4–5.

Jeffrey, Ian. "Paul Strand." *Photographic Journal* 116 (March-April 1976), 76–81.

Jewell, Edward Alden. "Art in Review: Film Overtones." *The New York Times* (16 April 1932), 13.

——. "Strand: Three Decades." *The New York Times* (29 April 1945), X-5.

Jones, Harold. "The Work of Photographers Edward Weston and Paul Strand: With an Emphasis on Their Work in New Mexico." M.A. thesis, University of New Mexico, 1970.

Joseph, Robert. "Unimportance of budget. . . ." *Hollywood Spectator* 13 (25 June 1938), 11.

Keller, Ulrich. "An Art Historical View of Paul Strand." *Image* 17 (December 1974), 1–11.

Kleinholtz, Frank. "Paul Strand: Radio Interview." *American Contemporary Art* 2 (May-June 1945), 10–13.

Koch, Robert. "Paul Strand/Tir a'Mhurain: Outer Hebrides." *Aperture* 11 (New York, 1964), 80–81.

Lachaise, Gaston. *Paul Strand, New Photographs* [exh. cat., The Intimate Galleries] (New York, 1929).

Lacome, Pierre-Françoise. Un photographe de l'éternel." *Monthly Bulletin. Guilde du Livre* (September 1955), 362–363.

"Living Egypt." *Album* 2 (1970), 39.

Losey, Joseph. "Famous U.S. Photographer in Moscow." *Moscow Daily News* (17 May 1935), 3.

"Manhattan—The Proud and Passionate City: Two American Artists Interpret the Spirit of New York Photographically in Terms of Line and Mass." *Vanity Fair* 18 (April 1922), 51.

Mann, Margery. "Two by Strand: When the People Draw a Curtain." *Popular Photography* 65 (December 1969), 90–91, 126.

Martin, Marcel, and Marion Michelle. "Un Humaniste Militant Photographe et Cinéaste." *L'Écran* (March 1975), 36–45.

Mayer, Grace M. "Paul Strand's Tir a'Mhurain." *Infinity* 12 (April 1963), 21–23, 27.

McBride, Henry. "Attractions in the Galleries." *New York Sun* (16 April 1932), 10.

———. "Attractions in the Galleries." *New York Sun* (28 April 1945), 9.

———. "The Paul Strand Photographs." *New York Evening Sun* (23 March 1929), 34.

McCausland, Elizabeth. "For Posterity." *Photo Technique* 3 (January 1941), 40–42.

———. "Paul Strand's Photographs Show Medium's Possibilitites." *Springfield Sunday Union and Republican* (17 April 1932), 6E.

———. "Paul Strand's Series of Photographs of Mexico." *Springfield Sunday Union and Republican* (7 July 1940), 6E.

———. "Paul Strand Turns to Moving-Pictures." *Springfield Sunday Union and Republican* (6 September 1936), 5C.

———. "Paul Strand." *U.S. Camera* 8 (February-March 1940), 20–25, 65.

———, *Paul Strand and His Art.* Springfield, 1933.

———. "The Stieglitz Group at Anderson's." *Evening Sun* (14 March 1925), 13.

McIntyre, Robert L. "The Vision of Paul Strand." *PSA Journal* 38 (August 1972), 18–21.

Mellquist, Jerome. "Paul Strand's Portfolio." *New Republic* 103 (4 November 1940), 637–638.

Meyers, Sidney [Robert Stebbins, pseud.]. "Pescados." *New Theater* 2 (June 1935), 11.

———. "Paul Strand's Photography Reaches Heights in *The Wave*." *Daily Worker* (4 May 1937), 7.

Mishkin, Leo. "Screen Presents. *The Wave.* Mexico Government Opus Reaches Crest Only in Photography." *Morning Telegraph* (21 April 1937).

Moore, Dorothy Lefferts, and Lloyd Goodrich. "In the New York Galleries." *The Arts* 15 (April 1929), 264.

Mullin, Glenn. "Alfred Stieglitz Presents Seven Americans." *The Nation* 120 (20 May 1925), 577–578.

"Native Land." *Time* (8 June 1942), 36.

"Native Land . . . Readers Discuss Pros and Cons." *Daily Worker* (2 May 1942), 8.

Neugass, Fritz. "Photo League, New York." *Camera* 29 (September 1950), 262–275.

Newhall, Beaumont. "Book Reviews. Un Paese." *Aperture* 3 (1955), 30–32.

———. "Paul Strand, Traveling Photographer." *Art in America* 50 (Winter 1962), 1–2.

Newhall, Beaumont, and Nancy Newhall. "Letters from France and Italy: Paul Strand." *Aperture* 2 (1953), 16–24.

Newhall, Nancy. *Paul Strand: Photographs. 1915–1945* [exh. cat., The Museum of Modern Art] (New York, 1945).

———. "Paul Strand: A Commentary on His New York." *Modern Photography* 17 (September 1953), 46–53, 103–104.

———. "Paul Strand, Catalyst and Revealer." *Modern Photography* 33 (August 1969), 70–75.

"New Labor Movie Tells Epic Story of Unions' Rise." *The CIO News* 5 (11 May 1942), 1.

"News and Notes." *American Photography* 10 (May 1916), 281.

"The 1918 Wanamaker Spring Exhibition." *American Photography* 12 (April 1918), 230–231. ill. p. 184, 197.

"Notes and Activities in the World of Art." *The New York Sun* (April 1917), sec. 5, p. 12.

Nugent, Frank S. "At the Filmarte: *The Wave.*" *The New York Times* (21 April 1937), 18.

O'Dea, Gerald. "Thirty Years with Paul Strand." *The Brooklyn Citizen* (2 May 1943), 8.

"L'oeuvre de Paul Strand." *Le Nouveau Photocinema* (6 October 1972), 50, 65–69, 106.

Oppenheim, James. "The Story of the Seven Arts." *American Mercury* (June 1930), 156–164.

Panter, Peter. "New Light." In *The German Annual of Photography 1930.* Berlin, 1929.

Parker, Robert Allerton. "The Art of the Camera: An Experimental Movie." *Arts and Decoration* 15 (October 1921), 369, 414–415.

"Paul Strand." *American Artist* 9 (October 1945), 40.

"Paul Strand." *Camera* 5 (May 1972), 24–33.

"Paul Strand, 1890–1976." *Popular Photography* 79 (July 1976), 113.

"Paul Strand, Influential Photographer and Maker of Movies, Is Dead at 85," *The New York Times* (2 April 1976), 36.

"Paul Strand Photo Exhibit at Museum of Modern Art." *The Worker* (6 May 1945), 14.

"Paul Strand, Photographer, Declines White House Bid." *The New York Times* (14 June 1965), 44.

Pellerano, Maria B. "Paul Strand and Charles Sheeler. A Modern Collaboration." M.A. thesis, Rutgers University, 1985.

Pereira, I. Rice. "Artists Equity." *Photo Notes* (May-June 1947), 6.

"Photographic Art at Modern Gallery." *Art News* 16 (31 March 1917), 3.

Pillsbury, Dorothy L. "The Enchanted Mesa." *The Christian Science Monitor* (23 May 1945), 8.

Platt, David. "The Screen." *Sunday Worker* (25 April 1937), 16.

———. "*Native Land* Is Powerful Exposé of America's 'Little Hitlers.'" *Daily Worker* (12 May 1942), 7.

"Power of a Fine Picture Brings Social Changes." *New York World-Telegram* (4 March 1939), 11.

Prampolini, Enrico. "The Aesthetic of the Machine and Mechanical Introspection in Art." *Broom* 3 (August 1922), 235–237.

Rathbone, Belinda. "Portrait of a Marriage: Paul Strand's Photographs of Rebecca." *The J. Paul Getty Museum Journal* 17 (1989), 82–98.

Read, Helen Appleton. "Alfred Stieglitz Presents 7 Americans." *The Brooklyn Daily Eagle* (15 March 1925), 2 B.

"Rétrospective de l'oeuvre de Paul Strand un grand photographe . . . américain." *La Dernière Huere* (6 February 1969).

Ridge, Lola. "Paul Strand." *Creative Art* 9 (October 1931), 312–316.

Rolfe, Edwin. "Prophesy in Stone for Paul Strand." *New Republic* 78 (16 September 1936), 154. Reprinted in *First Love and Other Poems.* Los Angeles, 1951.

Rosenblum, Naomi. *Paul Strand: The Stieglitz Years at 291 (1915–1917)* [exh. cat., Zabriskie Gallery] (New York, 1983).

———. "Paul Strand: The Early Years, 1910–1932." Ph.D. diss., City University of New York, 1978.

Rosenblum, Walter. "Paul Strand." In *American Annual of Photography.* Minneapolis, 1951.

———. "We Owe a Debt to Paul Strand as We Do to Pablo Picasso." *The New York Times* (23 January 1972), sec. 2, p. 21.

Sabine, Lillian. "Paul Strand, New York City." *The Commercial Photographer* 9 (January 1934), 105–111.

"The Screen." *New Masses* (27 April 1937).

"Seven Americans." *The Arts* 7 (April 1925), 229–230.

Sheeler, Charles. "Recent Photographs by Alfred Stieglitz." *The Arts* 3 (May 1923), 345–346.

Soby, James Thrall. "Two Contemporary Photographers." *Saturday Review of Literature* 38 (5 November 1955), 32–33.

Steiner, Ralph. *Ralph Steiner. A Point of View.* Middletown, 1978.

Sterne, Katherine Grant. "American vs. European Photography." *Parnassus* 4 (March 1932), 16–20.

———. "The Camera: Five Exhibitions of Photography." *The New York Times* (6 December 1931), XX18.

———. "Art in Review: Film Overtones" *The New York Times* (16 April 1932), 13.

Stettner, Lou. "A Day to Remember: Paul Strand Interview." *Camera* 35 (October 1972), 54–58, 72–76.

———. "Speaking Out: Strand Unraveled." *Camera* 35 (July/August 1973), 8, 67, 70.

Stieglitz, Alfred. "Our Illustrations." *Camera Work* 49–50 (June 1917), 36.

———. "Photographs by Paul Strand." *Camera Work* 48 (October 1916), 11–12.

Stoller, Ezra. "Living Egypt." *Infinity* 19 (June 1970), 20.

Strauss, Theodore. "Homesteading Our Native Land." *The New York Times* (3 May 1942), X-3.

T.B. "Paul Strand." *The Christian Science Monitor* (23 May 1945), 8.

Tazelaar, Marguerite. "The Plow That Broke the Plains—Grand Central Palace." *New York Herald Tribune* (26 May 1936), 13.

———. "The Wave—Filmarte." *New York Herald Tribune* (21 April 1937), 18.

Thirer, Irene. "Paul Strand and Leo Hurwitz Offer Data on *Native Land.*" *New York Post* (9 May 1942), 13.

Thirteenth Annual Exhibition of Photography [exh. cat., John Wanamaker] (Philadelphia, 1918).

Thomas, Eleanor. "Paul Strand Probes

Life's Recesses with His Camera." *The Daily Worker* (11 June 1945), 11.

Tomkins, Calvin. "Profiles: Look to the Things around You." *New Yorker* (16 September 1974), 44–94.

Twelfth Annual Exhibition of Photography [exh. cat., John Wanamaker] (Philadelphia, 1917).

Vail, Floyd. "Members' Work at the Camera Club, New York." *The Camera* 26 (October 1922), 533–535.

Warren, Dody. "Weston, Strand, Adams." *American Photography* 45 (January 1951), 49–53.

Watson, Forbes. "Seven American Artists Sponsored By Stieglitz." *The World* (15 March 1925), 13.

Weiner, Sandra. "Symposium Report." *Photo Notes* (Spring 1949), 8–9.

Weiss, Margaret. "Paul Strand, Close-up on the Long View." *Saturday Review* (18 December 1971), 20.

Winsten, Archer. "Redes Opens at the Filmarte Theater." *New York Post* (21 April 1937), 15.

Zavattini, Cesare. "Diario." *Cinema Nuovo* (May 1953), 264.

PUBLICATIONS BY PAUL STRAND
In chronological order

"Photography." *Seven Arts* 2 (August 1917), 524–525. Also printed in *Camera Work*, nos. 49–50 (June 1917), 3–4. Reprinted in Nathan Lyons, ed. *Photographers on Photography*. Englewood Cliffs, N.J., 1966.

"Aesthetic Criteria." *The Freeman* 2 (12 January 1921), 426–427.

"The Subjective Method." *The Freeman* 2 (2 February 1921), 498.

"Alfred Stieglitz and a Machine." New York, 14 February 1921. Reprinted in *MSS* 2 (March 1922), 6–7. Rewritten for Frank, Waldo, Lewis Mumford, Dorothy Norman, Paul Rosenfeld, and Harold Rugg, *America and Alfred Stieglitz*, New York, 1934.

"The Independents in Theory and Practice." *The Freeman* 3 (6 April 1921), 90.

"American Watercolors at the Brooklyn Museum." *The Arts* 2 (December 1921), 148–152.

"John Marin." *Art Review* 1 (January 1922), 22–23.

"The Forum." *The Arts* 2 (February 1922), 332–333.

"Photography and the New God." *Broom* 3 (November 1922), 252–258. Reprinted in Lyons 1966; and in Bunnell, Peter C., *A Photographic Vision: Pictorial Photography 1889–1923*. Salt Lake City, 1980.

"News of Exhibits: Sometimes a Week Elapses before Criticisms Are Published." Letter to the Editor of *The Sun* (31 January 1923).

"The New Art of Colour." *The Freeman* 7 (18 April 1923), 137. Letter to the Editor in response to Willard Huntington Wright, "A New Art Medium." *The Freeman* 6 (6 December 1922), 303–304.

"Photographers Criticized," *The Sun and the Globe* (27 June 1923), 20. In response to Boughton, Arthur. "Photography as an Art: Photographers Themselves Do Not Appreciate Its Possibilities." *The New York Sun and The Globe* (20 June 1923), 22.

"The Art Motive in Photography." *British Journal of Photography* 70 (5 October 1923), 612–614. From address delivered at the Clarence White School of Photography, 1923. Reprinted in Lyons, 1966. Précis of text and notes of discussion in "The Art Motive in Photography: A Discussion," *Photographic Journal* 64 (March 1924), 129–132.

"Georgia O'Keeffe." *Playboy* 9 (July 1924), 16–20.

"Marin Not an Escapist." *The New Republic* 55 (25 July 1928), 254–255.

"Photographs of Lachaise Sculpture." *Creative Art* 3 (August 1928), xxiii–xxviii. Reprinted in "Lachaise." In *Second American Caravan*. Edited by A. Kreymborg et al. New York, 1928.

"Steichen and Commercial Art." *The New Republic* 62 (19 February 1930), 21.

"A Picture Book for Elders." Review of *David Octavius Hill* by Heinrich Schwarz, *Saturday Review of Literature* 8 (12 December 1931), 372.

"El Significado de la Pintura Infantil." *Pinturas y Dibujos de los Centros Culturales*. Mexico City, 1933.

"Correspondence on Aragon." *Art Front* 3 (February 1937), 18. In response to Louis Aragon, "Painting and Reality." *Art Front* 3 (January 1937), 7–11.

"Les Maisons de la Misere." *Films* 1 (November 1939), 89–90.

"A Statement on Exhibition Policy." *Photographs of People by Morris Engel*. New York, 1939. Reprinted in *Photo Notes* (December 1939), 5.

"An American Exodus by Dorothea Lange and Paul S. Taylor." *Photo Notes* (March-April 1940), 2–3.

Photographs of Mexico. Foreword by Leo Hurwitz. New York, 1940. Reprinted as *The Mexican Portfolio*. Preface by David Alfaro Siqueiros. New York, 1967

"Photography and the Other Arts." Lecture delivered at the Museum of Modern Art, 1945. Published in *Paul Strand Archive, Guide Series Number Two*, Center for Creative Photography, University of Arizona, Tucson, 1980.

"Photography to Me." *Minicam Photography* 8 (May 1945), 42–47, 86, 90.

"Weegee Gives Journalism a Shot for Creative Photography." *PM* (22 July 1945), 13–14.

"Alfred Stieglitz, 1864–1946." *New Masses* 60 (6 August 1946), 6–7.

"Stieglitz, An Appraisal." *Popular Photography* 21 (July 1947), 62, 88–98. Reprinted in *Photo Notes* (July 1947), 7–11.

"Address by Paul Strand." *Photo Notes* (January 1948), 1–3.

"A Platform for Artists." *Photo Notes* (Fall 1948), 14–15.

"Paul Strand Writes to a Young Photographer." *Photo Notes* (Fall 1948), 26–28.

"Realism: A Personal View." *Sight and Sound* 18 (January 1950), 23–26. Reprinted as "International Congress of Cinema, Perugia." *Photo Notes* (Spring 1950), 8–11, 18.

Photographs of Walter Rosenblum [exh. cat., Brooklyn Museum] (Brooklyn, 1950).

Time In New England. With Nancy Newhall. New York, 1950.

La France de Profil. Text by Claude Roy. Lausanne, 1952.

"Italy and France." In *U.S. Camera Yearbook 1955*. New York, 1954.

Un Paese. Text by Cesare Zavattini, Turin, 1955.

Tir a'Mhurain. Text by Basil Davidson. Dresden, London, and New York, 1962.

"Painting and Photography." *The Photographic Journal* 103 (July 1963), 216. Letter to the Editor in response to A. John Berger's "Painting—or Photography?" *The Observer Weekend Review* (24 February 1963), 25.

"Manuel Alvarez Bravo." *Aperture* 13 (1968), 2–9

Living Egypt. Text by James Aldridge. Dresden, London, and New York, 1969.

Paul Strand: A Retrospective Monograph. The Years 1915–1968. 2 vols. New York, 1970. Single volume reprint, New York, 1971.

"The Snapshot." *Aperture* 19 (1973), 46–49.

The Garden, New York, 1976.

Ghana, An African Portrait. Text by Basil Davidson. New York, 1976.

On My Doorstep, New York, 1976.

MANUSCRIPT SOURCES

Ansel Adams Archive, Center for Creative Photography, University of Arizona, Tucson.

Sherwood Anderson Papers, The Newberry Library, Chicago.

John Marin Archive, National Gallery of Art, Washington.

Herbert Seligmann Papers, The Pierpont Morgan Library, New York.

Alfred Stieglitz Archives, Collection of American Literature, Beinecke Rare Book and Manuscript Library, Yale University, New Haven, Connecticut.

Paul Strand Archive, Center for Creative Photography, University of Arizona, Tucson.

The plates in this book are made using
Paul Strand's original negatives, lantern slides, and prints.
In some cases film positives or
new prints from his negatives have been used.
Whenever possible the plates are printed in the same size
as Strand's original contact prints.

The presswork has been done on a six-color offset press.
Using varying combinations,
the reproductions are as faithful to
Strand's original prints as possible.
This process has allowed for color variation within
the reproductions throughout the book.